**UTSA
Memorial Fund**
in memory of

Ruth Hines

**From a Gift
to UTSA by**

the donors to the
UTSA Memorial Fund

Cultural Differentiation and Cultural Identity in the Visual Arts

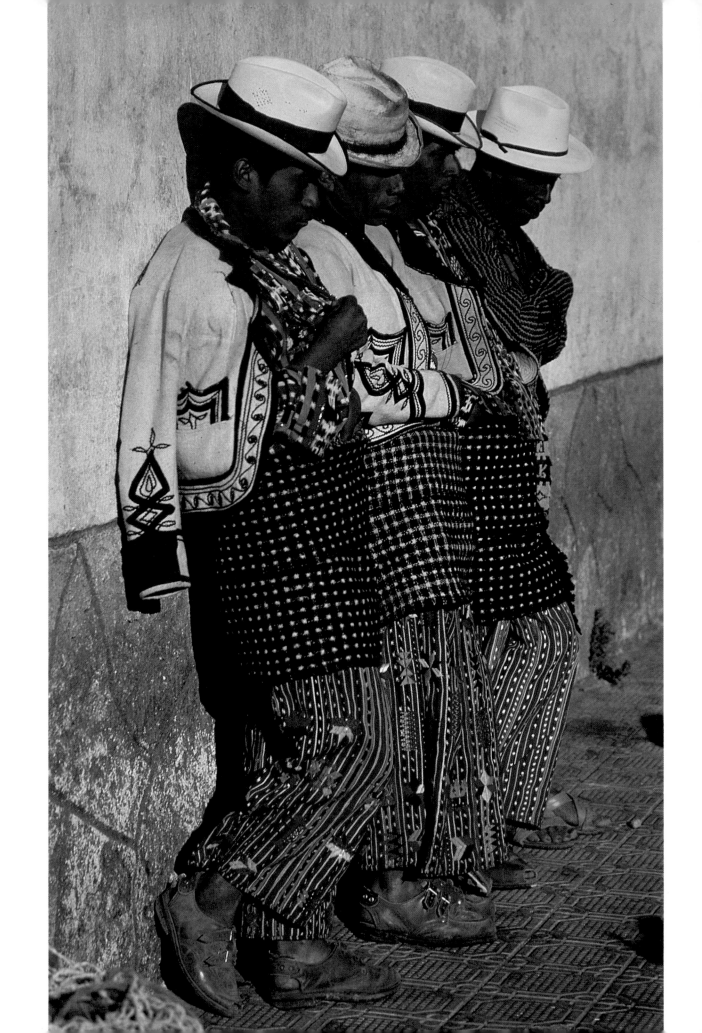

STUDIES IN THE HISTORY OF ART · 27 ·

Center for Advanced Study in the Visual Arts
Symposium Papers XII

Cultural Differentiation and Cultural Identity in the Visual Arts

Edited by Susan J. Barnes and Walter S. Melion

National Gallery of Art, Washington

Distributed by the University Press of New England
Hanover and London 1989

All rights reserved. No part of this book may be reproduced without the written permission of the National Gallery of Art, Washington, D.C. 20565

Copyright © 1989 Trustees of the National Gallery of Art, Washington. All rights reserved

This publication was produced by the Editors Office, National Gallery of Art, Washington
Printed by Wolk Press, Baltimore, Maryland
The text paper is 80 pound LOE Dull text with matching cover
The type is Trump Medieval

Distributed by the University Press of New England, 17½ Lebanon Street, Hanover, New Hampshire 03755

Abstracted by RILA (International Repertory of the Literature of Art), Williamstown, Massachusetts 01267

Proceedings of the symposium "Cultural Differentiation and Cultural Identity in the Visual Arts," sponsored jointly by the Center for Advanced Study in the Visual Arts, National Gallery of Art, and The Johns Hopkins University Department of the History of Art, Washington, D.C., 13-14 March 1987

ISSN 0091-7338
ISBN 089468-133-8

Dimensions are given in centimeters followed by inches, with height before width and depth

Cover: Detail, Nicholas Hilliard, *George Clifford, 3rd Earl of Cumberland*, c. 1590. National Maritime Museum, London

Frontispiece: Solala, Guatemala, modern men in native dress. Photograph by Otis Imboden, from David Stuart, et al., *The Mysterious Maya* © National Geographic Society, Washington, 1977, 185

Studies in the History of Art
Published by the National Gallery of Art, Washington

This series includes: Studies in the History of Art, collected papers on objects in the Gallery's collections and other art historical studies (formerly *Report and Studies in the History of Art*); the Monograph Series, a catalogue of stained glass in the United States; and Symposium Papers (formerly Symposium Series), the proceedings of symposia sponsored by the Center for Advanced Study in the Visual Arts at the National Gallery of Art.

Contents

Preface

In 1982 the Center for Advanced Study in the Visual Arts and the Department of the History of Art at The Johns Hopkins University initiated a joint annual symposium to consider broad issues in the history of art and related disciplines. The 1987 symposium on "Cultural Differentiation and Cultural Identity in the Visual Arts" concerned the way political entities use the visual arts to differentiate themselves from others and shape a distinctive cultural identity. Implicit here are the procedures and structures adopted to form a specific cultural norm, maintain its currency, and effect its modification. The theme of the symposium was also intended to encourage examination of the development and formation of cultural identities that either may result from a gradual accretion or may be the consequence of the events of a brief moment.

This publication, containing the seven papers presented in March 1987 plus an introduction, is the third of the Center-Hopkins programs to result in a volume within the symposium series of *Studies in the History of Art*. The cosponsoring institutions are grateful to Susan J. Barnes and Walter S. Melion for editing the papers for publication and preparing the introduction. The Center also expresses its appreciation to the Arthur Vining Davis Foundation for making its part of these joint gatherings possible. The volume was prepared for publication by the Editors Office of the National Gallery.

The symposium series of *Studies in the History of Art* is designed to document scholarly meetings held under the auspices of the Center for Advanced Study in the Visual Arts and to stimulate further research. Future volumes in the series will chronicle additional symposia, including those jointly sponsored by the Center and sister institutions.

HENRY A. MILLON
Dean, Center for Advanced Study in the Visual Arts

Introduction

The essays in this volume were presented at a symposium on "Cultural Differentiation and Cultural Identity in the Visual Arts," sponsored jointly by the National Gallery of Art's Center for Advanced Study in the Visual Arts and the Department of the History of Art at The Johns Hopkins University. Three sessions, held in March of 1987, invited discussion on the ways in which the visual arts function as cultural signifiers; that is, ways in which they articulate the identity of corporate entities and mediate exchanges between communities that represent themselves through art. Implicit in the choice of topic was a question about process: how do cultural artifacts come to function as social representations?

In "Identity and Difference: The Uses and Meanings of Ethnic Styles," Esther Pasztory calls attention to a peculiar feature of Mesoamerican art of the classic period—the conspicuous juxtaposition of distinct styles, evident in stelae, configurations of pyramid profiles, and two rituals, "flowery war" and the ball game. These examples testify to political and economic circumstances in which competing polities emphasized ethnic differences while engaging intensively in social and commercial exchanges. The clash of polity styles affirms the inalienability of ethnic identity by preserving the otherness of foreign institutions and representing the threshold at which the local and the foreign meet. Pasztory shows how the ethnicity signaled by polity styles posits boundaries between communities that function in many respects as neighbors. She emphasizes that interaction among many polities enhances the value placed on cultural forms resistant to cross-cultural assimilation. In her account the history of classic period styles proves resistant, too, to the art-historical model of development through the incorporation of influences. Her article aims ultimately to challenge the European understanding of style by suggesting the function and significance of style in the Mesoamerican context.

Evelyn Harrison sees that depictions of the gods, of rituals, and of historic or mythic events in the art and literature of early classical and classical Greece reveal the influence of contemporary events on attitudes toward Athenian cultural identity. "Hellenic Identity and Athenian Identity in the Fifth Century B.C." presents a synthesis of evidence gleaned from the sources and from scrupulous analysis of surviving sculpture to support a view of evolving Athenian self-perception during the establishment of the Democracy. Harrison argues that Athenian identity is expressed in such artistic conventions as the depiction of hair and dress as well as in the subjects chosen for depiction or discussion. The conventions, like the subjects, serve to unite Athens with her chosen ancestors and allies, or to distinguish her from them, as needed, while she

passes from internecine battles to the common Hellenic struggle against the Persians, to the emergence of the autochthonous Athenian state.

Martin Powers explores the politicization of taste during the Latter Han dynasty in "Rival Politics and Rival Tastes in Late Han China." He explains how competing systems of domestic decoration and tomb construction came to emblematize the increasingly hostile ideologies of two elites, the imperial eunuchs and the provincial scholar-bureaucrats. Imperial and scholarly iconography diverged when social, political, and aesthetic distinctions between the private and public domain began to blur. Powers shows how the visual arts of Late Han China encoded social worth through the appropriation of Confucian or feudal symbols, whose incompatibility registered the growing factionalization of the society. He describes a situation in which, to apply Pasztory's terms, two ethnic styles struggle for hegemony within a single polity.

In "The *Uomini Illustri*, Humanist Culture, and the Development of a Portrait Tradition in Early Seventeenth-Century Italy," Susan Barnes questions the assumption that political patronage alone determined the cultural identity of artists who had consolidated their status as members of the cultural elite. She considers the humanist tradition of the portrait series, as it was promulgated by Paolo Giovio and harnessed by Palma Giovane and Ottavio Leoni to claim their own value as *virtuosi*. The merits of literary and visual cultures are conjoined in the portrait series, allowing artists both to attest their cultural autonomy and to stress their affinity with the privileged liberal arts. Through the portrait series, Barnes avers, the artist assumes the role of cultural arbiter who defines his place in a network of social and professional relations that he himself articulates. The artist effectively casts himself as a patron of the arts.

The fashioning of pictorial, emblematic, and architectural usage suited to the political aspirations of the Elizabethan court forms the topic of Alice Friedman's "Did England Have a Renaissance? Classical and Anticlassical Themes in Elizabethan Culture." Friedman contests the standard account of the English Renaissance, which argues the fundamental misunderstanding of Italian theory and art by local patrons and artisans. Instead she proposes to show how English art of the sixteenth century appropriates Italian elements and juxtaposes them with indigenous forms and functions. This refusal to elide foreign imports into native patterns of use recalls Pasztory's account of Mesoamerican art, and confirms as well her hypothesis that polity styles represent the demarcation of multiple ethnicities. Friedman demonstrates that English painting and architecture of the era are multivocal and depend for their meaning on the conversation between chivalric and humanist, traditional and modern modes of discourse.

Walter Melion illuminates the importance of the early history of art, specifically the lives of the artists, in articulating cultural identity and cultural differentiation in the visual arts. In "Karel van Mander's 'Life of Goltzius': Defining the Paradigm of Protean Virtuosity in Haarlem around 1600," he argues that Van Mander, like Vasari before him, fashioned certain biographies to create the exemplars through which a cultural consciousness could be defined. Although Van Mander appropriated Vasari's terms, he redefined them to accommodate the attitudes, ideals, and accomplishments of northern art, and to describe their supreme fulfillment in the life and oeuvre of Hendrick Goltzius. Thus, common terminology functions to demarcate one regional tradition from another and to celebrate, through contrast with Italy, the contributions of the north to the history of art.

"Constructions of the Bourbon State: Classical Architecture in Seventeenth-Century France" describes the successful campaign by the French crown to achieve cultural hegemony in Europe through the appropriation and adaptation of classicism as a national style. Hilary Ballon suggests that Louis XIV's success in laying claim to the classical heritage in architecture, which was written even more clearly in the history of perception than in the history of style, owed as much to the actions of individual architectural theorists and practitioners as to the institution of the Royal Academy of Architecture. She posits that

two contemporary, conflicting critiques of the survival of the classical tradition in the Renaissance conspired to shake the foundations of faith in the orders, perhaps unwittingly creating a vacuum that the crown desired, and that the crown succeeded in filling. The internal politics of the Royal Academy as described by Ballon and the relation of that institution to the royal patron on whom it depended are more complex than has been assumed, leading her to advance a revised interpretation about the position of "official" architects in the Quarrel of the Ancients and Moderns.

SUSAN J. BARNES
Dallas Museum of Art

WALTER S. MELION
The Johns Hopkins University

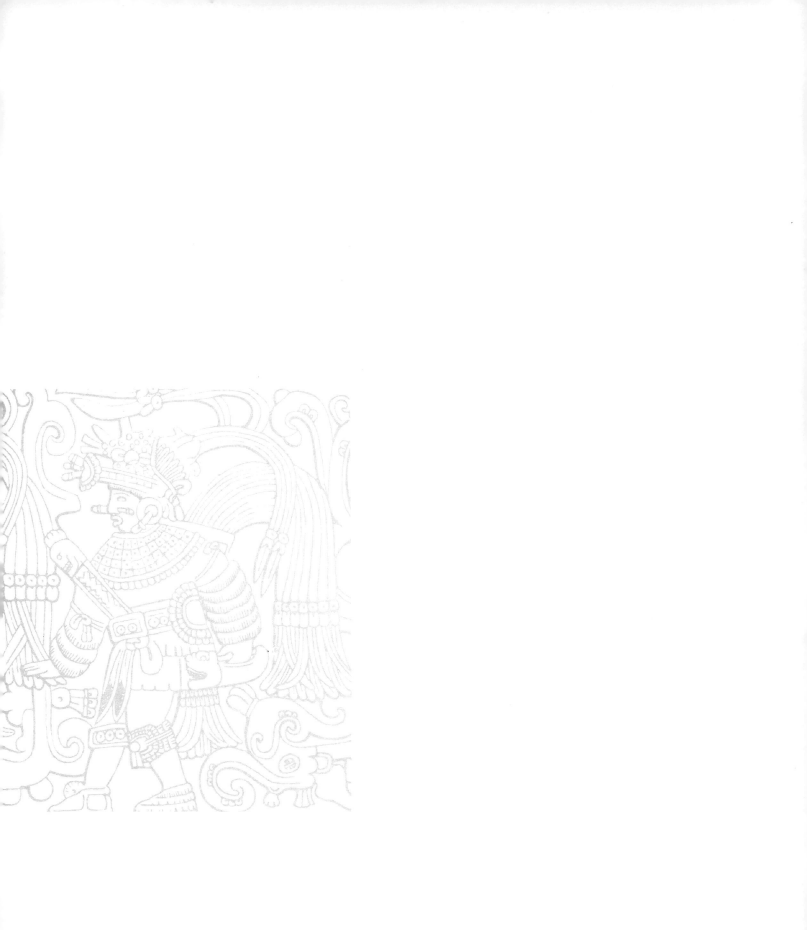

ESTHER PASZTORY
Columbia University

Identity and Difference:

The Uses and Meanings of Ethnic Styles

This book first arose out of a passage in Borges, out of the laughter that shattered, as I read the passage, all the familiar landmarks of my thought—our thought, the thought that bears the stamp of our age and our geography—breaking up all the ordered surfaces and all the planes with which we are accustomed to tame the wild profusion of existing things, and continuing long afterwards to disturb and threaten with collapse our age-old distinction between the Same and the Other. This passage quotes a "certain Chinese encyclopaedia" in which it is written that "animals are divided into: (a) belonging to the Emperor, (b) embalmed, (c) tame, (d) sucking pigs, (e) sirens, (f) fabulous, (g) stray dogs, (h) included in the present classification, (i) frenzied, (j) innumerable, (k) drawn with a very fine camelhair brush, (l) etcetera, (m) having just broken the water pitcher, (n) that from a long way off look like flies." In the wonderment of this taxonomy, the thing we apprehend in one great leap, the thing that, by means of the fable is demonstrated as the exotic charm of another system of thought, is the limitation of our own, the stark impossibility of thinking that.

Michel Foucault, *The Order of Things,* 1970

When I entered graduate school at Columbia University in 1965, Douglas Fraser was away on sabbatical, and I spent my first year studying with Paul Wingert, just before his retirement. Wingert was among the first art historians to define "primitive art" as a field of academic study. His approach to primitive art was then called the "style-area" method. Works of art—for Wingert that meant primarily sculpture—were analyzed in language derived from the study of modern art. Wingert would discuss a figure in terms of shapes, surfaces, and transitional passages, articulating in words the nature of the artist's conventions. He defined style by the conventions of a few normative pieces in each tribe or tribal area.[1] In a very short time we learned the criteria of each style, the names of the ethnic groups, and their geographic locations on the map. In one academic year we could tell Bamana from Baule (figs. 1, 2) and could identify the tribal styles of Africa, Oceania, and North America. Learning these tribal styles transformed primitive art into a finite group of coherent, familiar traditions. Wingert assured us that we now knew everything there was to know on the subject and cautioned us against reading a lot of new-fangled books that merely confused the picture. Douglas Fraser returned the following year and assigned us all the books Wingert had warned against. I still think back with nostalgia to that brief period of intellectual certainty engendered in us by Wingert.

The recognition that each ethnic group had its own style was indeed momentous: it provided an easy way to distinguish be-

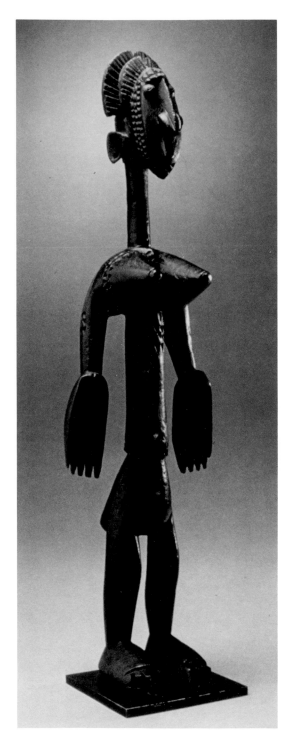

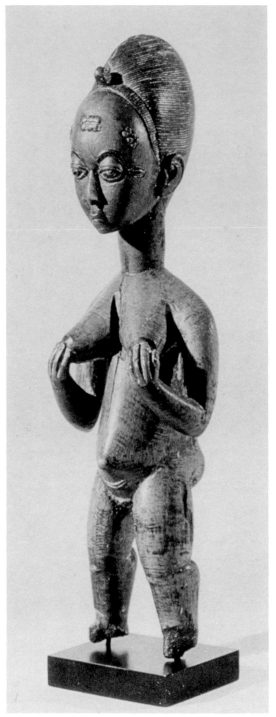

1. Bamana, Africa, sculpture of a woman, wood, 46.3 (18¼)
From Christopher Roy, ed., *Art and Life in Africa* (Davenport, Iowa, 1985), fig. 8

2. Baule, Africa, sculpture of a woman, wood, 34.6 (13⅝)
Photograph courtesy of Pace Primitive Art

tween different peoples. More important, by having distinct styles, each of these peoples became comparable to a chronological period or to the work of an artist belonging to the canon of Western art. The style-area

method was significant to the processes through which non-Western objects were validated as works of art and primitive man was reevaluated positively. The mere fact that these people had ethnic styles of such

clarity indicated that they were creative animals like us and belonged to the family of man.

The style-area method was first devised in museums as a classification scheme for sorting artifacts from around the world. For example, Olbrechts based his classic work of 1946, *Plastiek van Congo*, on the organization of materials deposited in the Belgian Musée Royale de l'Afrique Centrale, Tervuren.[2] Classification was also a useful way of organizing the material for art history classes. Intellectually, however, the concept was riddled with difficulties. For one thing the concept was entirely ahistorical, assuming that these styles had existed in these forms from time immemorial. This was due in part to the nature of the materials themselves—most of the arts were created in perishable media in tropical climates where wood decays normally in fifty to a hundred years. With a few exceptions, old works of art were not available for the creation of an art history. This supported the prevailing opinion that these cultures were extremely traditional and the notion that, like living fossils, they had preserved the lifestyles of early and neolithic man. In this context, discussion of the origin and development of styles was unlikely; the tribal styles were seen as a spontaneous and vague reflection of a given ethnic group's personality or "genius." The modern concept of Afro-American "soul" derives from this idea.

A second and I think even greater problem is that from the viewpoint of style area, the only cultures that existed on our mental map were those with distinctive art styles. In addition to the list we memorized in graduate school, there were groups whose style was neither consistent nor coherent from object to object, groups whose style seemed to be an uncomfortable blend of their neighbors' styles, and those whose art works were so rudimentary that one could not speak of a "style" at all. There also seemed to be groups not particularly interested in the visual arts. We dealt with these groups either by ascribing to them the inferior status of "minor artists," on the model of Western art, or by simply disregarding them. While art style was used to validate the worth of some groups, its absence was used to banish others to a limbo of uncreativity, which meant nonexistence. "Oh yes, the Tiv, they don't *do* anything. . . ."

The question not asked by Wingert and his generation was, why do some people develop distinctive styles at certain times and others do not? What circumstances favor the development of group styles? This question was never asked because it was assumed that ethnic styles emerged spontaneously. The very existence of ethnic style was taken as proof of its universal existence. Consider, for example, the Maya villages of Guatemala where the men and women of each village have their own style of weaving and embroidery, which distinguishes each village's, and each person's, ethnic identity (figs. 3, 4).[3] Such distinguishing style could be perceived in folk villages anywhere around the world. Since it was assumed that if folk cultures do something it must be universal, the issue of ethnic style seemed to need little more explanation than a reference to the collective unconscious. This was not strange to us in the Western tradition in which English, French, Italian, and German styles in art, music, and literature are clear and apparently self-evident. I will try to show that our very notion of group style emerges from, and is defined by, our Western experience of ethnicity and art, and that other, different concepts of style and ethnicity may exist but have not been examined. I will seek to show that just because the phenomenon of ethnic division through style is widespread, it is not necessarily a psychological or social universal. I shall try to determine what functions ethnic styles might fulfill in various societies on the basis of a few selected examples.

First, however, a note on the word "ethnic," which conveys several meanings. In a landmark study, *Ethnic Groups and Boundaries*, Fredrik Barth defined an ethnic group as having four central aspects: a self-perpetuating biology (sometimes racial), a shared basic culture, a shared system of communication (usually language), and a personally affirmed identity.[4] His study suggests that the concepts of ethnic groups, cultures, language groups, and societies are so interwoven that they are hard to unravel. Ethnographers are accustomed to talking

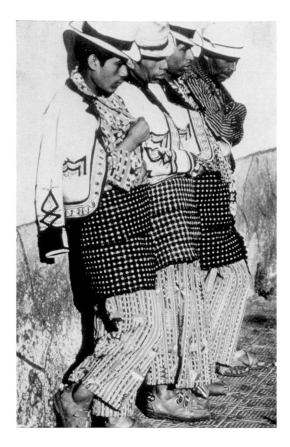 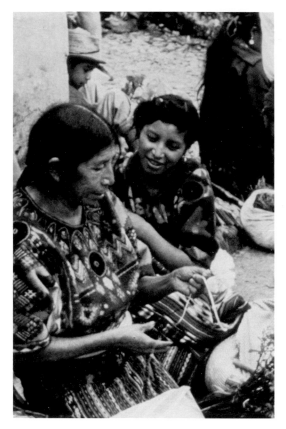

3. Solala, Guatemala, modern men in native dress
Photograph by Otis Imboden, from David Stuart, et al., *The Mysterious Maya* (© National Geographic Society, Washington, 1977), 185

4. Chichicastenango, Guatemala, modern women in native dress
Photograph by Jerry Jackna © 1979, from Mary G. Dieterich, et al., *Guatemalan Costumes* (Phoenix, 1979), frontispiece

about "tribal" groups, sociologists about "ethnic" groups, archaeologists about "cultures," and historians about "peoples and societies." I have chosen to use the term "ethnic" because it encompasses language, culture, and society. I shall use other terms as needed.

One aspect of the meaning of ethnic styles has already been discussed in terms of the style-area approach to the study of non-Western art; there is no question that the presence of ethnic styles enabled Western outsiders to more easily grasp different cultures, the necessary first step before we could evaluate such cultures positively or negatively.

The basic function of an ethnic style is to create a coherent visual form that functions as a badge of identity within the group; by projecting the image of a self, ethnic style immediately implies the existence of others who do not belong. Ethnic styles create identity and difference through the for-

mal articulation of visual images, ranging from dress to architecture. Barth has noted that ethnic identity is not created once and for all. The dynamics of ethnic identity require all individuals to make continuous affirmations of their sense of belonging and of their culture's acceptance. In this process, visual symbols in works of art are essential, they are continuously needed, and are manufactured.

The meaning of styles as badges of identity has been wonderfully exploited in cartoons (fig. 5). The young lady in the *Punch* cartoon rejects her suitor solely because he is drawn in pre-Columbian style. The point of the joke is that we grasp the difference between the styles and identify with the style of the girl and her mama. In identifying with them we also do not see their style as consisting of arbitrary signs but as the normal representation of forms and concepts. Thus the essence of stylistic identification is to see our own style as natural

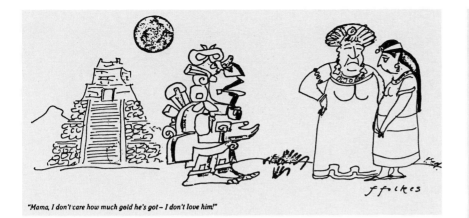

"Mama, I don't care how much gold he's got – I don't love him!"

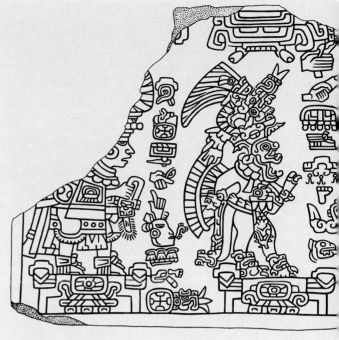

5. Cartoon, *Punch* magazine (London, 12 December 1984), 42

6. Monte Albán, Oaxaca, Mexico, Bazán Slab, classic period, stone relief
From Miguel Covarrubias, *Indian Art of Mexico and Central America* (Alfred A. Knopf, Inc. ©, New York, 1957), 153

7. Teotihuacán, Mexico, mural with figure wearing tasseled headdress, classic period
Fine Arts Museum of San Francisco, bequest of Harald J. Wagner 1985.104

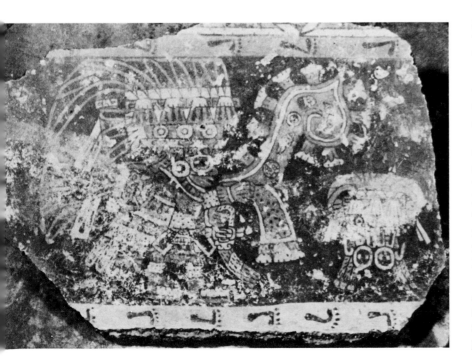

and the style of the other as artificial and literally unnatural, or against nature.

My attention was first drawn to the uses and meanings of ethnic styles by a few highly unusual works of Mesoamerican art that juxtapose two different styles, as if in a European painting one figure were in the style of Rogier van der Weyden and the other in that of Piero della Francesca. On the Bazán Slab, found at Monte Albán in Oaxaca, two figures are incised in stone (fig. 6). The figure in front is an anthropomorphic jaguar named 3 Turquoise. He is represented in flowing curvilinear lines. Behind him, 8 Turquoise is rendered in angular lines and shapes that approximate geometric forms such as squares, circles, triangles, and trapezoids. The figure of 8 Turquoise is represented in the style of Teotihuacán, a contemporary of Monte Albán, 350 kilometers from Oaxaca.[5] The Teotihuacán-style figure is very close to Teotihuacán priest figures found on mural paintings and pottery (fig. 7). Its identity is further indicated by a tasseled headdress glyph that may be either a name or rank, found in the column of glyphs before the figure on the Bazán Slab.

Although I consider such style juxtapositions theoretically and culturally highly significant, I must emphasize that they are very rare in Mesoamerican art. Nevertheless, I consider them symptomatic and therefore far more important than their rarity might suggest. Significantly, most are found in the classic period, a point to which I will return later.

A possible contemporary stela, dated A.D. 445, from the Maya city of Tikal, shows on its front the ruler Stormy Sky surrounded by curvilinear scrolls and masked personifications (fig. 8).[6] The side figures

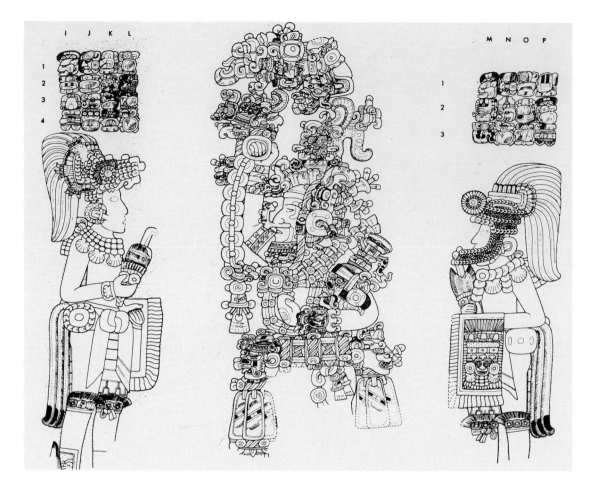

are wearing Teotihuacán costumes: feathered headdresses and shell necklaces. A tasseled headdress similar to the Teotihuacán representations is shown on the head of the deity on the shield (fig. 9). The central figure is clearly and entirely Maya in style. The side figures are composites: their linear simplicity and angular composition are close to Teotihuacán style, while the proportions and naturalistic details are Maya. The identity of the side figure is not clear, and it is unclear as well whether the two views are of one figure or two figures. He is described in much of the popular scholarly literature as an "ambassador" from Teotihuacán but more recently has been identified as the father of Stormy Sky, who may have originated from a Teotihuacán dynasty. Teotihuacán is nearly a thousand kilometers from Tikal.

What is significant in both instances is that two individuals are represented in different styles on the same work in order to indicate the ethnic groups to which they belong. This is very unusual in the history of Western art, and I could not find parallel examples in other cultures of what I am calling style juxtaposition. (I do not, of course, claim to be familiar with all of world art, and I hope that scholars in other fields will add to and modify these statements.) A cursory glance at the art of many parts of the world suggests that in almost all situations of culture contact, some effort is made to blend styles and create visual harmony rather than to exaggerate differences.

When the artists of Darius designed the sculptures of Persepolis, the vastness of the Persian empire was represented by tribute bearers from all corners of the realm, whose

8. Tikal, Guatemala, Stela 31, drawing of three sides, classic period, stone relief, 230 (90½) From Muriel Portes Weaver, *The Aztecs, Maya, and Their Predecessors* (New York, 1981), 289

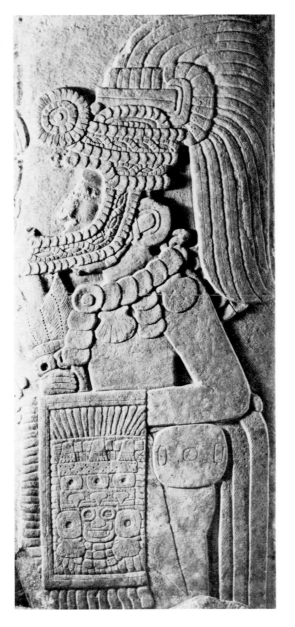

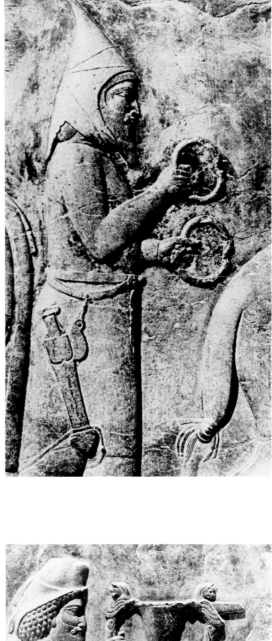

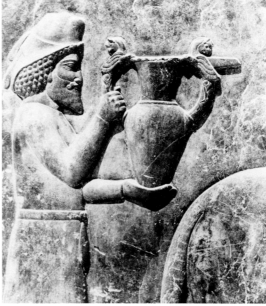

9. Tikal, Guatemala, Stela 31,
detail of figure in Teotihuacán
costume, classic period, stone
relief, 230 (90½)
From Michael D. Coe, *The Maya*
(London, 1980), fig. 42

10. Apadana, Persepolis, Iran,
Scythian tribute bearer from
eastern stairway, sixth/fifth
century B.C., stone relief
Photograph by Heinz Luschey, from
Erich F. Schmidt, *Persepolis* I (Chi-
cago, 1953), pl. 37

11. Apadana, Persepolis, Iran,
Armenian tribute bearer from
eastern stairway, sixth/fifth
century B.C., stone relief
Photograph by Luschey from Schmidt
1953, pl. 29

ethnic features and distinctive dress were
clearly delineated (figs. 10, 11).[7] However,
although the curly hair of the Armenians
and the peaked cap of the Phrygians were
faithfully represented, the figures were styl-
istically identical, and that style is clearly
what we call Achaemenid Persian. The em-
pire is visually evoked by the homogeneity
of the Achaemenid style, and the minor
differences of its subject peoples are rele-
gated to details. In the metaphor of lan-

guage, we could say the Persepolis reliefs proclaim that all of Persia speaks the same language, although its dialects are different. By contrast, the Bazán Slab represents a situation in which two languages of equal stature confront one another.

So far my discussion has focused on patrons and social contexts rather than the artist. There are few examples of artists working in both their home style and the style of an alien group, although with recent studies the list is growing. An example familiar to me is Gentile Bellini's portrait of a Turkish artist in the style of a Turkish miniature in the Isabella Stewart Gardner Museum, Boston.

Gentile Bellini, a Venetian, spent several months between 1479 and 1480 at the court of Mohammed II in Istanbul.[8] The sultan had asked for a portrait painter because he was enamored of Venetian art, and this cultural mission took place after the signing of a peace treaty between Venice and the sultan. Among works Bellini painted in his home style for the sultan is a royal portrait in oil, now in London (fig. 12). More unusual, however, is the little miniature, painted on parchment with pen and gouache, that looks surprisingly like a work of oriental art (fig. 13). We do not know what this means in the sense of the interaction between the two artists. Is it Gentile saying: "I can work just as well in your style!"? Is it Gentile's appreciation of Turkish art or of his friendship with this particular artist? The answers to these questions may lie either in the personal realm—the relationship between artists—or in the aesthetic realm—the play with different stylistic traditions for its own sake. Clearly the sultan did not commission Gentile Bellini to work in the Turkish style—the mere notion is absurd.

Another possible example of style juxtaposition in the work of a European artist is a drawing by Dürer in which a Venetian and Nuremberg costume are compared (fig. 14).[9] Erwin Panofsky described this drawing in terms of the concept of style opposition that was then current in art historical thinking:

. . . in one truly remarkable drawing he illustrated the fundamental difference between the Southern and Northern fashion by repre-

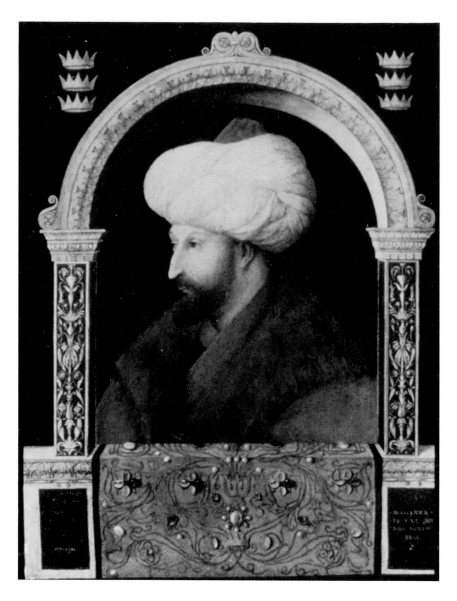

senting a Ventian gentildonna side by side with a Nürnberg Hausfrau. Everything wide and loose in the Italian dress is narrow and tight in the German one, the bodice as well as the sleeves and the shoes. The Venetian skirt is cut on what may be called architectural lines; the figure seems to rise from a solid horizontal base, and the simple parallel folds give an effect not unlike that of a fluted column. The German skirt is arranged so as to taper from the waist downward. The Italian costume accentuates the hortizontals (note the belt and the very form of the necklace), uncovers the shoulder joints and emphasizes the elbows by little puffs. The Ger-

12. Gentile Bellini, *Mahomet II*, oil, 70 x 50 (27½ x 19⅝) National Gallery, London

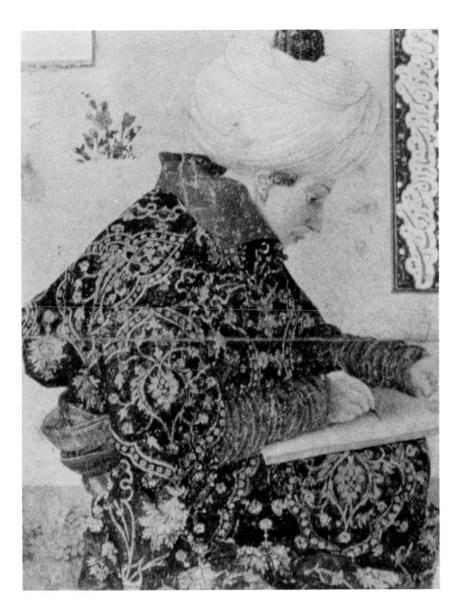

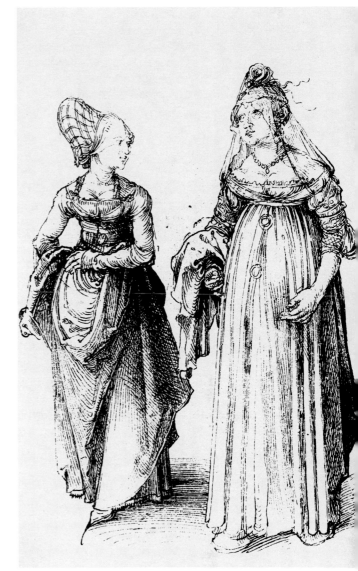

13. Gentile Bellini, *A Turkish Artist*, pen and gouache on parchment, 18.4 x 14 (7¼ x 5½)
Isabella Stewart Gardner Museum, Boston

14. Albrecht Dürer, *Venetian and Nuremberg Costume Compared*, undated, pen and ink, 24.5 x 16 (9⅝ x 6⁵⁄₁₆)
Städelisches Kunstinstitut, Frankfurt. From W. L. Strauss, *The Complete Drawings of Albrecht Dürer* I (New York, 1974), 273

man costume does precisely the opposite. The very idea of this juxtaposition might have been suggested by Heinrich Wölfflin. Dürer contrasted the two figures as the modern art historian would contrast a Renaissance palazzo with a Late Gothic town house; there is in fact another Dürer sketch, probably made on the occasion of his second trip to Venice (1582), where an analogous comparison is drawn between the ground plan of two central-plan buildings, one medieval and the other Leonardesque. In sum the costumes are interpreted not only as curiosities, but also as documents of style.[10]

Like the Gentile Bellini portrait of a Turkish artist, the Dürer drawing is a personal sketch and not a commission. It tells us a great deal about Dürer's psychology both as an artist and as an individual. Panofsky has shown that Dürer was the earliest German artist to take a trip to Italy and to try to bring Italian Renaissance styles and theories of art, which he saw as superior, to the north. His friends were aristocrats and intellectuals, and he became an artist in the southern tradition of humanists rather than in the northern tradition of craftsmen. The comparison in the drawing

is therefore skewed; the Venetian *gentil-donna* is meant to be superior and historically more modern than the Nuremberg *hausfrau*. Panofsky does not ask whether there is anything special in the political situation of Europe that results in such communications between artists and comparisons of styles. I find it striking that both Gentile Bellini and Albrecht Dürer are nearly contemporary, that Dürer stayed in Giovanni Bellini's house in Venice and copied paintings by Gentile Bellini, including one entitled "Turks,"[11] and that Venice had especially close connections with a non-European culture and had, too, a highly developed sense both of itself and of that Other. Neither does Panofsky ask why Dürer in particular should have been so interested in the issue of ethnic and cultural identity and comparison; he merely lets it go as a "curiosity."

What is unusual about the Mesoamerican works of art in which style juxtaposition is present is that they are public rather than private statements, and represent politically sanctioned attitudes toward style. The significance of style juxtaposition for Mesoamerica and for the study of style will be clarified by a brief look at Mesoamerica. Since most of the history of Mesoamerica is archaeological, we are used to speaking of its various cultures, some of which have been given ethnic names, such as Maya or Aztec; but for many cultures, such as Teotihuacán, the ethnic identity is not known. In terms of political organization most of the cultures in Mesoamerica were states, although we often have little detail about them. I shall use the term polity to refer to these states.

Mesoamerica is comparable to Europe in that it consisted of diverse ethnic groups speaking different languages and living in politically separate and independent states (fig. 15). Even the largest empire we know, that of the Aztecs, never conquered and controlled more than two-thirds of Mesoamerica, and at no time was the whole area politically unified (fig. 16). This is not unlike the situation in Europe, with Hitlers and Napoleons trying to unify it on occasion, but through most of its history the area has consisted of highly interactive but independent countries.

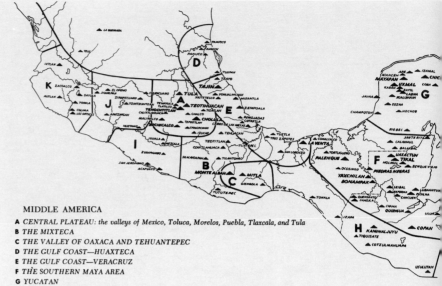

MIDDLE AMERICA

A CENTRAL PLATEAU: *the valleys of Mexico, Toluca, Morelos, Puebla, Tlaxcala, and Tula*
B THE MIXTECA
C THE VALLEY OF OAXACA AND TEHUANTEPEC
D THE GULF COAST—HUAXTECA
E THE GULF COAST—VERACRUZ
F THE SOUTHERN MAYA AREA
G YUCATAN
H THE PACIFIC COAST: *southern Chiapas, Guatemala, Honduras, El Salvador*
I WESTERN MEXICO: *Guerrero*
J WESTERN MEXICO: *Michoacán*
K WESTERN MEXICO: *Colima, Nayarit, Jalisco*

15. Map of Mesoamerica and its culture areas
From Miguel Covarrubias, *Indian Art of Mexico and Central America* (Alfred A. Knopf, Inc. ©, New York, 1957), 2

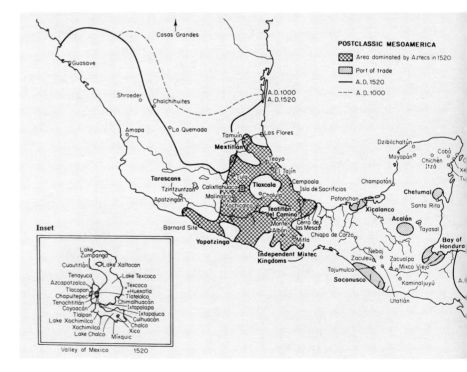

16. Map of postclassic Mesoamerica and the Aztec empire
From Muriel P. Weaver, *The Aztecs, Maya, and Their Predecessors* (New York, 1972), 198

The Aztec state became a conquest empire and tried to control a large part of Mesoamerica. This empire, however, was not a territorial empire, but what has been called a hegemonic empire.[12] Conquered territories outside the capital and heartland were allowed to retain their local rulers and customs, and in most cases Aztec colonists did not move in and settle among them. Conquered areas were expected to send tribute to their overlords, who depended on the raw materials, manufactured goods, or labor skills the areas possessed. Provinces frequently rebelled by not sending the agreed tribute, and the Aztec empire was constantly at war putting down rebellions. This is very different from the European concept of empire in which territory is overtaken, colonies are settled, languages may be changed, and an attempt made by the conqueror to impose his art and culture on the conquered. In the extreme case of Hitler, the conqueror sought to control even biology.

Because the Aztec empire was conquered by the Spanish in 1521, only about 150 years after its inception, it is difficult to know whether a more integrated imperial structure might have developed in time. It has been suggested that an integrated state did not develop in Mesoamerica due to physical constraints, such as the lack of draft animals for transport, essential both for commerce and war. The formation of an integrated state was also hampered by the nature of the Mesoamerican world view that saw the cosmos in a constant, ineluctable state of flux between creation and destruction. Whether the nature of Mesoamerican states and cultures was determined by material conditions or ideology is a complex question I shall not try to consider here. I am suggesting that the material and ideological contexts of Mesoamerica made unlikely the visualization of a stable, universal state.

The history of Mesoamerica is divided into three periods: the preclassic period from 1500 B.C. to A.D. 300, the classic period from A.D. 300 to 900, and the postclassic period from 900 to the Spanish conquest in 1521. The empire of the Aztecs existed during the latter half of the postclassic period.

In the classic period, Mesoamerica did not have a single major empire like that of the Aztecs. The largest and most influential state was that of Teotihuacán in central Mexico, about fifty kilometers northeast of Mexico City. Other important states were Monte Albán in Oaxaca, El Tajín in Veracruz, and Kaminaljuyu in the Guatemala highlands. The Maya of Yucatán, Guatemala, and Honduras lived in city-states, the most important of which included Tikal, Palenque, Piedras Negras, Copan, Uxmal, Dzibilchaltún, and Chichén Itzá (fig. 15).

Like Europe, Mesoamerica formed its own "known world" in Fernand Braudel's sense of the term, through shared customs and institutions. The states were associated with each other through long-distance trade in necessary items such as obsidian and grinding stones, as well as in luxury goods such as exotic feathers, shells, and greenstone. The elites of the different states frequently intermarried and were related by shifting alliances and wars. Although each state had its own customs, they all shared a similar calendar, religion, and world view. This is comparable to Christianity in Europe, which was a unifying force despite the great differences between Catholics and Protestants. The Maya area might be comparable to Renaissance Italy in comprising an area in which a single language and culture were widely shared, although it was politically fragmented into separate city-states. Teotihuacán, Monte Albán, and El Tajín were larger polities comparable to the emerging nation-states in the Renaissance, such as England or France, in each of which there was a different spoken language and a different sense of ethnic identity.

George Kubler discussed the characteristic architectural profile associated with each of the major polities in classic Mesoamerica (fig. 17).[13] He suggested that these were similar to the classical orders, and if we think of the orders as having different origins, rather than different symbolic functions, that is a good parallel. However, the architectural profiles in Mesoamerica never served different purposes at the same site, and they were more rigidly polity-related than the Greco-Roman orders. Until the classic period, pyramid profiles consisted of simple vertical or sloping sides. In the classic period each platform stage was articulated into two or more segments, consisting of vertical, horizontal, and diagonal

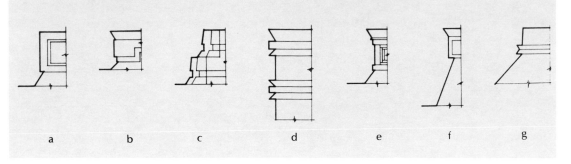

a. *the tablero-and-talus, Teotihuacan*
b. *the dentated profile of Monte Albán*
c. *the slanted and undercut profile of the southern Maya lowlands*
d. *the binder molding of the northern Maya provinces*
e,f. *the outsloping cornices of Tajin (e), and Xochicalco (f)*
g. *the double-sloped balustrade of Aztec architecture*

a b c d e f g

17. Comparison of Mesoamerican architectural profiles
From George Kubler, "Iconographic Aspects of Architectural Profiles at Teotihuacán in Mesoamerica," in *The Iconography of Middle American Sculpture* (New York, 1973), 34

sections. The tropical sun striking these forms directly from above creates high contrasts of light and dark, making them effective from a distance.

At Teotihuacán the pyramid stages were divided into a sloping *talud* and a rectangular panel with an inset called a *tablero*, creating a series of horizontal forms (fig. 18). At Monte Albán the *tablero* consists of overhanging square panels, emphasized

18. Teotihuacán, Mexico, platform with talud-tablero profile, classic period, stone
Author photograph

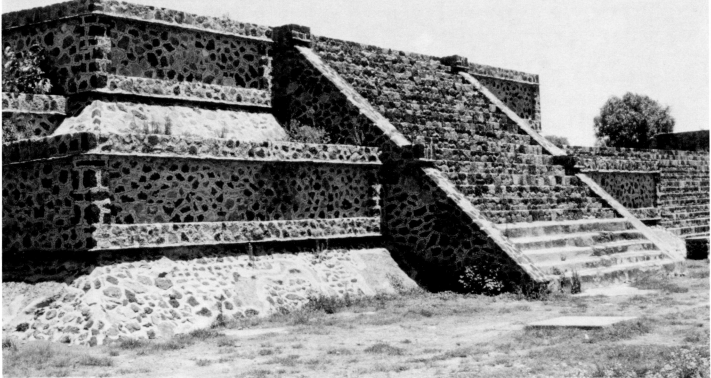

19. Monte Albán, Oaxaca, Mexico, temple model, classic period
Museo Nacional de Antropología, Mexico City. Photograph by Vincent Phillips

20. Tajín, Vera Cruz, Mexico, Pyramid of the Niches, detail, late classic period
Photograph by Marvin Cohodas

on the corners where they create definite ends, thus avoiding the monotony of the horizontal Teotihuacán forms (fig. 19). In Veracruz at El Tajín, a flaring cornice, reversing the line of the *talud*, is added on the *tablero* (fig. 20). Among the Maya there is variability from site to site, but in general a sloping *talud* usually has other sloping elements such as apron moldings on top of it, avoiding the more dramatic contrast of a *tablero* (fig. 21). The presence of inset corners and continuous sloping lines emphasizes the vertical forms. The greatest contrast in style is between Teotihuacán and the Maya.

For hundreds of years these profiles were characteristic of important structures in these areas, and they appear to have been visual symbols of identity and belonging, like the dress of Guatemalan villagers today. So clear are these conventions that a building in an alien style at a given site is generally believed to represent a foreign conquest or an interaction of similar magnitude. An example is the small shrine with a characteristic Veracruz profile at the Maya site of Tikal, which stands out as highly unusual (fig. 22).

Of particular interest is that such articulated profiles were unknown in the preclassic period and were much less developed in the postclassic era. Both in preclassic and postclassic periods platforms generally had simple sloping stages without elaborate articulation, although Aztec temples have a characteristic balustrade form. This suggests that in the classic period, for some reason, ethnic and polity differences were so important that identifying symbolism evolved even in architecture. In other words, architectural profiles in Mesoamerica appear to have been symbolic of polity identity in some periods, but not all, suggesting that the visualization of group identity is not always equally important in societies and that its presence needs explanation.

It is notable that in Mesoamerica of the classic period a large number of coexisting, separate, ethnic groups came into intensive and extensive contact with one another. Despite the intensive contact, the maintenance of cultural differences appears to have been a major concern. The Dürer drawing discussed earlier makes clear the

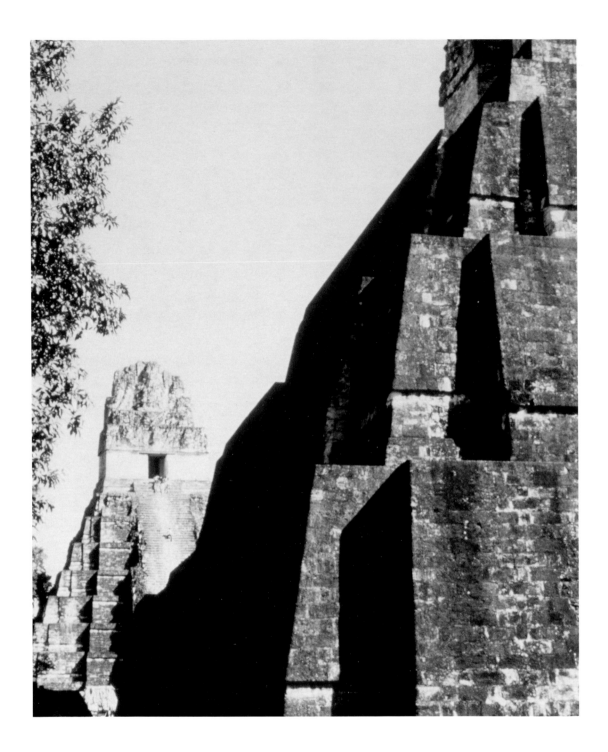

different situation in Europe: Dürer casts the Venetian lady as superior to the Nuremberg one because of the superiority of Italian style. There is no suggestion that for Dürer art style is related to politics or religion, and that by espousing Italian style he is also espousing Italian politics or religion.

The Bazán Slab and Stela 31 from Tikal were made in a context of localism and cosmopolitanism where the differences between groups were seen as unbridgeable. The origin of a person is depicted not just in dress but in the style of the entire figure. On a structural level this implies that we cannot read a common denominator, such

21. Tikal, Guatemala, Temple II, detail showing inset corners and moldings, classic period
Author photograph

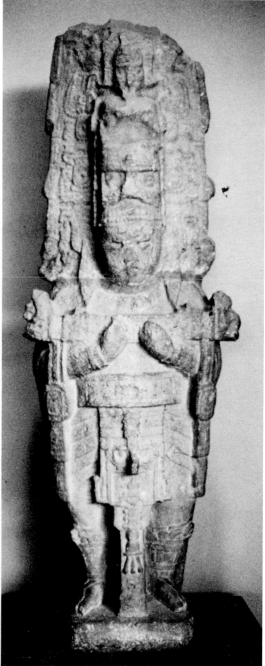

22. Tikal, Guatemala, central acropolis, Structure 5D-43, classic period
Photograph by Fred Werner

23. Tonina, Chiapas, Mexico, stela, classic period
Museo Nacional de Antropología, Mexico City. Author photograph

as "man" into the Bazán Slab. Man is inseparable from "Teotihuacán man" or "Monte Albán man." In classic Mesoamerica there is an unusually strong sense of the difference between the self and the other, which is seen as being practically insurmountable. Like the maiden and the suitor in the cartoon, marriage is not possible because the figures inhabit different visual worlds. Mesoamerica in the classic period therefore appears to have considered ethnic units as basic and immutable and to have created rigid barriers in order to maintain them. In this view, style was inseparable from society, politics, and probably even linguistic or biological roots.

Further proof of the association of style and ethnic identity in Mesoamerica are two conquest monuments in alien styles. The style of the Maya city-state of Tonina is characterized by an unusual emphasis on three-dimensional forms (fig. 23). It was therefore surprising to find in the Tonina excavations a monument in the low-relief style of Palenque (fig. 24).[14] Recent breakthroughs in the decipherment of Maya hieroglyphic writing have made it possible to identify these personages. The Palenque style relief at Tonina represents the Palenque ruler Kan Xul taken prisoner at Tonina and probably sacrificed there. Tonina commemorated the coup by a relief in which

the Palenque ruler was represented in his home style. We do not know how this was done: a Tonina artist may have imitated Palenque style, or a Palenque artist may have been made to carve the relief as an added humiliation. I find the second possibility intriguing. Sixteenth-century sources

tell us that when the Aztecs defeated a polity they often asked the conquered people to build roads and causeways or other projects as a form of tribute. Sometimes they did this if the polity was well known for its building crafts.[15]

Linda Schele and Mary Miller have suggested that Piedras Negras Stela 12 is very likely a monument carved by a Pomona artist to represent the Piedras Negras conquest of Pomona (fig. 25).[16] They cite as evidence the unusually individualized and even sympathetic portrayal of the victims bound by ropes (fig. 26). It would seem that in Mesoamerica it was possible to capture not only prisoners but also styles. Further, it would seem that at this time there was no concept of stylistic assimilation or of a "melting pot," just as there was no concept of a territorial empire. Alien groups may have been conquered and made to send tribute, and their leaders may have been killed and sacrificed, but there was no attempt to destroy the land, culture, or style of the Other either by incorporation or annihilation. Despite all the warfare and the sacrifice of individuals, the right of the Other to exist as a group was continuously validated and maintained. We might even say that erecting a Palenque-style conquest monument at Tonina was a reaffirmation of the continued separate existence of Palenque. Palenque was not wiped out visually; it was humiliated but maintained with the understanding that at some future time it might be victorious over Tonina.

Until recently, the Palenque-style relief at Tonina would have been attributed to the "influence" of Palenque, based on a European-derived art history in which style had been seen as advancing aggressively on its own like a conquering army. Michael Baxandall has shown that this view reverses actual events, since the influenced party is in fact the active agent. He demonstrates the complexity and richness of this process by the words available to describe it: ". . . draw on, resort to, avail oneself of, appropriate from, have recourse to, adapt, misunderstand, refer to, pick up, take on, engage with, react to, quote, differentiate oneself from, assimilate oneself to, align oneself with, copy, address, paraphrase, absorb, make a variation on, revive, continue,

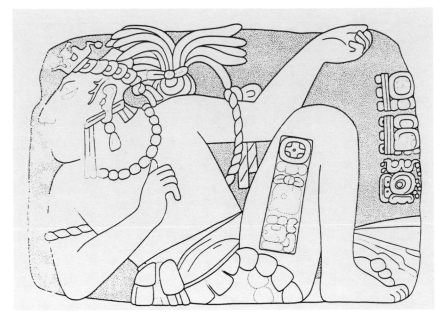

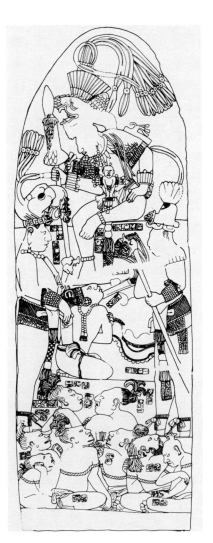

24. Tonina, Chiapas, Mexico, Monument 22, drawing in Palenque style, classic period
From P. Becquelin, et al., *Tonina, Une Cité Maya du Chiapas (Mexique)* (Mexico, 1982), 1355

25. Piedras Negras, Guatemala, Stela 12, A.D. 795, drawing by Linda Schele
Philadelphia University Museum. From Linda Schele and Mary Miller, *The Blood of Kings* (Fort Worth and New York, 1986), 219

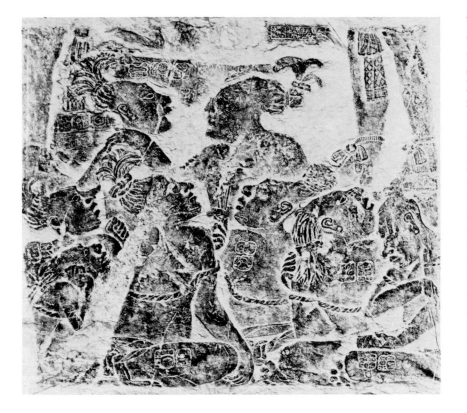

26. Piedras Negras, Stela 12,
A.D. 795, detail, rubbing of
prisoners
From Merle Greene, et al., *Maya
Sculpture* (Berkeley, 1972), pl. 16

remodel, ape, emulate, travesty, parody, extract from, distort, attend to, resist, simplify, reconstitute, elaborate on, develop, face up to, master, subvert, perpetuate, reduce, promote, respond to, transform, tackle."[17] I have quoted him in full because this wonderful list of words expresses primarily the various modifications interactions are expected to induce, and allows little room for situations of juxtaposition in which the aim is not to modify but to maintain as is. Baxandall's language is incorporative in the traditon of European art history.

Art and theories of art are related to larger social and political contexts, and I would like to illustrate the Mesoamerican preoccupation with the maintenance of the Other, as this is seen in art and style, with the example of an Aztec custom. The concept of the maintenance of the Other goes to the extreme of preserving the enemy; it can be seen in one of the Aztec institutions most incomprehensible to the Western mind: "flowery war." According to sixteenth-century histories, this institution was

begun under Motecuhzoma I when the Aztec empire was so large and consolidated that wars were fought far from home. Since one of the aims of war was to bring victims home for ritual sacrifice, the lack of warfare near home created a problem. This was solved by a mutual agreement with the polity of Tlaxcala, never conquered but close to the capital, to hold periodic ritual wars. Battles were declared at an appointed place so both sides could take prisoners. These wars were considered good training ground for soldiers, but clearly this aspect was secondary. Although the sixteenth-century texts suggest that the Aztecs invented the practice, this is historical fiction. There is evidence that the practice existed earlier among the Chalca, and it very likely existed in different forms at different times and places.[18] In the flowery war it was more important to capture victims to sacrifice than to conquer and control an alien group and territory. Indeed, there was a positive commitment to the preservation of different ethnic groups, since the victim needed to come from an alien group.

We still do not know what mechanisms and institutions in classic Mesoamerica allowed for the reasonably stable period of six hundred years in which these highly individual and distinctive cultures flourished with a maximum of interaction without the breakdown of barriers. I would like to suggest that some of the interaction between groups may have been highly organized and perhaps ritualized. The extensiveness of the interaction was, in my view, a critical aspect of this period. The exchange of trade, ideas, and perhaps even personnel is evident everywhere and seems to account for the signs of wealth and florescence. This exchange did not occur without war, but it was limited and neither drastically changed the status quo nor altered the territorial situation.

I have long been intrigued by the Mesoamerican ball game, and wondered what political and economic circumstances fostered the development of this institution. Although this game was played throughout Mesoamerican history, from the point of view of related architecture and sculpture, it was most important in the classic period.[19] At that time most sites had at least

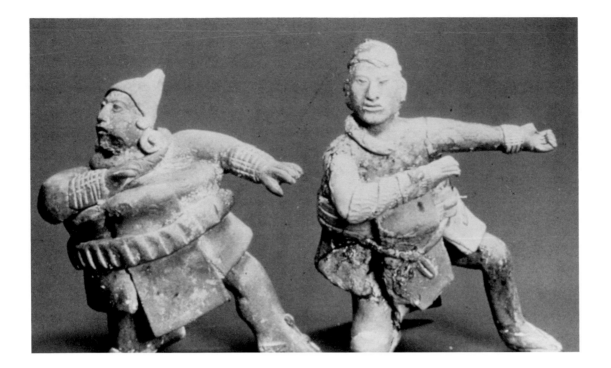

one masonry ball court, and some had nine or more. Moreover, ball players were frequently represented on monumental sculpture as well as on pottery and figurines (fig. 27). The characteristic thick padding they wear and their special playing postures make them easily recognizable. The game, a team sport, was played with a solid rubber ball hit by the hips, knees or elbows. A number of reliefs indicate that the ball game was important ritually and carried a sacrificial aspect. Ball players are shown decapitated, sometimes with flowering vines emerging from their necks, as though some symbolism of cosmic regeneration were suggested by the game (fig. 28). Frequently the two teams shown on the reliefs represent different ethnic types and costumes, although in this example they are not in different styles (figs. 29, 30). On this Chichén Itzá relief, a team with mosaic collars faces a team with shell necklaces. The teams have sometimes been said to represent ethnic groups; historical events, such as a conflict between the Maya and the Toltec;[20] or ritual groups divided into teams representing the cosmic forces of light and dark.[21] I will not try to determine whether these players represent certain ethnic groups or ritual performers. But it is relevant that through ethnic dress the two teams are visualized as separate and distinct.

We know the ritual and mythic aspects of the ball game from the *Popol Vuh*, a Quiche Maya book from the colonial period.[22] The story of the ball game follows immediately the description of the creation of the world, and is therefore placed in a privileged context. Two brothers, the hero twins of the story, play ball on the surface of the earth, angering the lords of the underworld who envy their playing gear. The lords invite them to play ball in the underworld, planning to kill them. Before the ball game, the twins must stand various trials, each of which they lose, and after finally losing the game, they are decapitated. The head of one brother is placed on a calabash tree, and the tree miraculously bursts into fruit. A maiden of the underworld passes by and becomes pregnant from the spittle of the skull. When the lords of the underworld discover her pregnancy, they are extremely angry and banish her. She goes up to the world and resides with the old grandmother of the original twins until

27. Jaina style, Mexico, ball player figurines, classic period
Museo Nacional de Antropología, Mexico City

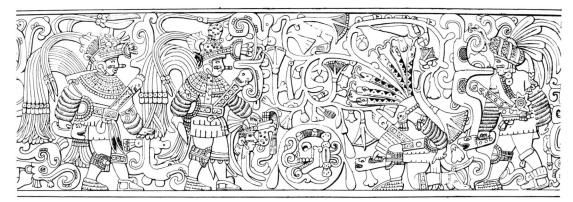

28. Chichén Itzá, Yucatán, Mexico, central section of great ball court relief, drawing
From Ignacio Marquina, *Arquitectura Prehispanica*, Instituto Nacional de Antropología e Historia (Mexico City, 1964), pl. 266 top

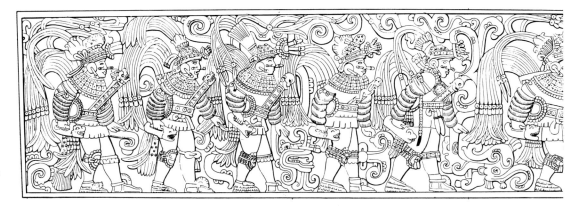

29. Chichén Itzá, Yucatán, Mexico, detail of ball players of the team with mosaic necklaces, drawing
From Marquina 1964, pl. 266 center

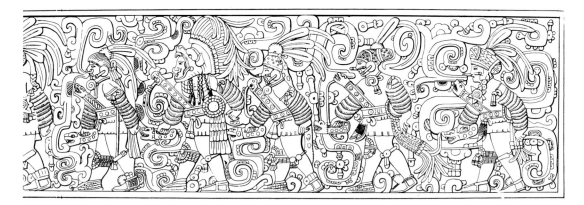

30. Chichén Itzá, Yucatán, Mexico, detail of ball players of the team with shell pendant necklaces
From Marquina 1964, pl. 266 bottom

she gives birth to a second set of twins, who are the heroes reborn in magic guise. They too play ball and are invited into the underworld by the lords of death, but this time they have various magic tricks and succeed at all the impossible trials. Finally, they show the lords of death that they are masters over life and death when one hero cuts up the other and brings him back to life. The lords of death ask that the same be done to them, too, and of course the twins do not bring them back to life. The story ends with the hero twins ascending into the sky and becoming the sun and the moon.

It is accepted that this Maya version of the harrowing of hell is a cosmic parable with two parallel stories: the first ball game in which the lords of death are victorious and the second in which the lords of life—the sun and the moon—are victorious. In each, victory is at the expense of the other, who dies. These zero-sum games are consistent with the widespread Mesoamerican belief that all cosmic forces are cyclical: the sun is defeated by the forces of darkness when it enters the earth at sunset in the west, and the forces of darkness are defeated by the sun reborn every morning in the east. Each alternation represents a birth and a death. Although the story has a happy ending, the implication of course is that this cycle never ends. A second aspect of the myth is the blooming of the tree in the underworld when the decapitated head is placed on it, expressing the necessity of the first deaths: the sacrificial death of the heroes brings forth the resurgence of nature and the rebirth of the forces of light.

It is very likely that some ritual games ended with sacrificing a member of the losing team, and that the game was a reenactment of the myth with the players representing the forces of light and darkness. The winners and losers were probably thought to have been selected by the gods and therefore were preordained. The game could have been played by different teams in the home city, but I think it possible that in the classic period games might have been played between ethnic groups as well. The representation of different ethnic associations on the reliefs suggests this much. Some sources in the sixteenth century indicate that in certain situations instead of fighting a war to determine who pays tribute to whom, a ball game was played. Rulers are shown confronting each other within a ball court in a scene in the *Codex Nuttall*.[23] I am suggesting that the ritual ball game served to channel hostile ethnic competitiveness, in order to obtain sacrificial victims from alien ethnic groups, while at the same time fostering interaction, trade, and other activities concurrently with the games. The ball game may have been one of several ritualized mechanisms for interaction and exchange among ethnic groups in Mesoamerica that nonetheless maintained separation and even hostility.

Writing about the modern Maya villagers of Chiapas in Mexico, Henning Siverts stated that their cultural differences are "over-communicated," a term that is apt for classic Mesoamerica.[24] This is evident in the presence of clearly defined polity styles and architectural orders that are unique to certain groups. Unusual representations, such as style juxtapositions and the use of an alien style to represent conquered individuals, indicate that style is not considered a "manner" superimposed on things and traveling separately on its own, but part of the essential nature and reality of things.

Mesoamerican art is not simply different from Western European art, but it developed in the context of a different understanding of style. There is a possibility that the uses and meanings of style as a whole differ greatly between groups and at different times in the same group. Similarly, our own concepts of style as art historians and archaeologists are part of a specific European tradition of understanding the nature of style. The practice and theory of style therefore exist together and reinforce one another. When Paul Wingert taught African art from the perspective of style area in a way that was so handy for students, that concept was not intrinsic to the material, but was an artifact of European thought derived from the notion of folk and national styles characteristic of European culture. Future art historians interested in this subject may find significant differences between the theory and behavior of styles in various parts of the world. Such research might add new dimensions to art history as a discipline.

It is not my purpose here to describe our own concepts or style except by way of brief illustration. As Westerners, we tend to value highly distinct and formalized styles and to feel uncomfortable with indefinite ones. The styles of the non-Western world have been defined from this perspective as "tribal" and "cultural" styles. Rather than seeing these as normal to societies, such group styles need to be regarded as specific reactions to certain circumstances that have practical economic and political dimensions. "Tribes" and "chiefdoms" and the making of ethnic maps were largely the creation of colonialist administrators for the purposes of political and economic control. In effect, these colonial governments created clear boundaries whether they existed or not, thereby creating a situation in which some groups, previously not clearly defined, could, if they wished, nurture and emphasize their own tribal identity through art and ritual. Other tribes, upon being separated into different European colonies, and speaking different European languages, also began a process of cultural differentiation and separation. On the basis of the material remains discovered through archaeological excavation, Mesoamerica appears to have had a more rigidly defined sense of stylistic boundary than many other parts of the world, including Western Europe.

On the basis of this rather briefly sketched material, I would like to conclude with a few hypotheses:

Ethnic or polity styles emerge primarily as a way of dealing with others, and their main purpose is the creation of difference. The socio-political conditions essential for them is the close proximity of other independent groups with whom there is interaction that probably includes competition and hostility. This condition can exist on the tribal village level, as in many areas of Africa; on the peasant folk level, as in the Guatemala highlands; on the state level as in Mesoamerica; and on the level of the nation-state.

Such group styles are therefore not linked to any developmental stage of culture, such as folk or tribal cultures, but are linked to the patterns of interaction between centers among the cultures. For example, in preclassic Mesoamerica, when states and chiefdoms were few and just emerging, polity styles were not highly developed. In fact, many of the high-status items in different centers were similar, suggesting that the elite were sharing objects for ritual and prestige.[25] Group styles are clearer in the pottery and figurines on the village level, suggesting that interaction between villages was highly structured and defined. By A.D. 300, ethnic styles existed on the level of state polities.

Ethnicity has been of great intellectual interest in the last twenty years. In 1955 Nikolaus Pevsner still attributed the "Englishness of English art" to language and the misty weather, otherwise accepting the immutability of national style and character.[26] It has now become fashionable to talk about the invention of traditions everyone once felt were buried in antiquity. Hugh Trevor-Roper's analysis of the Scottish tartans widely believed to be clan symbols is a very fine example of such intellectual unmasking.[27] He has shown that the clan tartans were introduced by an English industrialist and were later elaborated into named designs by textile firms competing for business. The tartans were associated with spurious texts about the antiquity of the highland Scot tradition by various individuals. Some of these individuals always knew that the antiquity of the tartans was bogus, while others involved in the creation of the myth believed it themselves. What Hugh Trevor-Roper does not ask is why the clan tartans became so popular, since correct information was always available and many voices were raised against the collective tartan-"hallucination." Although Scotland is not my story here, it is evident that for various economic and political reasons Scotland needed an ideology and visual indicators of ethnic identity so much that even the spurious would do. Siverts has shown in the case of the Indians of Chiapas that the nature of ethnic symbols may change and may even incorporate alien elements. The Chamula use as Indian a costume derived from a French grenadier's uniform introduced under Maximilian in 1862.[28]

Some of the most perceptive work on ethnicity and society has been undertaken by anthropologists and sociologists. Fredrik Barth has shown that "ethnic distinctions

do not depend on an absence of mobility, contact, and information," and he considers simplistic the view that geographical and social isolation have been critical in sustaining cultural diversity. Instead, he suggests that ethnicity is intentionally created *despite* contact between groups. He recommends focusing on the boundaries that separate groups, through which a steady stream of contact is structured in such a way that the ethnic identity of both sides is preserved. Ethnicity for Barth means the maintenance of boundaries; and he suggests that the ethnic boundary defines a group rather than the cultural stuff it encloses.[29]

Abner Cohen has analyzed the ways in which Hausa traders in West African cities maintained their ethnicity.[30] In brief, his study suggests that the development of clear ethnic identity and culture was of great economic and practical value for the Hausa living within the ethnically very different Yoruba towns. In the creation of ethnicity he singles out the creation of distinctiveness through art and myth, a shared ideology, and patterns of communication, authority, and discipline. He supports Barth's view that ethnicity is not static once it is achieved, but survives only if individuals are constantly making personal commitments to it throughout their lives.[31]

The following are my hypotheses about the nature of the relationship between art and ethnicity:

Cultural Dimensions of Ethnic Art Styles

All peoples and cultures do not automatically evolve ethnic styles. Such styles emerge only when external articulation of ethnic identity is necessary for a variety of political and economic reasons. Although information is often lacking or may not be recoverable, various lines of evidence have shown that ethnicity in art and ideology is tightly related to practical and material aspects of society, and is a strategy for survival.

Formal Aspects of Visual Identity; Articulation and Standardization; the Creation of a Brand Image

Visual forms are essential in the realization of ethnic identity both on political and personal levels. In the arts the forms may include anything from architecture to dress. Characteristically, visual distinctions are made through articulation—the manipulation of forms so they result in distinct, clear units, easily remembered, recognized, and repeated—and through their repetition, once the forms have become standardized. They may be the result of increasing complexity, or of the simplification of forms. Good examples are the pyramid profiles in Mesoamerica or the various Guatemalan weaving patterns.

The Overt Meaning Given to New Forms—a Mythical Historic Identity

As has been mentioned briefly, the actual forms used to create ethnic identity may be borrowed or historically bogus, as in the case of the Scottish tartans, which in no way lessens their effectiveness. Such forms, whether architectural orders or patterns, are associated with a mythology of meanings. The foremost of these meanings concerns antiquity. The forms used are said to be ancient, ancestral, and proper, and are meant to embody the identity of the group from time immemorial. This is a form of validation through history.

The Covert Meanings of Ethnic Styles— Competition and Difference

While the articulated forms ostensibly are looking backward to an authentic past, covertly they are also looking to a present occupied by other ethnic groups or polities similarly creating images of themselves and trying to be distinct from their neighbors. These social relations are often competitive and hostile; and many ways of showing ethnic distinctness are oppositions: curves oppose straight lines, verticals oppose horizontals, life forms oppose geometrics, three-dimensionality opposes two-dimensionality. Such patterns of oppositions can be found on a variety of levels from the national to the individual, and are as true of the Bazán Slab as of the Dürer drawing.

Ethnic Art Styles Result from Interaction, Not Isolation

Cultural and ethnic art styles as defined above are the physical representations of the complex boundary between a polity and its neighbors. The *talud tablero* of Teotihuacán represents not Teotihuacán, but Teotihuacán in relation to its past and its contemporary neighbors in Oaxaca, Veracruz and Guatemala. Isolated peoples, whether New Guinea highlanders or Iowans, are not known for their highly developed ethnic styles.

Theoretical Concepts of Style

Although a few generalizations can be made about ethnic styles at present, the issue is complicated by the fact that different historical traditions have different understandings of style in general; styles, therefore, do not behave in the same way from culture to culture. Because of the high development of European art history, its theoretical models hold a privileged position and are generally believed to be universal. The European concept or style, including the concept of influence or borrowing and the gradual annihilation of old styles by newer styles, is an evolutionary paradigm that may be related to European patterns of politics, war, and a theory of history. If there are any universal patterns and functions of stylistic behavior in art, these are yet to be discovered. A comparative analysis of the practice and theory of style in various other cultures might provide the factual information on which such a theory could be based. I hope that this study of ethnicity in Mesoamerican art is a step in that direction.

1. Paul S. Wingert, *Primitive Art: Its Traditions and Styles* (New York, 1962).

2. Franz M. Olbrechts, *Plastiek van Congo* (Antwerp, 1946).

3. Mary G. Dieterich, Jon T. Erickson, and Erin Younger, *Guatemalan Costumes* [exh. cat., The Heard Museum] (Phoenix, 1979). Anne P. Rowe, *A Century of Change in Guatemalan Textiles* [exh. cat., The Center for Inter-American Relations] (New York, 1981).

4. Fredrik Barth, ed., *Ethnic Groups and Boundaries: The Social Organization of Culture Difference* (Boston, 1969), 9–38.

5. Kent V. Flannery and Joyce Marcus, *The Cloud People: Divergent Evolution of the Zapotec and Mixtec Civilizations* (New York, 1983), 179.

6. Christopher Jones and Linton Satterthwaite, *The Monuments and Inscriptions of Tikal: The Carved Monuments, Tikal Report no. 33* (Philadelphia, 1982), 64–74.

7. Michael Roaf, "The Subject Peoples on the Base of the Statue of Darius," in *Cahiers de la Délégation Archéologique Française en Iran* (Paris, 1974), 73–160. Erich F. Schmidt, *Persepolis* (Chicago, 1953).

8. Howard F. Collins, "Gentile Bellini: A Monograph and Catalogue of Works" (Ph.D. diss., University of Pittsburgh, 1970).

9. I would like to thank Professor Egon Verheyen of George Mason University for bringing this drawing to my attention.

10. Erwin Panofsky, *The Life and Art of Albrecht Dürer* (Princeton, 1943), 36.

11. Panofsky 1943, 36.

12. Ross Hassig, *Trade, Tribute, and Transportation* (Norman, 1985).

13. George Kubler, "Iconographic Aspects of Architectural Profiles at Teotihuacán and in Mesoamerica," in *The Iconography of Middle American Sculpture* (New York, 1973), 24–39.

14. Pierre Becquelin and Claude F. Baudez, *Tonina, Une Cité Maya du Chiapas, Mexico, Mission Archéologique et Ethnographique Française au Mexique* (Mexico City, 1982).

15. Esther Pasztory, *Aztec Art* (New York, 1983), 52.

16. Linda Schele and Mary Miller, *The Blood of Kings: Dynasty and Ritual in Maya Art* [exh. cat., Kimbell Art Museum] (Fort Worth, 1986), 219.

17. Michael Baxandall, *Patterns of Intention* (New Haven, 1985), 59.

18. Nigel Davies, *The Aztecs* (London, 1973), 324.

19. Esther Pasztory, "The Historical and Religious Significance of the Middle Classic Ball Game," in *Religion in Mesoamerica, XII Mesa Redonda, Sociedad Mexicana de Antropología* (Mexico City, 1972), 441–455.

20. Alfred M. Tozzer, "Chichén Itzá and Its Cenote of Sacrifice: A Comparative Study of Contemporaneous Maya and Toltec," in *Peabody Museum Memoirs*, vols. 11 and 12 (Cambridge, 1957).

21. Marvin Cohodas, "The Great Ball Court at Chichén Itzá, Yucatán, Mexico" (Ph.D. diss., Columbia University, 1978).

22. Dennis Tedlock, *Popol Vuh: The Definitive Edition* (New York, 1985).

23. Zelia Nuttall, ed., *Codice Nuttall* (Mexico City, 1974), 80.

24. Henning Siverts, "Ethnic Stability and Boundary Dynamics in Southern Mexico," in Barth 1969, 101–116.

25. David Grove, "The Olmec Horizon" (Paper presented at the Symposium on Pre-Columbian Horizon Styles, Dumbarton Oaks, Washington, D.C., 1987).

26. Nikolaus Pevsner, *The Englishness of English Art* (New York, 1955).

27. Hugh Trevor-Roper, "The Invention of Tradition: The Highland Tradition of Scotland," in *The Invention of Tradition*, eds. Eric Hobsbawm and Terence Ranger (London, 1983), 15–42.

28. Siverts in Barth 1969, 111.

29. Barth 1969, 16.

30. Abner Cohen, *Custom and Politics in Urban Africa: A Study of Hausa Migrants in Yoruba Towns* (Berkeley, 1969).

31. Barth 1969, 73.

EVELYN B. HARRISON
New York University

Hellenic Identity and Athenian Identity in the Fifth Century B.C.

What I am going to discuss might rather be called "ethnic" than "cultural" identity, though it is mostly features of cultural differentiation that serve to express such identity in art. The word *ethnos* to the ancient Greeks implied a smaller unit than what we would think of as an ethnic group today.

We could take as an example the dedication of a bronze four-horse chariot group that Herodotus saw on the Acropolis at Athens around the middle of the fifth century B.C. He quotes the epigram: Having overcome the *ethne* of the Boeotians and Chalcidians in deeds of war, the sons of the Athenians (*paides Athenaion*) quenched their arrogance with iron chains and dedicated these horses to Pallas Athena as a tithe of the proceeds.[1]

This happened in 506 B.C., when the new Athenian Democracy was trying to establish itself. The Athenians ransomed the prisoners for two minas a head and hung up the chains on the Acropolis alongside their gift to Athena. The Boeotians and the Chalcidians were close neighbors of Athens, Boeotia immediately to the north and Chalcis just across the narrow Euboean strait. Both neighbors had been egged on by the Spartans, who felt that Athens needed her wings clipped. These were all different *ethne*, but they were all Hellenes and they all spoke Greek.[2]

In Aeschylus' *Persians*, performed in 472 B.C., the messenger describing the battle of Salamis to the Persian queen says: "The whole fleet swept out and you could hear a great cry: *O paides hellenon ite*: 'On, sons of the Hellenes, free your fatherland!'"[3] Here Athenians and Spartans are arrayed together against the Persians, and their larger identity as Greeks is what counts.

When this battle was being fought, in the autumn of 480 B.C., the Persians had already taken Athens and burnt the temples on the Acropolis.[4] This conflagration is among those that archaeologists are accused of liking because the destruction levels form a good basis for chronology. For the Athenians, the trauma of their burnt city left a burning hatred of the invaders and a desire to keep the memory of their outrage alive forever. In the land battle of Plataea a year later, Athenians and other Hellenes fought under the leadership of the Spartan king to drive the Persians out of mainland Greece.[5]

These events mark the boundary between the archaic and the classical periods of Greek art. This is not the place to try to define the essence of the classical style or even to say what was mainly responsible for its genesis, but it seems clear that the desire to express ethnic identity had something to do with it. We might just look at some of the phenomena.

Late archaic Greek art is richly decorative and seems to express admiration for a rich style in life as well as in art; voluminous garments of fine material—thin linen

dresses or tunics underneath, and cloaks of soft, fine wool draped over or wrapped around them—are clearly related to similar fine clothing that had been portrayed in Near Eastern sculpture for many centuries past.[6] We find the same kind of richness in Egyptian art except that owing to the heat in Egypt the mantles as well as the dresses were usually of linen.[7] In Greece older men and the more dignified male gods wore these long white garments.[8] We generally call this rich archaic dress "Ionian," and indeed it must be especially via the Ionian cities that Near Eastern fashions reached the mainland. Contacts with Egypt, too, were especially plentiful in Ionia, though finds of pottery in Egypt show that Athens and Sparta contributed to the trade.[9]

A fashion of wearing a thin mantle diagonally draped over a linen dress, perhaps as a festival dress for maidens, migrated from Samos and the coast of Asia Minor to the Greek mainland in the second half of the sixth century (fig. 1),[10] and we find even the warrior goddess Athena wearing this dress in Athens. Here, in a votive relief from the Acropolis, Athena receives the sacrifice of a pig from an Athenian family (fig. 2).[11]

In one of the earliest figures of Athena from the Acropolis that dates after the Persian sack, the goddess looks quite different (figs. 3, 4).[12] Here she is wearing what we commonly call a peplos, because the Athenians used that name for the robe that they gave to Athena at the Panathenaic festival. We know that the Panathenaic peplos was a simple rectangle of cloth, not a shaped or sewn garment. In later times it was displayed like a sail on the processional ship, and it may well be that there were different ways in different periods of putting it onto the statue of the goddess, sometimes draped like a cloak, sometimes pinned on like a dress, or perhaps even pinned over the dress on both shoulders and hanging down the back like a cape. It was always made of wool and had elaborate figures, even mythological scenes, woven into it. These could have political significance. In the fourth century B.C. the design of the peplos had to be approved by the Council.[13]

The peplos worn by this little statue has no seams. The top is folded over and the dress is wrapped around and pinned on both

1. Marble kore, Acropolis 682, late sixth century B.C., 182 (71⅝)
Photograph by Alison Frantz

shoulders. A belt passed over the overfold keeps it from flying open at the right side, where we see the edges of the cloth. The material looks heavy and the folds are few. Compared with the late archaic dress this peplos looks simple, even austere, and the prevalence of such forms has helped to inspire the name, "severe style" for the early classical phase of Greek sculpture.

Indeed this open peplos seems so simple as to appear primitive. There is nothing exactly like it in earlier Greek art, even in the Late Bronze Age. There are, however, dresses that are seamed only at the sides and are fastened on the shoulders with pins (figs. 5–7). These are common in the seventh century outside of Athens, and they seem to correspond to the descriptions of dresses worn by the goddesses in the *Iliad*.[14] Herodotus tells how Athenian women once used their dress-pins to murder the lone survivor of a disastrous expedition to Aegina in which all their husbands had been

2. Sacrifice of a pig to Athena, marble votive relief, Acropolis 581, c. 510/500 B.C., 66.5 (26⅛)
Photograph by Deutsches Archäologisches Institut, Athens

3., 4. Marble statue of Athena signed by Euenor, Acropolis 140, second quarter fifth century B.C., 89.5 (35¼) preserved height
From Hans Schrader and Ernst Langlotz, *Die archaischen Marmorbildwerke der Akropolis*

killed. Henceforth they were required to give up the pinned woolen dresses and wear linen chitons that were sewn at the shoulders.[15] We have no certain date for this event, if it really happened, but sometime in the eighth century B.C., too early for us to track in art, has been suggested as probable.[16]

What interests *us* about this story is that Herodotus says that the pinned dresses, like those worn by Corinthian women in his day, were called Dorian but were really Hellenic, whereas the linen chitons with sewn shoulder seams, commonly called Ionic, were really Carian.[17] Since Carians were thought to have inhabited the Cycladic islands in early times,[18] we could think of these garments as descendants of the linen dresses of the Aegean Bronze Age, like those shown in wall-paintings in Thera.[19]

Herodotus' history is that of the Persian Wars, and his point of view is broadly Hellenic. So we could well imagine that the people of Athens, in giving their city goddess a pinned woolen dress of primitive form, were stressing their identity as Hellenes rather than as Ionians or Athenians. Such an idea is supported by the fact that the peplos turns up all over the Greek world in the second quarter of the fifth century, in maidens from Lycian Xanthos in southwest Asia Minor (fig. 8),[20] in the well-known Nike from the Cycladic island of Paros,[21] and in a bronze statuette of a maiden supporting an incense burner, found in Delphi.[22]

In the sculpture of the Temple of Zeus, in the Panhellenic sanctuary of Olympia, the pinned woolen dress in one form or another is worn by most of the female figures.[23] Archaeologists extend the name peplos to all of these dresses, belted and unbelted, and even to those that are closed by a side seam and have a short overfall ending above the belt (fig. 9). This is sometimes called "Argive peplos."[24] It is worn by brides and married women and is appropriate for Argive Hera, the goddess of marriage. This is no doubt the dress Herodotus refers to when he says that the Hellenic dress is like that worn by the Corinthian women.[25] A votive plaque from the second half of the sixth century found near Corinth shows women in this dress,[26] and we could guess that the strong Corinthian influence on Attic vase painting in the first

half of the sixth century was responsible for its introduction into Attic art by Kleitias, the painter of the François Vase. Dancing Nereids by Kleitias are a good example.[27] Herodotus seems to imply that Athenian women in his day were not wearing it; this supports a suspicion that scenes in classical Athenian art cannot always be read literally as a reflection of contemporary life.

As our subject is cultural identity *in art*, we can concentrate on representations of gods and heroes, for it is through these that propaganda messages are conveyed in both art and poetry. The helmet that Athena wears on the coins of Athens, beginning in

5., 6., 7. Bronze statuette from Dreros, Heraklion Museum 2446, c. 40 (15¾)
Photographs by Alison Frantz

the late sixth century, is referred to as the "Attic helmet," just as the helmet worn by Athena on the coins of Corinth is called "Corinthian." Many real Corinthian helmets have been excavated, especially at Olympia, but very few real Attic helmets have ever been found.[28] The Athenians in battle in the late archaic period seem to have worn Corinthian helmets.[29] Beth Cohen has actually suggested that the Attic hel-

met that we see in art, which like the open peplos impresses us as rather primitive and impractical, never really existed in the form depicted, but was a creation of archaic artists specifically for their portrayals of Athena.[30] What is striking, however, is that all the helmets portrayed in the sculptures of the Temple of Zeus at Olympia seem to be of this type.[31] In the iconography that stresses Hellenic identity, the Attic helmet does not seem to have a specifically Athenian con-notation. Conversely, Athena may be por-trayed at home on the Acropolis of Athens wearing a Corinthian helmet as in the "mourning Athena" relief.[32] It even seems likely that Pheidias gave a Corinthian hel-met to the great bronze Athena that we know as the Athena Promachos. Heads on Roman lamps found in Athens are thought to reflect the bronze Athena (fig. 10).[33]

Pausanias tells us that the bronze Athena was dedicated from the spoils of Mara-thon.[34] It may seem odd that this dedication was made in the 450s, nearly forty years after the battle, but it seems to have been at the same time that the battle was first depicted in a mural in the Painted Stoa in

the Athenian Agora. An epigram, which ancient writers state accompanied the painting, declared that the Athenians as champions of the Hellenes, *Hellenon promachountes*, had laid low the Persians at Marathon.[35] This emphasis on Marathon, the victory over the Persians in which Sparta had no part, marks the beginning of a new phase in Athenian attitudes: it was in the 450s that sharpening confrontation with Sparta pushed the hatred of the Persians into the background.[36]

Male coiffures in early classical sculpture show a richness and elaboration that hardly suit the notion of a severe style. When we look into these, it appears that they derive from an iconography of rites of coming of age.[37] Plutarch in his life of Theseus relates that Theseus went to Delphi on the occasion of his coming of age and cut off his front hair, leaving the rest long. This coiffure was called *Theseis*.[38] Dedicating locks of hair cut off at puberty was a widespread practice in the ancient Greek world and seems to have been so already in the Bronze Age Aegean, as Ellen Davis[39] and Robert Koehl[40] have shown in recent studies; but Plutarch's *Theseis* corresponds best to the common hairstyle of archaic Greek *kouroi*, short curls across the forehead and long hair hanging down the back, with or without shoulder locks in front. This is regular for both youths and maidens in the so-called Daedalic style of the seventh century B.C.,[41] the style in which the shoulder-pinned tubular woolen dress was popular.

In the late archaic period the coiffures, like the dresses, became more varied, reflecting an exchange of influence from many quarters and a loosening of the old iconography. Athletic youths wore their hair short, apparently for practical reasons.[42] It is in the late archaic period, the time of the conflict with Persia, that iconographical distinction between the uncut hair of preadolescent males and the short front hair of adolescents and adults becomes emphasized. The long back hair of the *Theseis* is sometimes left hanging, as on the wounded youth from the west pediment at Aegina,[43] but more often it is bound up in back, as on the Theseus from Eretria,[44] or braided and wound around the head as in the Blonde Boy from Athens, who is more accurately

10. Terracotta lamp with bust of Athena Promachos, Athens, Agora L 3731, third century A.D., 9.3 (3¹¹/₁₆) width
Agora photograph

called the Blonde Ephebe.[45] The so-called Kritios Boy is indeed a *pais*, with uncut front hair bound up in the same fashion as the hair on the sides and back.[46] These distinctions become typical of the Early Classical period. In the west pediment at Olympia, Apollo (fig. 11) and the bridegroom Peirithoos have cut front hair, while Theseus is portrayed as still a boy, with all his hair long and bound up like that of the Kritios Boy.[47] It seems possible that the Kritios Boy actually represents Theseus and the Blonde Ephebe, Apollo.

Grown-up, bearded gods such as Zeus and Poseidon also have short front hair and long back hair in the late archaic and early classical periods. Most often the back hair is

braided or rolled up like that of the ephebic Apollo.[48] Meanwhile athletes, both the human athletes of the victory statues and the mythical athletes of the Olympia pediments, continue to wear their hair short.[49]

Distinctions of age and status also seem to be observed in the female coiffures at Olympia. The girl with undeveloped breasts in the centauromachy has uncut, wavy hair.[50] The bride in the east pediment has short

front curls.[51] There may be distinctions of dress according to the mythical local origins of some of the figures in these sculptures.

It is remarkable that only one female figure in the whole assemblage wears a linen chiton. This is the little bride of Peirithoos who struggles with a centaur under the arm of Apollo (fig. 11). Theseus comes to her rescue, as he often does in Attic vase painting.[52] Perhaps the reason, both for her dress and for Theseus' defense of her, is that she was the daughter of Boutes, sometimes identified with an early Athenian hero.[53]

The Lapith women of the west pediment all seem to have worn a peplos closed on the right side, with an overfall long enough to conceal the belt, if there was one. The peplos is open, wholly or partly, on the left side in figures whose clothing has been ripped by the centaurs but not in the others. This closed peplos without a visible belt or *kolpos* is very common in bronze statuettes and mirror supports in the early classical period and does not seem to have had a specific local meaning. It is worn by the maiden from Xanthos (fig. 8) as well as by one in Corinth.[54]

The unbelted peplos open on the right side is worn in the east pediment by Sterope, the wife of Oinomaos.[55] It is also worn by Athena in the metope where she appears with Herakles and Atlas.[56] Since Sterope was one of the daughters of Atlas, there may be some connection between these two figures. It is worth noting that the figure from Delphi holding the incense burner,[57] who wears the same dress and has often been compared to the two Olympia figures, recalls the scheme of Atlas holding up the globe of the heavens. Perhaps she too is a daughter of Atlas, conceivably even Sterope, who is mentioned as having been loved by Apollo.[58] In other contexts the open, unbelted peplos belongs particularly to very young girls. Perhaps like another unsewn garment, the *exomis*, it came to be associated in the iconography of the fifth century with the primitive ways of early times and far-off places.

Athena in two metopes, the Stymphalian Birds and the Augean Stables, wears the closed "Argive" peplos with *kolpos*.[59] Certainly the overbelted peplos of Euenor's Athena (figs. 3, 4) and the Athena Parthenos

12. Head of Athena; Olympia, Nemean Lion metope, second quarter fifth century B.C. Photograph by Alison Frantz

does not serve here as Athena's principal dress. If she wore it at all, it must have been in the much-destroyed Nemean Lion metope, where only the head of the goddess survives (fig. 12).[60]

All in all, it seems clear that the iconography of the Zeus Temple is a Panhellenic one that integrates Athenian myths and forms into the broader Hellenic picture.

Many features of this early classical Hellenic iconography survive into the second half of the fifth century, but in the art of Athens there are some striking changes.

Most noticeable and easiest to date is the helmet of Pheidias' Athena Parthenos, presumably designed soon after 447 B.C. and dedicated in 438. This is once more the Attic helmet of the Athenian coins, with the addition of orientalizing ornaments that recall the art of the seventh century.[61] The Amazonomachy of her shield is not the joint expedition of Herakles and Theseus to the land of the Amazons but the defense of the Acropolis of Athens.[62] As the battle of the Gods and Giants was depicted on the inside of the shield, we have a parallelism between the city and the cosmos which is further emphasized in the exterior sculptures of the Parthenon. The Birth of Athena in the east pediment is a cosmic event, but the choice and disposition of the gods who attend it serve pointedly to remind us of Athens and her cults.[63] The west pediment represents a struggle for power between the gods Athena and Poseidon, but it is the power over Attica that they are fighting for, and the onlookers represent the generations of mythical Athenians.[64] The east and west metopes are contrasted in the same way, the east showing the battle of the Gods and Giants, the west the defeat of the Amazon invaders of Attica (here the scene of action is broader than on the shield of Athena, for the Amazons ride their horses and fight on level ground).[65]

I have suggested that the western segment of the Parthenon frieze also alludes to the land of Attica as a whole. Bernard Ashmole remarked that the dramatic focal group in which a powerful rider strains to control a splendid rearing horse is like an allegory of the art of government.[66] This whole section of the frieze, which seems to show disparate groups preparing and assembling to form a joint procession, could well represent the union of Attica under Theseus, an event commemorated in the festival of the Synoikia, which preceded the Panathenaea in the Athenian festival calendar. Now, since Athenian tradition had pushed the unification of Attica back to the time of Theseus, that is, back to what we should call mythological rather than historical times—though the Greeks themselves made no such distinction—it seems most probable that the west frieze really is intended to represent that very early time.[67]

Of the two long sides, the north carries references to the time before the constitution of Kleisthenes, a time when the four Ionian tribes formed the framework of Athenian citizenship. There are four sacrificial victims of each kind: four cows and four sheep. There are four water-carriers, four aulos-players and four kithara-players. There are sixteen old men. The chariots of the apobates race (figs. 13, 14) number eleven—a surpise![68] This indivisible number may have been chosen because, as Luigi Beschi has recently shown, this race was not a tribal contest: victory records show that the charioteer and the apobates could belong to different tribes.[69] So perhaps this is the exception that proves the rule. In any case it is reasonable to think of it as an old contest that dated back to before the time of Kleisthenes. Among the north riders, with their casual rhythms and picturesquely varied costumes, it is hard to find any numerical principle. The motif of brotherhood in such a group as that in the westernmost north slab, where the little brother adjusts a rider's costume, suggests that these youths represent the Phratries, subdivisions of the hereditary Ionian Tribes.[70]

In the south frieze everything alludes to the ten Tribes of the Kleisthenic Democracy. There are ten groups of riders clearly disposed in ranks of six, with the members of each group wearing a distinctive dress (fig. 15).[71] There are also ten chariots. Beschi would call these the *polemisteria harmata*, war chariots, indicating a different event from the race of the apobatai and one that can well have been tribal. In fact, no one is seen dismounting from a running chariot.[72] Finally, there are ten cows, including Keats' heifer, being led to the sacrifice.

In summary, we might say that the west frieze represents early times, with emphasis on the genesis of the Athenian state, with the welding of the Attic population into a single unit; the north frieze represents old times, with the constitution in its archaic form; and the south frieze represents modern times, with the constitution that was in effect when the Parthenon was built. Though Beschi and I would agree on most details of identification, he would not go so far as to separate the frieze into different blocks of real time. He would see

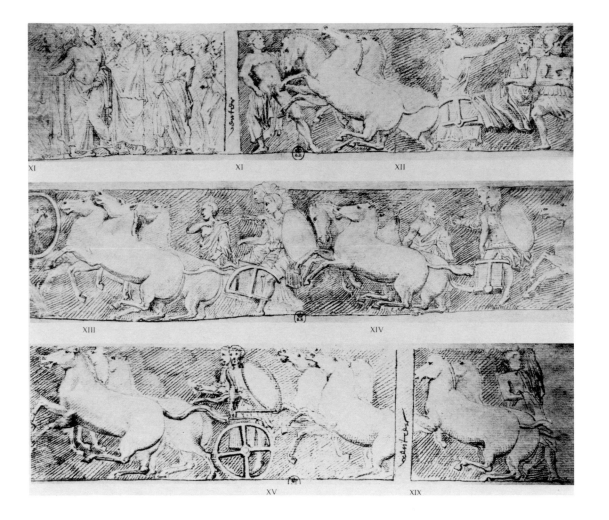

XI XI XII

XIII XIV

XV XIX

the whole as a generic representation of the Panathenaic festival (*heorte*) divided into its two main components of sacrificial procession (*pompe*) and contests (*agon*). The south side would represent the institutions typical of the Democracy, the west and north together the ancestral customs. The focus of the *pompe* would be the Acropolis; the contests would take place in different locations, as the actual contests did.[73]

Beschi would therefore not see the two bearded horsemen in the west frieze as heroes of early times. He identifies them as "the two Hipparchs" (commanders of the cavalry).[74] One might object that though it would be possible to take them as heroes who had functions like those of the Hipparchs, it would be hard to explain, if they were only Hipparchs, why one of them (west 15) is so much more splendid and com-

manding in aspect than the other (west 8).[75] Also, it is doubtful that two was the regular number of the Hipparchs at the time of the Parthenon.[76]

In either interpretation, these segments of the frieze taken together present a kind of history of the Athenian People, represented predominantly in the persons of the young men who have just come of age, with bearded fatherly figures present only to the extent necessary to suggest the framework of the state. Even the so-called marshals are predominantly young.[77]

When we turn either corner to the front of the cella, we are in a world of women. Like the males on the other sides, they are mostly very young. As coming of age for men means readiness for citizenship, for females it means readiness for marriage. The new citizenship law passed by Pericles in

13. Final stage of the apobates race, Parthenon north frieze, as drawn by Jacques Carrey
From Frank Brommer, *Parthenonfries*

451–450 laid a new stress on the female line in defining Athenian identity. No one could be an Athenian citizen unless his mother as well as his father were Athenian.[78] A legitimate and fertile marriage was thus the essential recurrent link in the chain of Athenian existence.

It is agreed by all that the female processions on each side of the east frieze are to be taken as continuous with the male processions on the flanks adjacent to each. Beschi points out that the five *phialai*, libation bowls, and five *oinochoai*, pitchers, carried by the southern file of women, adding up to ten, may well continue the reference to the Ten Tribes of the Democracy on the southern flank.[79] He has also made the important observation that those girls wearing the peplos in the southern file wear a linen chiton under it, whereas those on the north do not.[80] His explanation of this fact, however, cannot be correct. Noting that the weavers of the peplos of Athena

14. Winning apobates with foot on goal, cast from Parthenon north frieze
Basel Skulpturhalle photograph

15. Group of six riders dressed alike in petasos and chlamys, Parthenon south frieze, as drawn by Jacques Carrey
From Frank Brommer, *Parthenonfries*

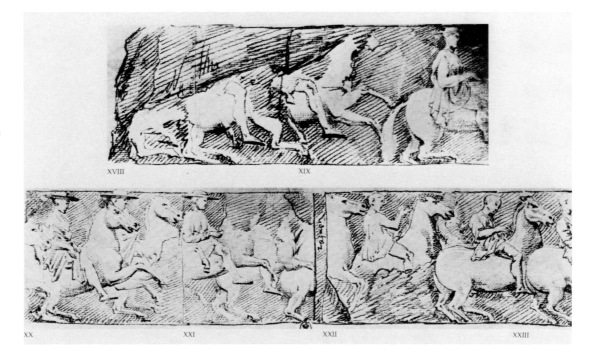

included both maidens (*parthenoi*) and married women (*teleiai gynaikes*), Beschi concludes that all the females of the southern procession are married women and those of the northern are virgins. He accepts the common and, I think, correct opinion that the girls at the head of the northern procession are Kanephoroi, carriers of the baskets that held the sacrificial knife and barleycorns. Since these wear no chitons and since the Kanephoroi are known to have been maidens, he assumes that all their companions are also maidens.[81]

A more reliable clue to the women's status, however, is the coiffure. Maidens wore their back hair long. We can take as examples the Erechtheum caryatids (fig. 16), mentioned in the building inscription as *korai*.[82] Married women appearing in public wore their hair bound up and covered with a kerchief.[83] If we look closely at the east frieze, we see that both coiffures occur on both sides: both processions must include married women as well as maidens.

The pairs of maidens who walk empty-handed have long back hair and wear the peplos with a mantle (veil) draped over the shoulders. There is one pair to the south of the central scene as well as two to the north, and it seems reasonable to call them all Kanephoroi. Thus each file of victims has its basket-carriers.[84] Of those who carry *phialai* and *oinochoai* on each side, some are kerchiefed and some have long back hair. Not all heads are preserved, but those figures that certainly wore kerchiefs wear a chiton and wrapped himation: east 8, 9, and 11 in the southern file, east 57 and 61 in the northern. There seems to be one long-haired maiden in each file who wears the chiton and wrapped himation, east 6 on the south and east 60 on the north. Both *phiale*-carriers and *oinochoe*-carriers include maidens as well as married women. Two pairs of maidens accompany the two *thymiateria*, incense burners, on the southern side, one maiden and one married woman accompany the one on the north.[85]

Since, except for the number, we have balanced groups on both sides, it seems likely that the wearing of the chiton under the peplos by the girls of the southern file should be interpreted as a sign of the more comfortable and sophisticated dress of modern times against the simplicity of early days, rather than as showing a difference of age, status, or function. In this case, the under-chitons of the southern group would support my suggestion that this group represents the people of Democratic Athens being called to join the procession of their ancestors.

These young women with their bowls and pitchers and incense burners are indeed coming to a sacrifice. But the sacrifice itself is not shown in this frieze, for reasons that we are just beginning to understand. Manolis Korres has recently discovered that there once was a smaller frieze running above the windows and doors of the east cella wall.[86] None of its sculpture is preserved, but the most logical subject for it would be the sacrifice. We would not expect to see the victims being killed, for depictions of this act are virtually nonexistent in classical Greek art, but priestesses, officials and paraphernalia that are missing from the large frieze might have been shown in this smaller, more intimate representation. We can compare the inner frieze of the Nereid Monument at Xanthos,[87] as well as the small friezes on the Ara Pacis[88] and in the upper zones of Roman triumphal arches.[89]

The central section of the larger Parthenon frieze presents the peplos of Athena in a grouping that recalls the sacred marriage of the wife of the Archon Basileus to Dionysus, an annual ritual to promote the fertility of the land, its crops and its people.[90] The peplos is being folded as if it were part of a dowry, held by the Basileus and a young boy.[91] The wife of the Basileus receives one of two seats carried by young girls, who must be the Arrhephoroi. These girls made the ritual beginning of the weaving of the peplos. When the Basileus and Basilinna take their seats, they will become a couple like the inmost pairs of gods that frame the peplos scene to either side. Zeus and Hera, to the left, are a regular bridal couple. Next to them are the Arrhephoroi, the young girls whose rituals represent the initiation of adolescent girls into the mysteries of womanhood. Walter Burkert has shown that the daughters of Kekrops are their mythical prototypes.[92] On the right, next to the male child who holds the peplos, Athena and Hephaistos are a couple of a

16. Erechtheum, west end and caryatid porch
Photograph by Alison Frantz

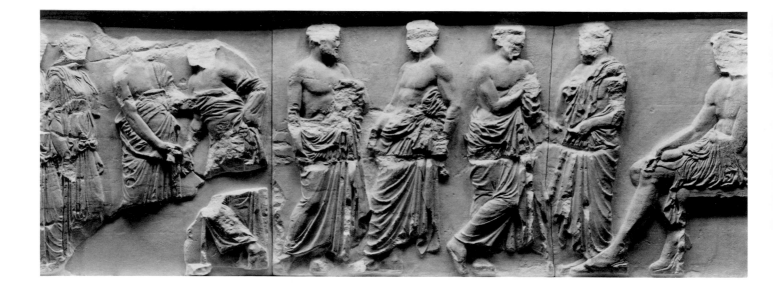

17. Tribal Heroes between gods and procession, cast from Parthenon east frieze, south half
Basel Skulpturhalle. Photograph by Dieter Widmer

more unusual sort. From their interaction the child Erichthonius was born out of the Earth. He is the prototype of the Temple Boy on the frieze. Erichthonius became the mythical ancestor of the Athenians and symbol of their claim to be autochthonous, a people who had always inhabited the same land. This contrasted them to the Dorians, who even in their own traditions had come from outside to take control over resident populations. In the case of Sparta these resident populations remained as an inferior component of the state.[93]

The myth of autochthony, together with the citizenship law of Pericles, reinforced in a radical way the democratic constitution of Kleisthenes with its ten artifically created Tribes as the framework of government and the ten arbitrarily chosen Heroes who gave their names to the Tribes and so became *de facto* ancestors of the citizens who belonged to them. Thus it was no longer possible for a citizen to claim superiority in the eyes of the state by virtue of his family's descent from one or another great hero of ancient times.

The Eponymous Heroes were all real mythical personalities, however, and their myths were shaped in art and oratory to give a common inspiration and identity to members of their Tribes, especially in battle and in the training of young men for their role as citizens.[94] It is hard to over-estimate the importance of the Eponymoi for the iconography of Athenian identity, and in recent years the majority of scholars have recognized them in the ten figures who come between the gods and the procession on the frieze, six to the left (fig. 17) and four to the right (fig. 18). The latest attempts to give these figures other names have generally been based on arguments that do not take into account how much we really know by now about the Eponymoi.[95] The fact that the feet of the gods overlap theirs does not simply indicate a change of picture plane but a vital transmission of generative power from the gods to these ancestors of the Athenians. It is across these timeless symbols of continuity through recurrent generation that the procession of the south, representing contemporary Athens, is called by a beckoning marshal (fig. 18) to join those of earlier times.[96] Thus the whole citizen body of Athens is shown to be one family, blessed by its gods throughout time past and time to come.

It is somewhat paradoxical that the narrowing of iconographical identity from Hellenic to Athenian brought with it an increased openness to things that impress us as foreign. In reacting against the Spartan ideal, Athens returned to Ionian forms such as we see in the Erechtheum (fig. 16) and to the free interaction with Near Eastern culture that had characterized the late ar-

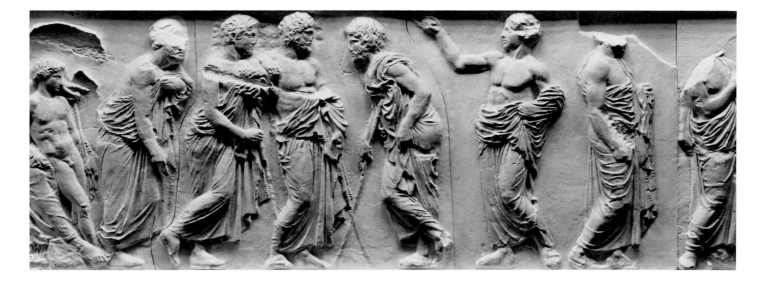

18. Tribal Heroes between gods and procession, cast from Parthenon east frieze, north half

Basel Skulpturhalle. Photograph by Dieter Widmer

chaic. The Persians were no longer the number one enemy, and the magnificence of display that Persian art afforded appealed even to those who rejected its stiff conventionality. Other scholars had observed, and Margaret Cool Root has recently argued in detail, that the Parthenon frieze with its processional composition and its cast of hundreds, if not literally thousands, all directed toward a common inward center of reverence, recalls the sculptures of Persepolis and may well have been inspired from there.[97] It may even be true, as Root suggests, that Pericles wished to portray Athens as worthy to rule her Empire, just as Darius wished to show the Persian monarchy as worthy to rule the peoples of Asia.

That does not mean, however, that this is the only or even the most important message of the frieze. For what is shown as worthy to rule is not Pericles or an abstract Athenian state, but the Athenian Demos, that is the Athenian Democracy. A contradiction between democracy and imperalism did not exist for the ancient Athenians. The most striking difference between the Parthenon frieze and the Apadana reliefs of

Persepolis is that the subjects of the Empire, what the Athenians always called the "allies," are nowhere to be seen in the picture. Iconographically they had been absorbed into the myth that all the Ionians were ultimately descendants of Ion, the son of Apollo and an Athenian princess.

The main elements cited from Fredrick Barth elsewhere in this volume as necessary components of ethnic identity[98] seem to be present in the attempt of Periclean Athens to celebrate its ethnic identity in the art of the Parthenon. The reaching back for old traditional forms, fictitious or real, is very apparent. The emphasis on maintaining biological continuity was the motivating cause for the citizenship law of Pericles and is the leitmotif of the frieze. The importance of confrontation with other cultures is easy to see. It is the search for definition of boundaries that was most difficult for these small states in the face of the larger power relations and economic necessities in which they were always doomed to find themselves. Their identity was broader or narrower according to the scale of their opponents.

1. Herodotus V, 77. *Inscriptiones Graecae, editio minor*, vol. 1, ed. Friedrich Hiller von Gaertringen (Berlin, 1924), no. 394. For the surviving fragments of the base of the monument, see Antony E. Raubitschek, *Dedications from the Athenian Akropolis* (Cambridge, Mass., 1949), nos. 168 (the original base) and 173 (the base of the monument as restored in the middle of the fifth century B.C., the one seen by Herodotus), with very full citation of previous bibliography. For a brief, authoritative discussion of the text and the historical occasions for the erection and reerection of the monument, see Russell Meiggs and David Lewis, *A Selection of Greek Historical Inscriptions to the End of the Fifth Century B.C.* (Oxford, 1969), no. 15. A brief mention in Richard E. Wycherley, *The Stones of Athens* (Princeton, 1978), 135, does not add to the bibliography.

2. The Greeks of archaic times did not distinguish sharply between an ethnos and a polis (city-state). We should call Chalcis a polis, the Boeotians an ethnos, in which some settlements, such as Thebes, counted as poleis in their own right. For a discussion of the distinction, see Anthony Snodgrass, *Archaic Greece* (Berkeley and Los Angeles, 1980), 42–47. Aristotle (*Politics* 1326 b 4) wrote, "A polis with excessive population becomes like an ethnos."

3. Aeschylus *Persae*, 402–403.

4. Herodotus VIII, 51–55.

5. The fourth century orator Lycurgus (*Against Leocrates*, 81) quotes the oath that he says was sworn "by all the Hellenes" at Plataea before taking up their positions to fight. He includes the words, "I will not rebuild any of the shrines burnt and razed by the barbarians but will allow them to remain for future generations as a memorial of the barbarians' impiety." Diodorus XI, 29, also includes in his quotation of the oath this vow to leave the destroyed shrines unrestored, but a version inscribed on stone in the fourth century omits any mention of the temples. Already in the late fourth century, the authenticity of the oath had been questioned by Theopompus. Herodotus made no mention of it. There is still not unanimity on the question. For general discussion, see Russell Meiggs, *The Athenian Empire* (Oxford, 1972), 155–157 and 504–507; Marcus N. Tod, *Greek Historical Inscriptions*, II (Oxford, 1948), 303–307.

6. For a discussion of the different kinds of early Greek dress, see Evelyn B. Harrison, "Notes on Daedalic Dress," *The Journal of the Walters Art Gallery* 36 (1977), 37–48. Fine-folded linen dresses with full "sleeves" are shown on the goddesses of the rock reliefs at Yazilikaya, from the time of the Hittite Empire. See Ekrem Akurgal and Max Hirmer, *The Art of the Hittites* (New York, 1962), pls. 76, 77, 79. For wrapped mantles on men and women, see the orthostates from Alaca Hüyük, Akurgal 1962, pl. 92. Compare similar dress from Malatya in the eighth century B.C., Akurgal 1962, pls. 106–107, and a carefully rendered fine-folded chiton on a woman from Karatepe, c. 700 B.C., Akurgal 1962, pl. 150.

7. See especially sculpture and painting from the late 18th and 19th Dynasties: I. E. S. Edwards, *Tutankhamun, His Tomb and His Treasures* (New York, 1977), for late 18th Dynasty; A. Mekhitarian, *Egyptian Painting* (Geneva, 1954), figures on 136, 140, 142–143, 151, for 19th and 20th Dynasties.

8. See the reclining man from the Geneleos group at Samos, John Boardman, *Greek Sculpture, the Archaic Period* (London, 1978), fig. 93; seated men, Boardman 1978, figs. 94–96. In vase painting, see Antenor and Priam on the the François Vase, Paolo Enrico Arias and Max Hirmer, *A History of One Thousand Years of Greek Vase Painting* (New York, 1961), pl. 44; John D. Beazley, *Attic Black-Figure Vase-Painters* (Oxford, 1956), 76, no. 1. Arkesilas of Cyrene on a Laconian cup, Arias and Hirmer 1961, pl. XXIV. Dionysus on an amphora in the Louvre by the Lysippides Painter, Arias and Hirmer 1961, pl. 89; Beazley 1956, 254, no. 1.

9. John Boardman, *The Greeks Overseas* (2d ed., London, 1980), 111–159. Marjorie S. Venit, *Greek Painted Pottery from Naukratis in Egyptian Museums* (Winona Lake, 1988).

10. Acropolis Museum 682. Gisela M. A. Richter, *Korai* (London, 1968), 73–75, no. 116, figs. 362–367, with earlier bibliography. For the Ionian forerunners, see Richter 1968, 46–47, nos. 55–59, figs. 183–200. Nos. 58 and 59 are made in Naxian marble but found on the Athenian Acropolis. They may have been imported ready-made. All these belong shortly before the middle of the sixth century. The diagonal himation appears on the mainland in the caryatids of the Cnidian Treasury at Delphi soon after the middle of the century, Richter 1968, 57, nos. 87–88, figs. 282–283; on the date see Evelyn B. Harrison, *The Athenian Agora*, XI, *Archaic and Archaistic Sculpture* (Princeton, 1965), 5. Soon after, around 540 B.C., comes the first surviving *kore* with diagonal mantle made by an Athenian artist, the so-called Lyons Kore, upper part Lyons Museum, lower part Acropolis Museum 269, Richter 1968, 57, no. 89, figs. 275–281; Maria Brouskari, *The Acropolis Museum* (Athens, 1974), 60, no. 269, fig. 108.

11. Acropolis 581. Brouskari 1974, 52–53, fig. 94, with bibliography. Add Brunilde S. Ridgway, *The Archaic Style in Greek Sculpture* (Princeton, 1977), 309, fig. 66. On the date, probably c. 510–500 rather than, as generally stated, c. 490, see Evelyn B. Harrison, *Gnomon* 1981, 497–498.

12. Acropolis 140. Brouskari 1974, 129–130, fig. 248; Boardman 1978, 87, fig. 173; Renate Tölle-Kastenbein, *Frühklassische Peplosfiguren, Originale* (Mainz, 1980), 54–56, no. 9 e, pls. 42–44 (with bibliography). Although the Athena (known as the Athena of Euenor) has often been dated in or just before 480, Tölle-Kastenbein argues that the developed *contrapposto* of the figure makes so early a date unlikely. The context in which it was found in 1864, in a trench for the foundations of a museum, gives no evidence for its date.

13. For the use of the word *peplos* in ancient Greek

poetry and prose, see Blaise Nagy, "The *peplotheke*: What Was It?" in *Studies presented to Sterling Dow, Greek, Roman and Byzantine Monograph* X (Durham, North Carolina, 1984), 227–232. For the garment called peplos by modern archaeologists, see Margarete Bieber, *Griechische Kleidung* (Berlin, 1928), 33–38. For a rich collection of early classical peplos figures, see Tölle-Kastenbein 1980. For a brief, recent discussion of the ancient sources for the Panathenaic peplos, see Peter J. Rhodes, *A Commentary on the Aristotelian Athenaion Politeia* (Oxford, 1981), 568–569. For the display of the peplos like a sail on a mast and spar, see Theodore Leslie Shear, Jr., "Kallias of Sphettos and the Revolt of Athens in 286 B.C.," *Hesperia,* suppl. XVII (Princeton, 1978), 39–44. Plutarch, *Demetrios* XII, says that in order to flatter Demetrios Poliorketes, the Athenians had portraits of him and his father Antigonos woven into the Panathenaic peplos along with images of Zeus and Athena. This may have been an excerpt from the Gigantomachy, which we learn from various sources was depicted on the peplos. See François Vian, *La Guerre des Géants* (Paris, 1952), 251–253.

14. For a general discussion of the structure of these dresses, see Harrison 1977.

15. Herodotus V, 87–88.

16. John Nicolas Coldstream, *Greek Geometric Pottery* (London, 1968), 361, n. 10, suggested the middle of the eighth century B.C. Sarah Morris, *The Black and White Style, Athens and Aegina in the Orientalizing Period* (New Haven and London, 1984), 107–116, discusses the question at length and tentatively favors a date in the early seventh century.

17. Herodotus V, 87–88.

18. Thucydides I, 8.

19. Christos Doumas, *Thera* (London, 1983), pls. VI and 27. Nanno Marinatos, *Art and Religion in Thera* (Athens, 1984), 100–104, figs. 68–71. The shoulder seams are clearly shown and it is also possible to understand from these paintings that the dress does not consist of a jacket and skirt but of a long tunic (which can be opened in front for ritual baring of the breasts) over which a flounced kilt may be worn for ceremonial occasions. See the reconstruction in Marinatos 1984, 102, fig. 70.

20. London, British Museum B 318. Tölle-Kastenbein 1980, 100–101, no. 13 c, pls. 62–63. John Boardman, *Greek Sculpture, The Classical Period* (London and New York, 1985), fig. 15.

21. Paros Museum 245. Tölle-Kastenbein, 1980, 264–266, no. 43 d, pls. 173–175. Boardman 1985, fig. 27.

22. Delphi 7723. Claude Rolley, *Fouilles de Delphes,* V, *Les Statuettes de Bronze* (Paris, 1969), 155–160, no. 199, pls. 44–47. Elena Walter-Karydi, "Eine parische Peplophoros in Delphi," *Deutsches archäologisches Institut, Jahrbuch* 91 (1976), 1–27. Tölle-Kastenbein 1980, 168–169, no. 28 a, pls. 117 b, 118. Boardman 1985, fig. 17. Rolley felt that the style could not be localized. Walter-Karydi assigned it to Paros. Tölle-Kastenbein, while stressing the uncertainties, includes it with Syracusan works in her catalogue.

23. For good photographs of all the sculpture, see Bernard Ashmole, Nicholas Yalouris and Alison Frantz, *Olympia, the Sculptures of the Temple of Zeus* (London, 1967).

24. See Tölle-Kastenbein 1980, 240 on the regional terms that have been applied by archaeologists to different forms of wearing the peplos. She makes it clear that these classifications do not correspond to any geographical or ethnic reality.

25. Herodotus V, 87–88.

26. Plaque from Pitsa in the Athens National Museum. Karl Schefold, *Die Griechen und Ihre Nachbahrn, Propyläen Kunstgeschichte,* I, (Berlin, 1967), pl. 190.

27. Fragments of a hydria from the Acropolis, Beazley 1956, 77, no. 8; John D. Beazley, *The Development of Attic Black-Figure,* 2d ed., (Berkeley, 1986), pl. 29, 5. The white, outlined faces of the Nereids and the long sidelocks in front of their ears are easily paralleled in Corinthian painting. See Humfry Payne, *Necrocorinthia* (Oxford, 1931), 100, fig. 34 B, 108, fig. 38, pl. 40, 2.

28. See Anthony M. Snodgrass, *Arms and Armour of the Greeks* (London, 1967), 51–52 for the form, origin and name of the Corinthian helmet, fig. 20 for an early example. See Snodgrass, 1967, 69 for the Attic helmet. Snodgrass points out that according to Herodotus the Corinthian helmet was so called in antiquity, but that the term "Attic helmet" is wholly modern.

29. A Corinthian helmet was dedicated at Olympia by the Athenian Miltiades: Alfred Mallwitz, *Olympia und seine Bauten* (Munich, 1972), 32, fig. 32.

30. I am grateful to Dr. Cohen for discussing with me her work in progress on this subject.

31. Ashmole 1967, pls. 15, 18 (Oinomaos), 46–47, 49 (Pelops), 202, 211 (Athena).

32. Acropolis Museum 695. Brouskari 1974, 123–124, fig. 237; Boardman 1985, fig. 41.

33. No direct copy of the Promachos has been surely identified. Attempts to see this figure in the Athena Medici are misguided. See Evelyn B. Harrison, "Lemnia and Lemnos: Sidelights on a Pheidian Athena," in *Kanon Beiheft Festschrift Ernst Berger,* Antike Kunst Belheft 15 (Basel, 1988), 101–107.

For coins and lamps showing an Athena with Corinthian helmet that is probably the Promachos, see Behrent Pick, "Die 'Promachos' des Phidias und die Kerameikos-Lampen," *Deutsches archäologisches Institut, Athenische Abteilung. Mitteilungen* (hereafter *AthMitt*) 56 (1931), 59–74. For a possible reflection of the type in the round, see Evelyn B. Harrison, "Preparations for Marathon, the Niobid Painter and Herodotus," *Art Bulletin* 54 (1972), 390–402, especially 396.

34. Pausanias, I, 28, 2.

35. Ernst Diehl, *Anthologia Lyrica Graeca,* II (Leipzig, Teubner, 1925), Simonides, no. 88, quoted by ancient sources with three different versions of the

second line, though the first is the same in all. The Souda quotes it s.v. *Poikile Stoa*, whereas Lycurgus, *Leocrates*, 109, seems to imply that it is funerary. See Richard E. Wycherley, *The Athenian Agora*, III, *Literary and Epigraphical Testimonia* (Princeton, 1957), 43, no. 92. In a recent general discussion of the epigram, valuable for its many references, E. D. Francis and Michael Vickers, "The Marathon Epigram in the Stoa Poikile," *Mnemosyne* 38 (1985), 390–393, have made the rather startling suggestion that the epigram was indeed in the Painted Stoa but so inscribed that one quarter of the poem, one hemistich, was inscribed under each of the four subjects of the mural painting.

36. See Russell Meiggs, *The Athenian Empire* (Oxford, 1972), 94–95.

37. See Evelyn B. Harrison, "Greek Sculptured Coiffures and Ritual Haircuts," in *Early Greek Cult Practice*, ed. Robin Hägg. *Skrifter utgivna av Svenska Institutet i Athen* (ActaAth-4°, 38), 247–254.

38. Plutarch *Theseus*, 5, 1.

39. Ellen Davis, "Youth and Age in the Thera Frescoes," *American Journal of Archaeology* (hereafter *AJA*) 90 (1986), 399–406.

40. Robert Koehl, "The Chieftain Cup and a Minoan Rite of Passage," *Journal of Hellenic Studies* 106 (1986), 99–110.

41. For the name and characteristics of the style, see Romilly J. H. Jenkins, *Dedalica* (Cambridge, 1936).

42. Compare Gisela M. A. Richter, *Kouroi, Archaic Greek Youths*, 3d ed. (London, 1970), nos. 135 (Munich), 138 (Copenhagen), and the relief base depicting athletes; Boardman 1978, fig. 242; Reinhard Lullies and Max Hirmer, *Greek Sculpture* (London, 1957), pls. 58–61.

43. Boardman 1978, fig. 206.4; Lullies and Hirmer 1957, pl. 71.

44. Boardman 1978, fig. 205.2; Lullies and Hirmer 1957, pls. 62–64.

45. Acropolis Museum 689. Brouskari 1974, 123, fig. 234; Boardman 1978, fig. 148.

46. Acropolis Museum 698. Brouskari 1974, 124–125, fig. 238.

47. Ashmole 1967, pls. 105–109 (Apollo), 118–120 (Peirithoos), 95–97 (Theseus).

48. Compare the Zeus of Artemisium, Boardman 1985, fig. 35; Caroline Houser and David Finn, *Greek Monumental Bronze Sculpture* (New York, 1983), 76, 84–85 (braids) and the Poseidon from Livadostro, Boardman 1985, fig. 36; Houser and Finn 1983, 46, 49 (rolled back hair).

49. Compare the boy wrestling with a centaur, Ashmole 1967, pls. 86–88, 90.

50. Ashmole 1967, pls. 127–133.

51. Ashmole 1967, pls. 16–17.

52. On Theseus as the rescuer of the bride in the centauromachy, see Brian Shefton, "Herakles and Theseus on a Red-Figured Louterion," *Hesperia* 31 (1962), 330–368, especially 353–355.

53. On the possible identity of Boutes, the father of Deidameia, and Boutes the Athenian hero, see Pauly-Wissowa, *Real-Encyclopädie der klassischen Altertumswissenschaft* (hereafter *RE*) III (1899), 1082, s.v. Butes, 5–6.

54. Corinth S 1577. Tölle-Kastenbein 1980, 259–261, no. 43 b, pl. 170. Brunilde S. Ridgway, "A Peplophoros in Corinth," *Hesperia* 46 (1977), 315–323. Evelyn B. Harrison, "A Pheidian Head of Aphrodite Ourania," *Hesperia* 53 (1984), 379–388, especially 384–385.

55. Ashmole 1967, pls. 45, 48.

56. Ashmole 1967, pls. 187–188.

57. See note 22, above.

58. *RE*, 2d series, III (1929), 2446–2447, s.v. Sterope I (Türk).

59. Ashmole 1967, pl. 153 (Birds), pls. 202–206, 210–211 (Stables).

60. Ashmole 1967, pls. 143–151. In this metope, where Herakles is shown as an ephebe, Athena wears the ephebic coiffure with short front hair and rolled-up back hair. A similar coiffure is worn by the kneeling bridal attendant in the east pediment, Ashmole 1967, pls. 22–27. This young girl wears the closed peplos girt over a long overfall, but also with a long *kolpos* that appears under it, probably because she is not yet grown to full height. The same dress worn by an old woman in the west pediment may suggest the shrunken height of the elderly female, but this figure is best left out of our discussion because it was made in the fourth century.

61. For the decoration of the helmet, see particularly Neda Leipen, *Athena Parthenos, a Reconstruction* (Toronto, 1971), 32–33. This is still the best collection of material for the reconstruction of the statue as a whole. For additions, consult the section on the Athena Parthenos in Ernst Berger ed., *Parthenon-Kongress Basel* (Mainz, 1984), 177–197.

62. On the different Amazonomachies of myth, see most recently John Boardman, "Herakles, Theseus and Amazons," in *The Eye of Greece, Studies in the Art of Athens* [presented to Martin Robertson], eds. Donna C. Kurtz and Brian Sparkes (Cambridge, 1982), 1–28. For the siege of the Acropolis on the shield, see Evelyn B. Harrison, "Motifs of the City-Siege on the Shield of Athena Parthenos," *AJA* 85 (1981), 281–317.

63. See Evelyn B. Harrison, "Athena and Athens in the East Pediment of the Parthenon," *AJA* 71 (1967), 27–58. The discussion of the reconstruction there has been superseded in various details, but the surviving corner figures still support the idea of a connection with Attic cults. For Parthenon bibliography to 1982 and for significant additions made in that year, see *Parthenon-Kongress Basel* 1984. See also Giorgos Despinis, *Parthenoneia, Bibliotheke tes en Athenais Archaiologikes Hetaireias* 97 (Athens, 1982), 37–85, for newly assigned fragments and discussion of some questions of composition.

64. For the most convincing interpretation of the west pediment, see Erika Simon, "Die Mittelgruppe

im Westgiebel des Parthenon," *Tainia, Festschrift für Roland Hampe* (Mainz, 1980), 239–255.

65. The subjects of both east and west metopes as a whole are generally agreed on, though it has sometimes been suggested that the enemy riders are Persians rather than Amazons. The absence of sleeves and trousers excludes the possibility of Persians. The basic work on the metopes, with full description of each metope and photographs of them in their actual state, is Frank Brommer, *Die Metopen des Parthenon, Katalog und Untersuchung* (Mainz, 1967). This is brought up to date in various ways by the publication of the casts of all the metopes: Ernst Berger, *Der Parthenon in Basel, Dokumentation zu den Metopen, Studien der Skulpturhalle Basel,* 2 (Mainz, 1986). The photographs of the casts supplement the photographs of the metopes on the building published by Brommer. Since both east and west metopes are mutilated, all available help is needed. The reconstructions in line drawings by Camillo Praschniker, *Parthenonstudien* (Vienna, 1928), 142–235 (east metopes), and "Neue Parthenonstudien," *Österreichisches archäologisches Institut in Wien, Jahreshefte* 41 (1954), 5–54 (west metopes), are still useful, though needing correction in some details.

66. Bernard Ashmole, *Architect and Sculptor in Classical Greece* (New York, 1972), 122–125.

67. See Evelyn B. Harrison, "Time in the Parthenon Frieze," in *Parthenon-Kongress Basel* 1984, 234. For the most complete documentation of the frieze, see Frank Brommer, *Der Parthenonfries, Katalog und Untersuchung* (Mainz, 1977).

68. Harrison 1984, 233. It was only the attempt at full-sized reconstruction in the Basel Skulpturhalle that demonstrated that Dinsmoor's count of twelve chariots, which had seemed entirely reasonable, was in error. Documentation of the frieze reconstruction has not yet appeared in print.

69. Luigi Beschi, "Il Fregio del Partenone: una proposta di lettura," *Accademia Nazionale dei Lincei, Rendiconti della Classe di Scienze morali, storiche e filologiche,* Series VIII, vol. XXXIX, fasc. 5–6 (May-June 1984), 1–23. A translation of this paper into Greek was given in Athens in April 1985 and is published in *Deutsches Archäologisches Institut. Abteilung Athen, Archaische und klassische griechische Plastik, Akten des internationalen Kolloquiums vom 22.–25. April 1985* (Mainz, 1986) II, 199–224.

70. Beschi retains the number twelve for the northern chariots without discussing the new Basel reconstruction, and quotes me as having taken them to represent twelve phratries (Beschi 1984, 4). Actually, I had mentioned phratries only in connection with the cavalry of the north side, where I did not find any clear numerical principle. In fact, Rhodes 1981, 68–71 argues persuasively against the identity of phratries and trittyes which would be the basis for assuming that only twelve phratries made up the four Ionian Tribes: "The obscurest point is the relationship between the trittys and the phratry: tribe and trittys and tribe, phratry, and genos seem to be two sets of institutions which have been artificially

combined to produce a single series."

71. Harrison 1984, 230–233. In the notes to this section printed in vol. II, 416, there are some confusing wrong numbers, which I take this occasion to correct. Note 9 should read "S I–II, riders 2–7" (not 1–6). In note 10, read "S III–V, riders 8–13" (not 7–13). In note 17, read "S XVI–XIX, riders 44, 45, 45*, 45**, 46, 47" (not 44–49). In note 18, read "S XIX–XXI, riders 48–53 (not 50–55). In note 19 read "S XXII–XXIII, riders 53*, 54–58 (not 56–60). Beschi agrees that these ten groups of riders represent the ten Kleisthenic Tribes.

72. Beschi 1984, 8, 18.

73. Beschi 1984, 18–19.

74. Beschi 1984, 15.

75. Although both wear Thracian cap, chlamys, and *chiton exomis,* west 8 has high-topped Thracian boots, whereas west 15, alone of all figures in the Parthenon frieze, wears sandals whose straps were added in metal, so presumably "golden." Also it appears that his chiton is much wider, i.e. richer in cloth and so more luxurious, than that of west 8.

76. Rhodes 1981, 685.

77. It is difficult to fit these young men to any official titles that have come down to us in connection with the organization of Attic festivals. Beschi 1984, 20–22, lists those who accompany the chariots as *athlothetai* (administrators of the contests), but the description of the duties and responsibilities of the *athlothetai* in Aristotle, *Athenaion Politeia,* 60 (see commentary in Rhodes 1981, 668–676) indicates that they had financial responsibilities such as would have been entrusted only to grown men. All the heads of the chariot marshals on the south frieze are now missing, but Carrey saw most if not all of them as beardless (admittedly Carrey is often mistaken about beards). On the north, 45 was certainly beardless. Thus it seems no more probable that these figures are *athlothetai* than that the beardless east-frieze figures in the groups of standing men flanking the gods: east 21, 22 and 44 are to be taken as Archons and east 19 as the Secretary to the Thesmothetai, a suggestion made recently by Ian D. Jenkins, "The Composition of the So-Called Eponymous Heroes on the East Frieze of the Parthenon," *AJA* 89 (1985), 121–127. It is a misconception of Greek iconography to think that a grown man can be "idealized" into an adolescent. Each age has its own ideal form. Gods and heroes specially concerned with the growing up of young males, such as Hermes, Dionysos, and Herakles, may be shown sometimes bearded, sometimes beardless, but neither form is more ideal than the other.

78. Plutarch *Pericles,* 37, 3. The date is given in *Ath. Pol.* 26, 4. For a full discussion see Rhodes 1981, 331–335.

79. Beschi 1984, 8.

80. Beschi 1984, 8–9.

81. Beschi 1984, 11–12.

82. *Inscriptiones Graecae, editio tertia,* I, fasc. 1, ed. David M. Lewis (Berlin and New York, 1981), no.

474, line 86. The Kanephoros depicted on a volute-krater from Spina by the Kleophon Painter, John D. Beazley, *Attic Red-Figure Vase-Painters* (Oxford, 1963), 1143, no. 1; Nereo Alfieri and Paolo Enrico Arias, *Spina* (Munich, 1958), pl. 87, has long hair hanging down her back.

83. This is an old custom, still observed in many places today. For examples in Bronze-Age wall paintings from Thera, see Davis 1986, 403–404, and Marinatos 1984, figs. 44–46.

84. The "marshal" who beckons to the southern pair of maidens from beyond the central group corresponds to those who face the two pairs of Kanephoroi belonging to the northern procession.

85. Beschi 1984, 9, retains the usual designation of the objects carried by maidens 12–13 and 14–15 as *thymiateria* against John Boardman, "The Parthenon Frieze—Another View," in *Festschrift für Frank Brommer* (Mainz, 1977), 40–41, who wants to see them as part of the loom on which the peplos was woven. It seems to be regular for two figures to accompany a *thymiaterion*. Compare the two youths flanking the *thymiaterion* in the sacrifice scene on the Spina volute-krater, above, note 82.

86. Manolis Korres, "Der Pronaos und die Fenster des Parthenon," *Parthenon-Kongress Basel* 1984, 47–54.

87. Institut Français d'Istanbul, *Fouilles de Xanthos*, III, *Le Monument des Néréides, L'Architecture*, by Pierre Coupel and Pierre Demargne (Paris, 1969), pl. 78.

88. Inez S. Ryberg, *The Rites of the State Religion in Roman Art, American Academy in Rome Memoirs*, XXII (Rome, 1955), pl. 11, fig. 22 a–b.

89. Ryberg 1955, pl. 53, fig. 80 a–b, and pls. 54–55, fig. 82 a–e.

90. Opinions on the identification of the individual figures in the central scene are far from unanimous. Brommer 1977, 263–270, lists and discusses the various opinions. I follow those who see the grown man and woman of the scene as the Archon Basileus and his wife, the Basilinna. More frequent is the interpretation of the woman as the Priestess of Athena Polias: see Erika Simon, "Die Mittelszene im Ostfriese des Parthenon," *AthMitt* 97 (1982), 127–144. Not only does this latter interpretation give a less satisfactory explanation for the two seats being carried by the girls, but it has the disadvantage of coupling the Basileus, an annually elected official of the Democracy, with a priestess whose office was hereditary in the genos of the Eteoboutadai. This would make her the representative of a single aristocratic segment of the state rather than the ritual embodiment of the fertility of the whole Demos, as the Basilinna was in her sacred marriage.

91. For the storage of the peplos, see Nagy 1984.

92. Walter Burkert, "Kekropidensage und Arrhephoria," *Hermes* 94 (1966), 1–25. The Arrhephoroi made the ritual beginning of the weaving of the peplos at the festival of the Chalkeia in the autumn. The weaving was then carried on by the numerous *ergastinai*, including both maidens and married women. As nine months elapsed between the beginning of the peplos and its delivery at the Panathenaea of the following year, a symbolic equivalence of the peplos and the child Erichthonius seems not unlikely.

93. Thucydides I, 2 contrasts the Athenians, who always inhabited the same land, with the other Greeks, who took part in migrations, and he has Pericles stress this fact in his Funeral Oration, II, 36.

94. For a very full and convincing treatment of the Eponymoi, see Uta Kron, *Die Zehn attischen Phylenheroen, AthMitt, Beiheft* 5 (Berlin, 1976). Add Evelyn B. Harrison, "The Iconography of the Eponymous Heroes on the Parthenon and in the Agora," in *Greek Numismatics and Archaeology, Essays in Honor of Margaret Thompson*, eds. Otto Mørkholm and Nancy Waggoner (Wetteren, Belgium, 1979), 71–85; Uta Kron, "Die Phylenheroen am Parthenon-Ostfries," in *Parthenon-Kongress Basel* 1984, 235–244.

95. Felix Eckstein, "Die Gruppe der sog. Phylenheroen am Parthenon-Ostfries," in *Stele* [volume in memory of Nikolaos Kontoleon] (Athens, 1980), 607–614, suggests that the standing male figure, east 18, is a marshal in conversation with east 19. Since this identification reduces the number of figures flanking the gods to nine, Eckstein questions their identification as Eponymoi. Those who take east 18 as a marshal argue that he does not lean on a stick, but Kron 1984, 239–240, notes that the closeness of his left arm to his body suggests that he had a stick propped under his left armpit. Such a stick could have been hidden behind his hanging himation and appeared only below its hem, where the stone is now broken away. One can compare a very similar figure on a red-figure cup in Omaha, *Corpus Vasorum Antiquorum, Joslyn Art Museum*, by Ann Steiner, fasc. 1 [U.S.A. Fasc. 21] (Omaha, Nebraska, 1986), pl. 37, 2.

96. This gesture is directed to the first pair of maidens south of the group of standing males, east 18–23, not to east 18, as Jenkins 1985, 123, suggests. Since east 18 has his back to the maidens, those who would make him a marshal must assume that he is leading the maidens, but that is not what these "marshals" do. We have evidence both from literature and from vase-painting that the Kanephoros herself is the leader of the *pompe*. In Aristophanes' *Acharnians*, line 242, Dicaeopolis says, "Let the Kanephoros go in front," and in the procession to Apollo on the volute-krater in Spina (above, note 82) the Kanephoros leads. A bearded man, priest or official, *receives* the procession. Since the existence of a smaller frieze above the entrance to the cella of the Parthenon raises the possibility that the paraphernalia of the actual sacrifice were shown there, it could be that representation of the Kanephoroi with the baskets actually on their heads was reserved for that scene. It may well be, then, that the maidens on the larger frieze are receiving rather than giving over their baskets. Those of the youngest contingent

are being called to receive theirs. It seems clear that Kanephoroi were not simply virgins but virgins ripe for marriage. Dicaeopolis says to his daughter, "Happy the man who will wed you!" (*Acharnians*, lines 254–255). See also *Lysistrata*, 646–648, where as in *Acharnians* the beauty of the Kanephoros is stressed. Thus the acceptance of the Kanephoroi on the large frieze by young men may represent the readiness for marriage of both sides, reinforcing the theme of biological continuity that is a leitmotif of the large frieze.

97. First discussed by A. W. Lawrence, "The Acropolis and Persepolis," *Journal of Hellenic Studies* 71 (1951) 111–119. Margaret Cool Root, "The Parthenon Frieze and the Apadana Reliefs at Persepolis," *AJA* 89 (1985), 103–120.

98. See Esther Pasztory's paper elsewhere in this volume.

MARTIN J. POWERS
The University of Michigan

Rival Politics and Rival Tastes in Late Han China

It is a remarkable property of art that purely physical features of form can stand for deeply cherished human values, whether aesthetic, moral, or social. Such equivalences are not obvious, however, and preferences in art or architecture generally seem less consequential than preferences in morality or politics. Yet often enough in history, conditions may occur whereby differences in architecture, art, or even clothing can lead to bloodshed. One thinks of England during the age of Cromwell or of China during the cultural revolution. Here, I shall argue that such a state of affairs occurred in China during the Latter Han dynasty, A.D. 25–220.

Rivalry in taste presupposes that people are aware of one another's purchases and possessions. What kinds of art did people purchase and display in early imperial China? During the Latter Han dynasty, rich and middle-income families alike were fond of erecting decorated shrines, towers, and tombs to deceased relatives and teachers. The popularity of the practice is understandable in view of the multifarious religious and social functions fulfilled by funerary monuments. A shrine for a respected elder at once allowed the departed to rest in peace, encouraged him or her to visit blessings upon the living, demonstrated the piety of the patrons and, incidentally, verified the extent of their financial resources. Rewards for such displays of piety were substantial: an enhanced reputation within the community and even the potential for a position within the imperial bureaucracy. The consequences of stinting on the funeral were correspondingly grim. The dead would send curses upon the living, who might also forfeit eligibility for public office. Moreover, according to one reliable source, a paltry funeral was likely to cause one's neighbors to become strangely uncooperative.[1]

These many incentives encouraged the production of a large number of decorated funerary monuments during the first and second centuries A.D. (figs. 1, 2). Many stones and some complete monuments still remain. Of these the greatest number by far is to be found in the vicinity of modern-day Shandong. Judging from the scattered inscriptions that remain, most of these monuments were commissioned by families of local renown whose members achieved or aspired to low- or middle-ranking positions within the bureaucracy. They were proud of their learning and they boasted of their piety in written eulogies. These same concerns are evident in the imagery of their tombs and shrines. Typically we find illustrations of famous men and celebrated moments from the Confucian classics: there are noble statesmen such as the Duke of Zhou, who willingly surrendered the reins of state to the rightful heir; there are unknown yet talented individuals such as the young boy who astonished Confucius with his wisdom (fig. 2); there are martyrs such

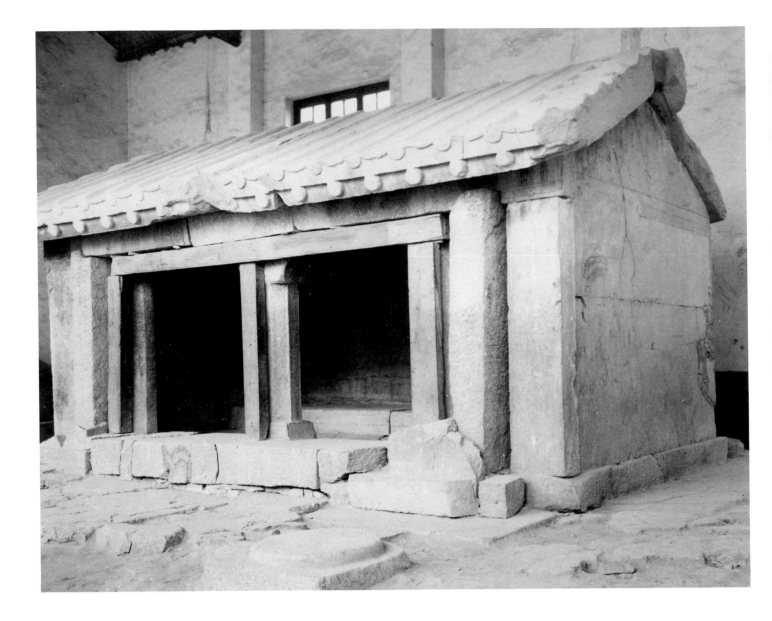

as the loyal Gongsun Chujiu who died at the hands of a ruthless tyrant; and there are righteous women who chose to die rather than betray their duty (fig. 3).[2] The heroes and heroines of these stories are disciplined, altruistic people for whom private gain remains inconsequential compared to public duty. This ethos often was adopted in public by those seeking public office, for the central government, aware that corruption was a major source of revenue loss, had little interest in recruiting men with a reputation for greed.

Not all images engraved on these stones are narrative scenes drawn from the classics. Strange animals and deities are frequently seen. Some of these protect the soul of the deceased; others ensure its happiness in paradise. A considerable number, however, are derived from classical sources and, like classical narrative scenes, speak clearly to the initiated of contemporary political and moral concerns. The phoenix, for example, was a familiar image from classical poetry and alluded to the desire of talented men to serve in government, i.e., to get a

1. Stone offering shrine at Xiaotangshan, Shandong, c. first century A.D.

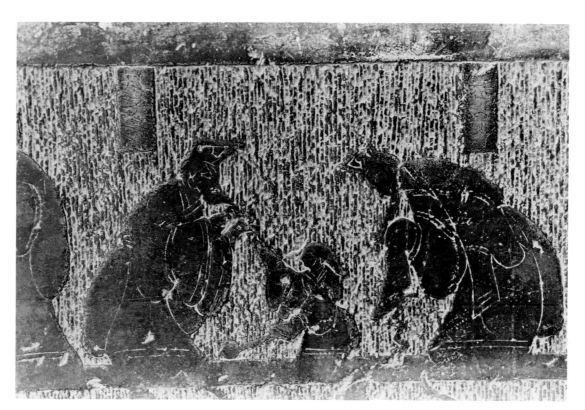

2. Stone funerary engraving with Confucius (left), Lao zi (right), and the boy Xiang Tuo with a push-toy (center), who astounded Confucius with his wisdom, from Shandong, second century A.D.
Photograph courtesy of Shandong Provincial Museum

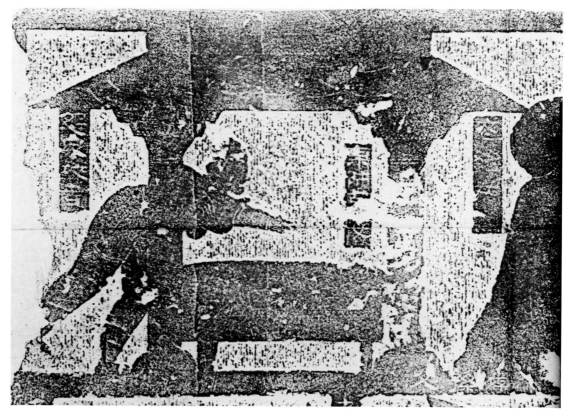

3. Illustration to the story "jing shi jie nü," in which a young woman places herself in her husband's bed, knowing an assassin plans to kill him; detail, rubbing of an engraving from the offering shrine of Wu Liang, Jiaxiang, Shandong, c. A.D. 151
Photograph courtesy of the Rübel Asiatic Research Collection, Fine Arts Library, Sackler Museum, Harvard University

job (fig. 4). Many of the stranger-looking creatures can be found in Han classics. These are the heavenly omens whose appearance or absence signaled success or failure in such areas of administration as welfare or official recruitment. The hybrid beast, for instance, appears miraculously only when the government takes care of the widowed and the orphaned (fig. 5). The crimson bear appears only when the government welcomes the humane and shuns the corrupt.[3]

Heavenly omens and narrative scenes alike share a source in classical learning and a thematic focus on issues of public concern. Such qualities were fundamental to the classical values espoused by the Han scholar-gentry. But the appeal of classical values—and consequently, classical subjects in art—was limited, for most citizens did not appreciate knowledge as they did money. The official standard of social value maintained, at best, an uneasy truce with popular standards. For example, the Confucian ethos valued farmers above merchants because farmers generated wealth through their own labor whereas merchants, it was claimed, lived like parasites from the wealth generated by others. As early as 178 B.C. the statesman Chao Cuo had the insight to recognize the contradictions introduced by this new standard of social value: "At present the laws and regulations degrade the merchant, but the merchant is already rich and honored. Laws and regulations dignify the farmer, but the farmer is already poor and degraded. Thus what practice honors is what rulers degrade, and what the petty officials debase is what the law dignifies."[4]

In Han China those openly devoted to scholarly values were rare; those openly devoted to material gain were many. At the bottom of the social scale were the villagers anxious to strike it rich; at the top were the great merchants and the court eunuchs whose ample incomes encouraged material indulgence. What kind of art did such men foster? The answer is not difficult to find. As early as the first century B.C the newly rich merchants began to appropriate for themselves the signs of status formerly possessed by royalty:

In the style of their carriages and clothing [the great merchants] usurp the prerogatives

4. Two phoenixes and a heavenly tiger alight on the roof of a scholar's home, detail, rubbing of a tomb engraving from Tongshan, Jiangsu, second century A.D.
Photograph courtesy of Xuzhou Municipal Museum

of dukes or kings; their palaces and mansions overstep the limits prescribed by the regulations; they . . . revel in feats of strength, football games and cock-fighting. The singing girls of Zhongshan play their seductive music on the balconies of their halls, while drums beat and spirited dancing takes place below. Their wives and daughters dress only in the finest silks and their maids and concubines trail trains of finest linen. The result is that we see the farmer abandoning his plow and toiling no more. The people become vagabonds and grow idle—why? Because, while they toil, others reap the fruit of their labor.[5]

This passage reads a bit like the script for a contemporary television soap opera: rich men in fancy vehicles, grand estates, seductive entertainers, gambling, and lots of beautiful women. These were the traditional signs of rank and wealth formerly enjoyed only by the nobility. The Han empire had put an end to the feudal system of hereditary rule, and as the old system of social relations deteriorated, commoners of means appropriated for themselves the old signs of status. This materialist tradition of taste developed alongside and in contrast to the tradition of classical taste. As products of a feudal system, signs of material success highlighted the personal wealth,

5. Hybrid beast and various winged creatures, detail, rubbing of a tomb engraving from Shilipu, Jiangsu, second century A.D.
Photograph courtesy of Xuzhou Municipal Museum

prerogatives, and pleasures of special individuals. They did not raise questions of public concern. At first, adherents of the two systems were able to coexist amicably, but it was not long before aesthetic differences gave way to competing systems of social value, contrary notions of right and wrong.

The conflict can be traced most clearly in the relations between provincial scholars and the court. In the early years of the Latter Han, cooperation between court and the provincial elite was exemplary. The dynasty was ushered in by an enthusiastic classical revival supervised by Emperor Guangwu and his son, Emperor Ming. Both rulers reduced the display of luxurious ornament at court and discouraged ostentation of any sort, establishing a standard for classical taste in the capital. They also created and maintained chairs in the classics at the imperial university, attended to public duties such as education and welfare, and otherwise promoted a Confucian agenda. This was surely the golden age of political participation for provincial scholars. The golden age lasted less than a century. Emperor He, who reigned from A.D. 89 to 106, was in no position to set standards of taste. He reigned feebly at the mercy of Empress Dowager Dou and her brother until A.D. 92, when the eunuch Zheng Zhong helped him defeat the consort family. As a reward Zheng was ennobled as a marquis, a title he would pass on to an adopted son.[6]

The consequences of soft imperial leadership for classical values soon began to show. Emperor An (A.D. 107–125), dominated by Empress Dowager Deng, was as weak in classics as in politics. It is said that the doctors at the imperial university hardly bothered to lecture, and that weeds began to overgrow the neglected campus. Officials likewise neglected their mourning rites. The more committed intellectuals perceived a trend and sought to revive classical values. Chen Zhong, for instance, tried to recruit committed Confucian scholars, and Liu Kai convinced the empress dowager to reject candidates who fudged on funerary rites. But at the same time that the empress dowager promoted classical values, she unwittingly laid the foundations of extravagance, for when she died in A.D. 121, she left the emperor no choice but to turn to the eunuchs, his only allies at court. With their aid he destroyed the empress dowager's family and, naturally, ennobled all those who had helped him. These eunuchs, unhindered by normal standards of bureaucratic behavior, sought to outdo one another in spending their newly-found wealth. They proclaimed their new status with traditional signs of material success: the silks, the brocades, the fine carriages, and the beautiful women. In the process they sometimes ended up on the wrong side of the law and often got away with it. They were able to do so not because they were eunuchs but because their power was granted directly by the emperor and, consequently, was not subject to legal checks and constraints.[7]

It was at about this time that Confucian statesmen such as Yang Zhen began to preach the virtues of the "pure" and to complain about the "filthy," code words for competing sets of social-aesthetic values. In A.D. 124 Yang Zhen delivered one sermon too many; the eunuchs who had helped Emperor An had him silenced forever. His friends, seeing birds gather and chirp about his tomb, knew that Heaven had sent them to mourn his death. The carving of birds at his tomb was a public statement that Yang had died unjustly, since Heaven itself had proclaimed his virtue. This method of claiming merit was not unique to Yang's supporters. Similar claims to virtue for lesser

men can be found in the many phoenixes adorning funerary monuments and very likely in the many corvine-like birds gracing the walls of tombs and shrines, for crows were believed to be exemplars of filial piety (fig. 6).[8]

The eunuchs managed to maintain their privileged position by helping the next emperor, Emperor Shun (A.D. 126–145), sit securely on his throne. Among those who helped him was the eunuch Cao Teng. Cao Teng is of special interest, for his family's vaulted tombs still lie in Bo County. All the tombs have been heavily plundered, but judging from what remains, the Caos do not appear to have been guilty of stinting on funerals. Many tombs contained fragments of jade suits, curios carved in precious stone, and other objets d'art in porcelain, metal, and ivory. One decorated tomb belonging to the clan closely resembles better-preserved tombs farther west in its structure, iconography, and style of engraving (fig. 15). The better-preserved tombs are situated in Mi County, Henan (figs. 7, 8). All these tombs were architecturally complex for the time, with vaulted ceilings spanning spacious chambers and richly carved doors and pillars (figs. 8, 9). The wall paintings and engravings in these tombs contain not a single hint of classical subject matter but instead display fashionably-dressed women (fig. 10), well-stocked kitchens (fig. 11), fine horses and carriages (fig. 12), and even such trivial items as the tomb occupant's favorite pet (figs. 13, 14). A full description of these tombs and their mural schemes would require a separate monograph, but suffice to say that the Cao clan tombs and others like them bear little in common with better-known monuments that sport classical imagery.[9]

The differences extend to features of structure as well as iconography. Tombs with classical imagery tend to have cantilevered ceilings (figs. 7, 16) and are built on a post-and-lintel system far simpler in conception than the vaulted chambers of the Cao clan tombs. Classical engravings, moreover, tend to be confined within the span of a single stone so that they could be carved aboveground and assembled as complete units in the tomb (fig. 2). The vaulted tombs follow the much costlier method of

6. Corvine-like birds pecking the ground, detail, rubbing of an engraving from the tomb lintel, at Maocun, Jiangsu, second century A.D. Photograph courtesy of Xuzhou Municipal Museum

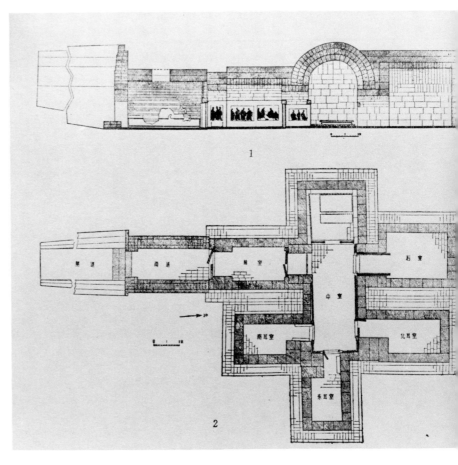

8. View of greeting chamber entrance, Dahuting tomb #1, Mi County, Henan, with vaulted passageway to the central chamber at upper left, late second century

7. Cross-section and plan of Dahuting tomb #1, Mi County, Henan. Passage to the tomb entrance extends farthest to the left (south); entrance doors lead to greeting chamber, which leads to grand, vaulted entertainment chamber perpendicular to it. Two northern chambers are the bedroom or coffin room (left) and harem (right). To the east is the kitchen; the other southern chamber represents the courtyard with stables, carriage house, and granary

carving compositions across several stones after the tomb had been assembled (fig. 13). The engravings and paintings of the vaulted tombs are more naturalistic, employing parallel perspective, three-quarter views, and attention to texture and other devices designed to record the quality and bulk of material things (figs. 10–14). But the essential difference between the two traditions is one of taste expressed in iconographical preferences: the engravings of the scholarly monuments frequently address matters of public concern, while the walls of the vaulted tombs display only the private possessions and cherished dreams of the tomb occupant.

The fullest evidence of this is to be found in Dahuting tomb #1 in Mi County, because it is the best preserved of these tombs. There, an entire chamber is devoted to the well-appointed kitchens of the tomb oc-cupant with their multi-burner stoves, wine presses, wine jars, scores of servants, and every variety of food in rich abundance (fig. 11). Other chambers display the tomb occupant's granaries, fine thoroughbreds, comfortable carriages, peacocks, macaques, and puppies. Unfortunately, due to restrictions on photography, only a few of these lively engravings can be illustrated here (figs. 12–14).

Yet another chamber is guarded by a large, toothy, Irish-wolfhound-like dog. The function of this magnificent beast is to guard the beautiful ladies who adorn the walls of this chamber (fig. 10). Here several women of higher rank are distinguished by elaborate coiffures with long hairpins, evoking Utamaro's beauties of a millennium and a half later. They sit idly, opening boxes of silks or cosmetics, munching snacks, or just

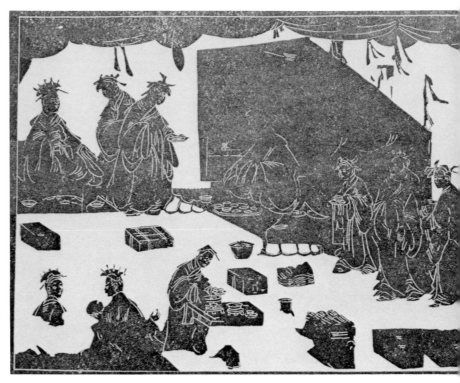

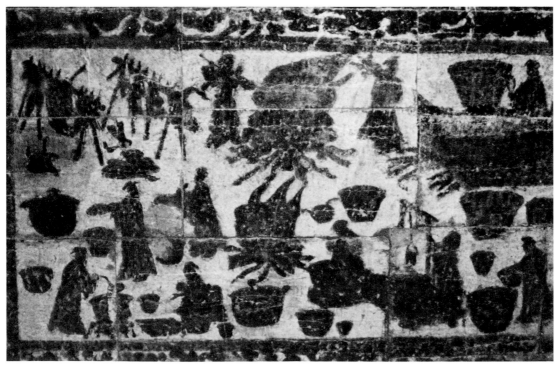

9. Winged tigers, deer, birds, and the mushroom of immortality amid cloud patterns; detail, carved door leading to the north or harem chamber, Dahuting tomb #1, Mi County, Henan, late second century

10. The tomb occupant's chief consort (seated on dais with screen), other consorts, and maidservants in the ladies' chambers; drawing of a rubbing of engraving from the west wall, north chamber, Dahuting tomb #1, Mi County, Henan, late second century
After An Jinhuai and Wang Yugang, "Mixian dahuting handai huaxiangshi mu ho bihua mu," *Wenwu* (October 1972), fig. 12

11. Kitchen scene with great boiling cauldrons (center), steamers (upper right), heavily-laden meat racks (upper left), a well (lower right), and numerous cooks; detail, east or kitchen chamber, Dahuting tomb #1, Mi County, Henan, late second century

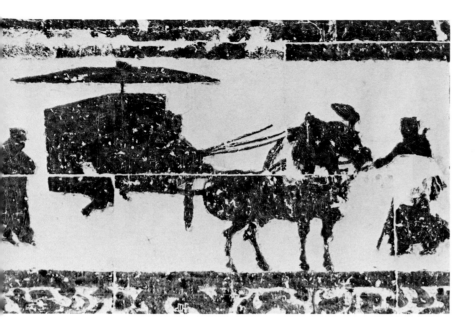

12. Single-horse carriage with covered sides, umbrella canopy, driver, and grooms. Note feathered crest on the horse's forehead and blank space in the midsection of the groom at right due to damage. Rubbing of an engraving, south (courtyard) chamber, Dahuting tomb #1, Mi County, Henan, late second century

waiting to be waited on. One woman in the foreground, more productively engaged, nurses a baby. The appearance of idleness in this scene is reinforced by the fact that the other walls of the chamber differ little in the range of activities shown. This is in sharp contrast to other chambers of the tomb, where an effect of endless variety is sought. It is not difficult to imagine why this look of languishment should have constituted part of the message of those engravings. The image of the idle, well-dressed beauty is common enough today in advertisements for luxury cars and brandy. More surprising is the fact that some men and women of the Han recognized the human cost of creating living emblems of surplus wealth. There was the Empress Dowager Deng, for instance, who took pity on the hundreds of women stuffed into the rear chambers of the palace in A.D. 106: "Now I am releasing them all, even to the women in the harem, who shall become ordinary citizens in order to free their pent-up feelings of frustration."[10]

Later in the second century, the official Lang Qi and the Confucian eunuch Lü Qiang both resorted to astrology to convince the emperor to release these palace prisoners of idleness, although with little effect.[11] Palace beauties were indispensable to a standard of social success that survived from feudal times into the Latter Han. In courtly circles the languishing beauty testified to success every bit as much as classical knowledge testified to worthiness in scholarly circles. For this reason we should not be surprised to learn that Dongyuancun tomb #2, in the Cao clan cemetery, sports large pictures of beauties on its walls just as at Dahuting #1—a tomb with which it shares a unique double-layered vaulting of brick and stone.[12] In these tombs the contrast between the monuments of the scholars and those of the court elite could not be clearer, for of all the emblems of luxury to be found in the more expensive tombs, none is so private as the ladies of the harem.

The public-private dichotomy can be construed as a matter of taste, but this taste had deep historical roots. Cao Teng, for instance, like many eunuchs of the time, used his influence at court to place friends and relatives within the bureaucracy, bypassing the usual channels of recommendation and review. Such practices signaled the beginning of the end of rational government. The distinction between public and private was fast wearing away, and with it the whole structure of liberal values important to middle-income scholars. The social critic Wang Fu, writing at this time, pinpointed the matter:

All those who are lords of states have forever desired to rule, but when it happens that one's rule is not recognized by the public, it is because those who are recruited for office are not worthy of office. The public has never known a shortage of men worthy of office, but when such men are not appointed, then all the officials become demoralized. If the ruler has the intention of attracting men worthy of office, but does not have the technique for obtaining them, or, if the officials have a reputation yet in reality have nothing to show for it, then the ruler will find himself dangerously isolated at court while the way of justice will be suppressed among the people.[13]

Up to this point Wang's language was fairly restrained. Further on in the same essay he laid bare the heart of the matter: "The way the lord of the state carries out his rule is by conducting affairs in a public manner. When public laws are promulgated then there is no way for disorder to arise in the law. Now the way that flattering

ministers benefit themselves is by means of private influence. When the government proceeds according to private interests then public law is destroyed."[14]

This is a perceptive analysis of mid-century social ills by a master critic. By this time the emperor's credibility was indeed sagging. In addition he had become dangerously isolated from the regular bureaucracy. His response was to turn increasingly for advice to his private aides, the eunuchs.

How did this situation come about? The pattern can be traced in several institutional changes throughout the four hundred years of the dynasty. For example, during the Former Han period the emperor's private purse was administered by the Privy Treasury or palace staff, while taxes for public use were handled by the Minister of Agriculture. This distinction was critical to bureaucratic rule because it insulated the public concerns of the bureaucracy from the private needs of the emperor. During the Latter Han the responsibilities of these two offices were fused. This change may have seemed innocuous or expedient at the time, but its implications were profound, for it blurred that distinction upon which the Han system of law and social mobility was founded. A similar confusion of roles occurred in the office of the Palace Assistant Secretary. This office inspected documents entering or issuing from the palace. Previously controlled by the Minister of Works, it came under the charge of palace aides (the Privy Treasury) during the Latter Han. Its censorial duties, however, were extended beyond the palace to include the general inspection of the central government.[15] In this way an important function formerly managed by the regular bureaucracy came under the jurisdiction of the palace staff.

The pattern of bringing regular bureaucratic functions within the administrative sphere of the palace was clearly to the advantage of eunuchs. During the Former Han, for instance, the office of the Regular Palace Attendant, who offered advice and guidance to the emperor, was never granted to eunuchs. During the Latter Han this office was staffed only by eunuchs. The ranks of the eunuchs were further enhanced when Emperor Guangwu created the Junior At-

tendants of the Yellow Gate. These officials assumed various secretarial duties and acted as messengers to the officials when the emperor was inaccessible. During the Latter Han these eunuchs saw to it that the emperor was frequently inaccessible, further widening the gulf between the civil bureaucracy and the palace. Small wonder the historian of the Latter Han complained that, "when the high officials wished to discuss state affairs, they had no means to get into the court. Therefore the emperor could not but employ the eunuchs with the fate of the empire."[16]

What does all this have to do with artistic taste? A great deal actually, because just as the scholars served their own interests by adopting cues for public concern in their art, the eunuchs fostered art forms derived from feudal cues for private prerogative. Indeed, the eunuchs and their clients became major patrons of art from the middle of the century onward. This was due in part to the fact that the eunuchs controlled the court painters and carvers, and were responsible for all aspects of court decoration.[17] But they were equally devoted to art patronage in their private undertakings, as is evident from a passage from the *History of the Latter*

13. The tomb occupant and his wife seated on dais, attended by servants; detail, stone engraving on the west wall, south (greeting) chamber, Dahuting tomb #1, Mi County, Henan, late second century

14. A puppy and possibly a cat beside the dais of the tomb occupant and his wife, detail, stone engraving on the west wall, south (greeting) chamber, Dahuting tomb #1, Mi County, Henan, late second century

15. Door guard, rubbing of an engraving from the foyer, Dongyuancun tomb #2, Bo County, Anhui, late second century
After Li Can, "Anhui boxian faxian yi pi handai zi zhuan he shike," *Wenwu ziliao congkan* (1978), no. 2, p. 173

Han: "[After the eunuch Shan Chao died, the four remaining eunuchs who had helped Emperor Huan] all competed in building their residences. Their storied buildings were magnificent and elegant, and the construction extremely skilful. Gold, silver, felt and feather decorations were used for their dogs and horses. They took many beautiful girls from good families as concubines whose precious ornaments were elegant and extravagant, imitating the standards of the palace ladies."[18]

The interest in dogs, finely bedecked horses, skillful decoration, and fashionable women is strongly reminiscent of the Cao clan tombs, Dahuting #1, and related tombs. The text and the tombs alike suggest that the eunuchs and their clients were heirs to a tradition of luxury consumption originating in the feudal courts. In place of heavenly omens they delighted in horses and dogs; in place of wise rulers they loved beautiful maidens. There are also those remarks about elegant ornaments. Just what kind of decoration was it that the eunuchs fostered at court and in their homes? Some clues can be gleaned from another text that describes the estate of the eunuch Hou Lan:

In A.D. 169 Hou Lan returned home for his mother's burial, constructing a burial ground and tomb on a large scale. At this time Zhang Jian, who was a commandery Investigator, charged Lan with being greedy and extravagant and having no regard for the property of others. [He charged that] Lan had . . . built sixteen residences, each with tall pavilions, ponds and parks, and that his halls and towers faced one another, decorated with brocade patterns, red lacquer [patterns] and the like, to the standard of the highest ranks, rivalling the imperial palace itself. He also constructed a tomb for himself with a vault [chamber?] of stone and twin towers.[19]

Typical decoration for brocade and lacquer in Han times consisted of cloud and animal decor (fig. 17).[20] This was the sort of decoration found in the imperial palace, and it was the sort one could find in Hou Lan's halls and pavilions. It was very different in tone from what appeared in the shrines of scholars but matches well the densely-packed cloud patterns that cover the doors of tombs in Mi County (fig. 9). There can be little doubt that the eunuchs, within the court and without, favored art-

ists who could achieve an effect of magnificence and dazzling complexity. To the eunuchs these features of style meant rank, honor, and material success, but to provincial scholars these same features of style represented corruption and the decline of rational government. Style had acquired the force of political assertion.

No incident reveals the assertive force of style so clearly as the great demonstration of A.D. 153, an event centered from beginning to end around monuments to eunuchs' and scholars' tastes. That year Zhu Mu, a Confucian scholar-official, was sent to Jizhou to bring peace to an unruly region. Zhu had been chosen for the job because of his earned reputation for principled, independent action. As chance would have it, the eunuch Zhao Zhong returned home that year to carry out funerary ceremonies for this father. The tomb he constructed was a red cape in the eyes of the Confucian bull. Like the Cao clan tombs it was lavishly designed and was furnished with such precious items as a jade suit and jade ornaments, as well as tomb figurines. When Zhu got wind of this he opened an investigation. Local officials, knowing his reputation, dispensed with formalities and simply broke open the tomb, destroyed the casket, exhumed the body, and confiscated Zhao's family possessions. The court retaliated by ordering Zhu into forced labor. The response of local scholar-officials to this action is quite telling. Just as Yang Zhen's followers had publicized his righteousness with images of heavenly omens, a local clerk in Jizhou wanted Zhu's portrait displayed as an inspiration to others, much as a portrait of Confucius might be displayed in school hallways. Zhu was to become a classical exemplar canonized in art. Several thousand university students, however, heard of the affair and took more direct action. They gathered in a mass demonstration and delivered a statement to the emperor supporting Zhu Mu. This marks the first recorded student demonstration in Chinese history.[21]

The document they posted was a product of the same ethos and taste as the engravings on scholars' shrines. It was studded with classical allusions, references to sage kings and worthy ministers, but at the same time it was shot through with intense emo-

tion. The students charged that the court had been favoring the eunuchs, whose relatives could be found in offices all over the empire, offices that the students must have felt belonged rightfully to them. In addition they charged that the eunuchs competed among themselves like beasts, gnawing away like rats at the lives of the common people. When Zhu Mu did his duty by attempting to clean them up, the eunuchs slandered him. The language at this point is far from reverent. Freely rendered, it may be read: "The whole empire knows what really happened. Everyone thinks of Mu as the equal of the ancient sages. If the dead were conscious, the sage kings Tang and Shun would wax wroth in their graves!"[22] They went further still, insinuating that the emperor was nothing but a front for the eunuchs: ". . . *their* hands control the appointments and *their* mouths utter the laws!"[23] In the face of all this, they argued, only Zhu Mu had the courage to disregard his own safety by doing what was right. The statement

16. Cross-sections and plan of a tomb from Cangshan, Shandong, dated A.D. 151: (1) tomb entrance viewed from inside, (2) tomb entrance viewed from outside, (3) east wall of the front chamber, (4) floor plan, with north and the coffin chambers to the right, (5) a longitudinal section viewed from the east, (6) plan of the ceiling over the front chamber; scale one meter
After Zhang Qihai, "Shandong cangshan yuanjia yuannian huaxiang shi mu," *Kaogu* (1975), no. 2, fig. 1

17. Winged tigers, deer, birds, and the mushroom of immortality amid cloud patterns; detail, lacquer tray from a tomb at Xutai, Jiangsu
Photograph courtesy of Yangzhou Municipal Museum

abandoned in Han times, but the students employed the strongest language they knew to express their resolve. Emperor Huan acquiesced and pardoned Zhu.

This little episode is indicative of the breakdown of regular, legal channels of communication between the provincial bureaucracy and the court. The local people knew they could not expect justice from above and so took matters into their own hands. It also tells us much about the chemistry of art, classical imagery, and public opinion in the mid-second century. Zhao Zhong made a public statement about himself and his father with the size and splendor of his tomb. He did not issue pamphlets describing the contents of the tomb, yet everyone knew about them, because in Han times funerary monuments were by nature public. Zhu Mu despised the eunuchs for their lawlessness, but he set out to prosecute this eunuch for the physical quality of his funerary art. When Zhu Mu suffered retaliation, the response of the elite in the community was to canonize him by displaying his portrait, setting the image of a public exemplar against the tokens of private consumption that marked Zhao's tomb.

The Zhu Mu affair shows well how thin a line separated artistic taste and social values, and as the century progressed the distinction grew more tenous still. Consider only what had happened to artistic taste within the court itself. Emperors Guangwu and Ming had christened the dynasty with a vigorous classical revival, a revival that rejected the elaborate decorations and lavish court styles typical of the previous period. By the third quarter of the second century the wheel had spun full circle again. Emperor Ling (A.D. 168–189) embraced wine, women, fine horses, lavish architecture, and fancy curios with a gusto that would have made his illustrious ancestors wince. In doing so, he not only rejected classical standards of taste. He buried, too, the distinction between public and private, as his minister Lü Qiang attempted to explain in a discourse on the nature of private and public wealth:

All the wealth of the world comes from [the operation of nature in] Yin and Yang and [therefore] comes back to your majesty. Since it [ultimately] returns to your majesty, how

ends with a moving appeal to the emperor: "It is not that we love disgrace and reject honor. It is not that we love death and reject life. But we feel that the ruler's laws do not promote justice and we fear that Heaven's precepts have too long been missed. Therefore, with all our hearts and filled with concern, we submit this proposal: ready to be branded and to cut off our feet, we wish to substitute ourselves for Zhu Mu."[24]

The reference to branding and the severing of limbs probably was rhetorical. These ancient forms of punishment had been

should you make a distinction between private and public? Yet now the Bureau of Palace Craftsmen is collecting all the treasures of the empire's [citizens] while the Bureau of the Imperial Wardrobe is collecting all the silk. The Western Garden [of the palace] draws upon the collected produce of the Minister of Agriculture and your private stables gather together horses meant for public use . . . This increases the suffering of the people and much is wasted but little actually contributed. Corrupt officers take advantage of the practice and the people take the brunt of it. And then the sycophants like to contribute their own possessions . . . and this is how it all started.[25]

Having exposed the breakdown of the distinction between public and private, Lü proceeded to describe the features of rational government:

According to the old statutes, when choosing personnel for the three ministries they would select a man, then place him in a minor position so as to observe his behavior and assess his ability. Then, after testing him, he would be assigned duties and his performance would be checked. If there was no fault, then eventually he might be made a secretary. If the Secretariat reported something amiss, this would be sent to the Commandant of Justice who would look into the matter and carry out a sentence if appropriate.[26]

Lü ended his argument by noting that too many contemporary officials were appointed through imperial favor, bypassing the regular channels. Their performance was not subject to checks and controls, and so there was no way to restrain them from utilizing public institutions for private gain.

Although Lü begins his discourse by claiming that there is no distinction between public and private, this is clearly a rhetorical ploy to convince the emperor that he need not personally own all the produce of the empire in order to think of it as his own. He then details how the emperor's private staff extended its greedy grasp to the objets d'art, silks, horses, and even the grain belonging to the citizens. The feudal aesthetic of display, the politics of consumption, had consumed the court.

Lü's plea for a return to rational, bureaucratic government is stirring, but there was little that he or others could do to reverse the trend. At the time Lü Qiang wrote this

memorial, the empire had little life left in it. Just over a decade later, all that remained of the capital was a charred area some forty kilometers across; most of the lavish tombs of the court elite in the region had been burnt or plundered.[27]

In retrospect, a certain reason to all this madness can be seen. The feudal age had bequeathed to Han China a certain symbology of social value expressed in cues for surplus wealth. With few exceptions this symbology was retained by the imperial and princely courts and was available for appropriation by merchants, brokers, craftsmen, eunuchs, and others who measured human worth in strings of cash. But the imperial court with its eunuchs, its beauties, and its traditional symbology remained in essence an anachronism, albeit a powerful one. For the imperial bureaucracy had been designed to weaken and ultimately replace a small group of feudal powers with a multitude of functionaries dependent on the government for authority. This gave rise to a new class of men whose social worth by definition was not contingent upon heredity or wealth. In time these men developed their own symbology of human worth coded with signs for knowledge, piety, and integrity and stripped of overt cues for material abundance. They did this not because they cared less for wealth, but because their source of strength did not derive from control of material as much as of human resources. Many of this class possessed limited financial reserves, but they were able to incite the cooperation of large numbers of officials and citizens through reputation and persuasion. For this very reason their powers were circumscribed, because the tide of public opinion was unpredictable. Their reputation was both their horse and their halter; hence, their overriding concern with subjects of public interest and their need for a system of visual emblems distinct from those of the old order.

At this stage in our discussion, the contradictions exposed in the passage by Chao Cuo at the beginning of this paper acquire a prophetic ring: "At present the laws and regulations degrade the merchant, but the merchant is already rich and honored. Laws and regulations dignify the farmer, but the

farmer is already poor and degraded. Thus what practice honors is what rulers degrade, and what the petty officials debase is what the law dignifies."

The government of the Han dynasty was a noble experiment whose history was shaped largely by the strain of just such fundamental conflicts. Disharmonies of taste in the dynasty's later years formed part of a larger drama in which society attempted to reconcile contradictions between public opinion and private influence as determinants of political power. The universal medium of exchange in matters of private influence, then as now, was wealth and its various tokens, and this left its imprint on the taste of the eunuchs, merchants, and the court. Public opinion was sensitive to emblems of character—what we now call "personality"—embodied in living exemplars of piety, frugality or integrity, and the art of the Shandong scholars was rich with images for these ideals. These different modes of persuasion—one new and self-conscious, the other old but tough—circulated as shifting attitudes among the men and women of the Han but took physical shape in the works of art that survive to this day. Properly understood, these works allow us a glimpse into the hearts of those who carried them to their graves.

1. For an introduction to Han funerary monuments, funerary practices, and patronage, see Martin J. Powers, "Social Values and Aesthetic Choices in Han Dynasty Sichuan: Issues of Patronage," in *Stories from China's Past* (San Francisco, 1987), 54–63; Robert Thorpe, "Qin and Han Imperial Tombs and the Development of Mortuary Architecture," in *Quest for Eternity* (San Francisco, 1987), 17–37; Wu Hung, "Myths and Legends in Han Funerary Art," in *Stories from China's Past* (San Francisco, 1987), 72–81.

2. For an estimate of the numbers of surviving funerary engravings in various regions of China see Li Falin, *Shandong Handai huaxiang yenjiu* (Jinan, 1982), ch. 7. For readers of Western languages, the standard reference for the stories illustrated at the Wu family shrines is Eduard Chavannes, *Mission Archéologique dans la Chine Septentrionale*, 2 vols. plus atlas (Paris, 1909–1915).

3. James Legge, trans., *The Chinese Classics*, 5 vols. (Hong Kong, 1960), 4:493. For a discussion of omens in Latter Han art, see Martin J. Powers, "Hybrid Prodigies and Public Issues in Early Imperial China." *Bulletin of the Museum of Far Eastern Antiquities* 55 (1983), 1–50.

4. Nancy Swann, trans., *Food and Money in Ancient China: The Earliest Economic History of China to A.D. 25* (Princeton, 1950), 166.

5. Huan Kuan (active first half of first century B.C.), *Yantie lun* (Shanghai, 1974), 9.20; translation based on Esson M. Gale, *Discourses on Salt and Iron* (Taibei, 1973), 56.

6. For an account of Emperor Ming's artistic policies see Martin J. Powers, "The Dialectic of Classicism in Early Imperial China," *Art Journal* (Spring 1988), 20–25. For the early history of eunuch intrigues at court, see T'ung-tsu Ch'ü, *Han Social Structure* (Seattle, 1972), 463–465.

7. Sima Biao (A.D. 240–305) and Fan Ye (d. A.D. 445), *Hou han shu* (Beijing, 1965), 79.2547; 39.1307. For the English rendering, see Ch'ü T'ung-tsu 1972, 464–466. Ulrike Jugel, in his authoritative study of eunuchs, suggests that the stereotype of the evil eunuch in the Chinese histories is based largely on misconceptions compounded by the biases of scholars towards mutilated men. See Jugel, *Politische Funktion und Soziale Stellung der Eunuchen zur späteren Han Zeit* (Wiesbaden, 1976), 88–98. Jugel's discussions of eunuch class origins, education and so on are a useful check on the uniformly anti-eunuch tone of the histories. Still, it would be a mistake to view the historical account of eunuch activities as primarily the product of bias, as one might view traditional accounts of women, for instance. That the historian treats eunuchs of a Confucian persuasion the same as other Confucian scholars suggests that the behavior of eunuchs was not thought to be a direct product of their sexual condition. More likely, they were viewed with suspicion because many of them were willing to mutilate themselves for no apparent reason other than access to court circles, much the way merchants were viewed with suspicion because of their attachment to material wealth. In any case, our recognition that the sexual status of eunuchs did not make them evil does not require us to ignore other aspects of their status which made them prone to mischief, namely, the fact that their authority was not subject to the same checks and reviews as other bureaucrats. Such checks did not guarantee responsible behavior among bureaucrats but by and large kept officials within certain bounds. Recent as well as ancient history provides numerous examples of what people do with power when that power remains unchecked. In the end it is this which separated the eunuchs from the scholars, and a close reading of the histories suggests that the scholars knew this.

8. *Hou han shu* 54.1761; 54.1767–1768. For the association of the crow with filial piety see Shen Yue (441–513), *Song shu* (Beijing, 1974), 28.813; 28.839; 28.841; Ouyang Xun (557–645), *Yiwen leiju*, comp., Wang Zhaoying (Hong Kong, 1973), 92.1591–1592.

9. Information regarding the dimensions and layout of Dahuting tomb #1 and its mate, Dahuting #2, can be found in An Jinhuai and Wang Yugang, "Mixian dahuting handai huaxiangshi mu ho bihua mu," *Wenwu*, (October 1972), 49–50; Jan Fontein and Wu Tung, *Han and T'ang Murals* (Boston, 1976), 50–53. Together with my wife Amy, I spent three days visiting the two tombs at Dahuting and three others at Houshiguo nearby in early spring, 1981. In China no scholar, native or otherwise, is allowed to photograph unpublished materials, and so we photographed only those walls that had appeared in Chinese journals to that point. Therefore, the descriptions of the mural schemes of each room presented here are based upon detailed notes taken at that time. Here I should also like to express my gratitude to the archaeological team of Mi County, and in particular to Mr. Wei for his courtesy and kind help during our brief stay there. For information on the Cao clan tombs see Li Can, "Boxian cao cao zongzu muzang," *Wenwu*, (August 1978), 32–45. See also Li Can, "Anhui boxian faxian yipi handai zizhuan he shike," *Wenwu ziliao congkan* 2 (1978), 142–175; Li Can, "Lue tan caoshi yuan mu 74 hao zi zhuan," *Wenwu*, (December 1981), 68–70; Tian Changwu, "Tan 'dui cao cao zongzu muzhuan ming di yidian kanfa' you gan," *Wenwu* (December 1981), 71–73.

10. *Hou han shu* 4.197–198.

11. *Hou han shu* 30B.1061–1062; 78.2529.

12. Li Can's report is not specific about the size of the female figures in Dongyuancun #2, but Su Bai of the Department of Archaeology at the University of Beijing has seen the tomb and informs me that the figures there are comparable in size to those at Dahuting. The structural similarity of this tomb to Dahuting #1 is even more apparent on site than is

evident from Li Can's report. The status of the women depicted in this tomb was raised by Sun Zuoyun in his study of the engravings in Dahuting tomb #1, "Henan mixian dahuting donghan huaxiangshi mu diaoxiang kaoshi," *Kaifenggshiyuan xuebao* (March 1978), 62. He considers the women represented in the tomb as "female slaves." Here it would be difficult to distinguish between bonded servants and the "legitimate" consorts of the tomb occupant since both could wear expensive clothing and both could share his bed. However, a definite hierarchy can be discerned among the ladies represented in this tomb on the basis of headgear, posture, and so on. The women in the greeting chamber would appear to belong to the higher-ranking group.

13. Wang Fu, *Qian fu lun*, annotated by Wang Jipei (b. 1775), collated by Peng Duo (Beijing, 1975), 2.96–97.

14. Wang Fu, 2.96–97.

15. Hans Bielenstein, *The Bureaucracy of Han Times* (Cambridge, 1980), 43–46, 55.

16. Bielenstein 1980, 58–59.

17. Bielenstein 1980, 63, 65; *Hou han shu* 78.2508–2509.

18. T'ung-tsu Ch'ü 1972, 478; *Hou han shu* 78.2521.

19. *Hou han shu* 78.2523; T'ung-tsu Ch'ü 1972, 481–482. My translation is based on that of T'ung-tsu Ch'ü but differs in one crucial respect. The passage I translate "decorated with brocade patterns, red lacquer (patterns), and the like," Ch'ü translates as follows: "decorated with exquisite designs and red varnish and the like." We both read the passage

the same way but the translation emphasizes different things. Ch'ü knows that the text literally says "brocade" patterns, and knowing that patterns in Chinese brocade are elaborate, he translated the term as "exquisite." This is not incorrect, but it is important for us to note that the kind of pattern mentioned is of the sort found in brocade. Likewise the compound "red lacquer" is parallel to "brocade patterns" and clearly implies "red lacquer patterns," an idea which further emphasizes the exquisite and extravagant character of the designs.

20. During the Latter Han, cloud patterns in red lacquer continued to be associated with the nobility, witness this passage from the *History of the Latter Han, Hou han shu zhi* 6.3152 "The nobility all have caskets made of camphor with red cloud patterns (painted) on them."

21. *Hou han shu* 43.1470–1471. The italics are mine. On student demonstrations and other protests, see Rafe DeCrespingy, "Politics and Philosophy under the Government of Emperor Huan, 159–168 A.D.," *T'oung Pao* 66, 1–3 (1980), 56. Rafe DeCrespingy, "Political Protest in Imperial China." *Papers on Far Eastern Studies* 11 (March 1975), 1–36.

22. *Hou han shu* 43.1470–1471.

23. *Hou han shu* 43.1470–1471. Italics added.

24. *Hou han shu* 43.1470–1471.

25. *Hou han shu* 78.2532.

26. *Hou han shu* 78.2532.

27. Chi-yun Chen, *Hsu'n Yu'eh* (Cambridge, 1975), 43–44.

SUSAN J. BARNES
Dallas Museum of Art

The Uomini Illustri, *Humanist Culture, and the Development of a Portrait Tradition in Early Seventeenth-Century Italy*

In their letter of invitation, the organizers of this symposium stressed the political aspect of cultural identity. Those invited to speak were charged to address the ways in which, long before the development of nationalism per se, "political entities used the visual arts to differentiate themselves from others to shape a distinctive cultural identity." The present participant respectfully declined that charge, and in fact took issue with its underlying assumption about the primacy of political patronage in the creation of artistic traditions.[1] Although the material contained in this paper differs somewhat from that presented at the symposium, the perhaps self-evident argument it serves remains the same: first, that many artistic expressions associated with a particular time and place may originate and evolve quite independently of official patronage; second, that these expressions can be generated by artists on their own initiative. "Cultural identity" here is seen as a multifaceted phenomenon that may intersect with geography, politics, or a time but cannot always be restricted within their limits. The case in point is humanist culture, an enduring cluster of traditions and ideas, with which artists may interact and to which they may contribute.

Artistic traditions—the forms, styles, conceits, subjects, and methods of representation that recur with variations over time—are not always easily identified, and hence are not studied, because by their very nature they live in use, in interpretation, and with each interpretive use can be transformed. Today's innovation may easily become part of tomorrow's tradition. I have chosen to focus on the portrait tradition of *Uomini Illustri*, which grew out of Paolo Giovio's early sixteenth-century collection of portraits of political and military leaders and other estimable figures. I want to examine two different manifestations of that tradition—one public, one private—by two artists working in Italy from 1600 to 1628: Palma Giovane and Ottavio Leoni.

Paolo Giovio, who incited Giorgio Vasari to write his *Lives* of the artists,[2] was the prime mover in the sixteenth-century cult of *Uomini Illustri*. What became Giovio's *Musaeum* began with his desire to decorate his room with images of outstanding poets and thinkers whose faces would inspire him to the highest achievement.[3] His interest in the likenesses of outstanding figures from modern times, first recorded in a letter he wrote on 28 August 1521, led Giovio to amass a collection of about 266 pieces. It contained two large groups—portraits of statesmen and generals, and portraits of poets and philosophers—as well as smaller groups, of eighteen popes, as many women, and a few artists.[4] Giovio installed his collection in the *Musaeum*, a villa he built on the shores of Lake Como, which was visited by great contemporaries and by the copyists

they sent to build their own collections. He wrote eulogies on his heroes, two volumes of which were published: one honoring poets and philosophers, in 1546; and another devoted to great warriors, in 1550. Unfortunately, Giovio's grand scheme to publish the eulogies together with prints after the portraits—which he hoped would give them the kind of broad distribution that the coin portraits of ancient rulers had received[5]— was not realized before his death in 1552.[6] Giovio did live to see the first edition of Vasari's *Lives* published, also without illustrations. He probably suggested to Vasari that portraits be included, for 144 appeared in the revised edition of 1568.[7]

Although the likenesses of artists of the trecento and quattrocento were sometimes erroneously identified or even invented by Vasari, the illustrated *Lives* helped stimulate an interest in collections of artists' portraits.[8] Later in the century, following Vasari's and Vincenzo Borghini's idea for the Accademia del Disegno in Florence, Federico Zuccari began a collection at the Accademia di San Luca in Rome of artists' likenesses going back to Cimabue.[9] In Florence, the Medici collection of artists' self-portraits, which had been begun by the late sixteenth century, also reflects the example of Vasari.[10]

Giovio's and Vasari's ideas spread north of the Alps, too, in the many forms that Paul Rave has described.[11] One of these, the northern response to the *Lives*, Karel van Mander's *Schilder-Boeck*, appeared in 1604. It was a culmination of an effort begun with Hieronymus Cock's *Pictorum aliquot celebrium Germaniae inferioris Effigies*, a collection of twenty-two artists' portraits accompanied by verses of Dominicus Lampsonius, published in Antwerp in 1572.[12] Previously, in the late 1550s, Cock had published a set of portraits of contemporary European rulers without verses; and from the beginning according to Timothy Riggs, Cock intended to publish the artists' portraits as a book.[13] He had initiated the project by 1565—three years before the illustrated Vasari appeared—with Cornelis Cort's portrait of Patinir, but it was not completed before his death in 1570.[14]

As for Palma Giovane's series of artists' portraits, there can be no doubt that the illustrated edition of Vasari underlay it. Although history subjects predominate in the oeuvre of the younger Palma, there are a few drawn portraits, including several depicting members of his family, particularly his wife Andriana.[15] In addition, Palma drew his group of thirty-six inscribed portrait heads of Italian sixteenth-century artists in a private pocket sketchbook that also contains studies of saints.[16]

Palma placed the artists' portraits three to a page on the verso of twelve of the leaves, and drew them in pen and gray wash on yellowish-buff prepared ground.[17] Although artists of Palma's own region, the Veneto, are in the majority, he depicted others from Rome, Florence, Siena, Umbria, and Parma.[18] Most belong to the two generations preceding his own, but he included Carpaccio, Bramante, and Fra Bartolomeo. In their notable company, and that of Michelangelo, Raphael, Titian, Tintoretto, and Veronese, Byam Shaw notes curious inclusions— Tommaso Lombardo and the architect Giovanni Antonio Rusconi—as well as the omission of Leonardo.[19] Byam Shaw also concludes that the portraits are "fair copies," rather than likenesses made directly into the sketchbook.[20]

The artist's systematic approach to this undertaking is seen in the consistent placement of the portraits on the verso of the leaves and their regular disposition, three to a page. A similar sense of order seems to underlie the grouping of the figures in such triads as Raphael, Giulio Romano, and Perino del Vaga (p. 7); Michelangelo, Baccio Bandinelli, and Daniele da Volterra (p. 14); Giorgione, Titian, and Francesco Bassano the Elder (p. 8; fig. 1); and Tintoretto, Veronese, and Palma Giovane (p. 16). But as can be seen even from these examples, the criteria changed from one grouping to another.

The sketchbook has not been widely studied, and there is no consensus on its precise date. Byam Shaw, following Franca Boccazzi, placed it in the very first years of the seventeenth century,[21] while David Rosand thought it belonged to the second decade.[22] Nor has much been said about why Palma undertook a series of portraits of his fellow artists. Rosand, who alone has raised the issue, saw it as a "revealing document

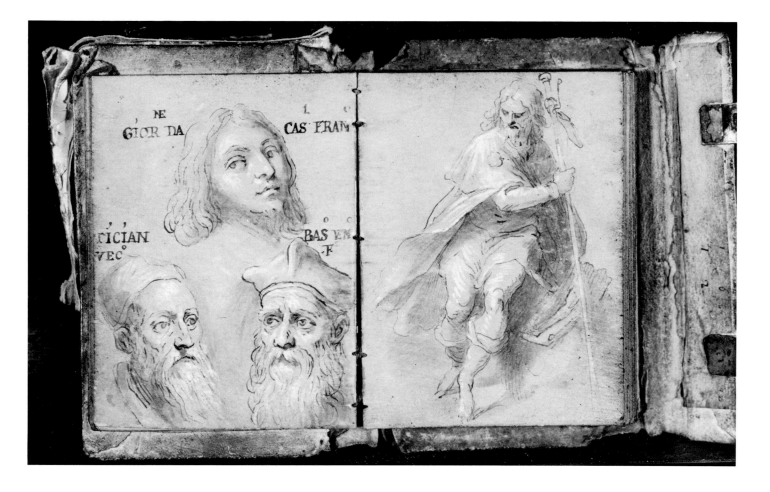

1. Palma Giovane, *Three Portraits*, of Giorgione, Titian, and Francesco Bassano; *St. James the Greater*; pen and gray wash over black chalk on yellowish-buff ground, heightened with white body color, pages 8 verso and 9 recto of a pocket sketchbook, 9.9 x 7 (3⅞ x 2¾) each
Fondation Custodia (Collection F. Lugt), Institut Néerlandais, Paris

of art historical self-consciousness."[23] His hypothesis has a psychobiographical angle: "At the very end of his career, Palma must have consciously looked back and seen himself as continuing the traditions of these masters, Central Italian as well as Venetian, with whom he associated himself on these pages."[24] Byam Shaw noted that Palma had derived several of his portraits from the woodcut illustrations in the 1568 edition of Vasari's *Lives*.[25] Further, with the exception of the Bassani, all of Palma's subjects who were of Vasari's time had been included in the *Lives*. Palma thus seems to have culled this historic gallery of subjects largely from Vasari, but with emphasis redirected to favor the Veneto, and to have brought it up to date with additions including a self-portrait.[26]

Shortly after Palma made his private pocketbook *Parnassus*, Ottavio Leoni

(c. 1578–1630) launched a public campaign to record and reproduce portraits of the most distinguished men of his day in Rome. According to the biography published by his friend and colleague, Giovanni Baglione, "He wanted to make many portraits of some of the most loved Princes and virtuous men of all the professions; he etched them, retouching them with the burin with great diligence and exquisite stippling, and they were striking likenesses. . . ."[27] Illness and death (which Baglione blamed on Leoni's diligent pursuit of the project) shortened Leoni's life before this work was complete.[28]

Surprisingly little is known today about Leoni's life and oeuvre.[29] The son of Ludovico Leoni, himself a portraitist who had come to Rome from Padua before his son's birth, Ottavio was distinguished enough to be elected *principe* of the Accademia di S. Luca in 1614. Indeed, Baglione tells us Leoni

was the preeminent portraitist of his day in Rome, and that he depicted the most important people of his time, "li Somme Pontefici . . . li Principi Cardinali, e Signori titolate, e d'ogni altra qualità, pur che famosi fussero, sì religiosi come seccolari."[30] The etched portraits that engaged Leoni at the end of his life represented a departure for him, for he only began using the medium around 1620.[31] Those forty prints, and the surviving scores of small portrait drawings in red and black chalk for which he was best known, compose the overwhelming majority of Leoni's known work; but he also executed numerous life-sized painted portraits as well as some altarpieces for Roman churches and chapels.[32]

It is Leoni's etched portraits that concern us particularly here, but they must be seen in relation to the drawings. Four hundred of Leoni's portrait drawings owned by the Prince Borghese in the mid-seventeenth century[33] were dispersed with the collection of M. d'Aubigny at a Paris sale in 1747, which Pierre Jean Mariette attended and recorded.[34] John Spike's admirable research in gathering and describing more than a hundred of these enabled him to make observations that have shed great light on Leoni's working method.[35] The first dated drawings are inscribed "1600." From then through 1614 Leoni recorded only the year of the drawing, but in 1615 he began to number them in sequence and to give the month (and occasionally the day) as well as the year in which they were made.[36] Spike recognized that Leoni had numbered the drawings in the series consecutively over a period of fifteen years, and he convincingly argued that the artist must have kept them all until his death, when they passed *en bloc* to the Prince Borghese.[37]

Although many of the portrait drawings are unidentified, those sitters who are known, including Popes Gregory XV and Urban VIII,[38] support Baglione's account of the high status of Leoni's subjects. Interestingly, considering that he himself was among them, Baglione failed to note the number of artists depicted in the drawings, and especially in the prints. In John Spike's inventory, the first dated portraits of artists, Carlo Saraceni and Orazio Borgianni, were made in 1614,[39] the year Leoni was elected

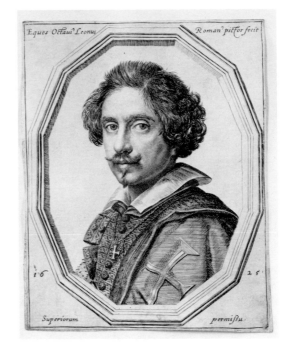

2. Ottavio Leoni, *Self-Portrait*, 1625, engraving and stipple, 13.9 x 11 (5⁷⁄₁₆ x 4⁵⁄₁₆) Gift of Paul Sachs, courtesy of Museum of Fine Arts, Boston

principe of the painters' academy.[40] Spike lists no more until 1620, however, which corresponds to the time that Leoni embarked on the print series.[41]

Since Baglione, it has been noted that Leoni's sitters all came from his own epoch and his Roman milieu. Federico Barocci, whose undated portrait drawing is in the Pierpont Morgan Library in New York, could be an exception, having spent only a few years as a youth in Rome; but Barocci's altarpiece of the *Visitation* in S. Maria in Vallicella ranked among the most celebrated paintings in the city. Leoni probably never met Barocci and would have had to base his portrait on someone else's work. He drew the other artists, however, either from life or, as was probably the case for Caravaggio and Annibale Carracci, from memory.[42] Indeed, Baglione tells us that Leoni was celebrated for his ability to create lifelike images of people from memory, or "*alla macchia*," having just seen them once.[43]

Many questions remain about Leoni's vast collection of portrait drawings, including the rationales for the works. In addition,

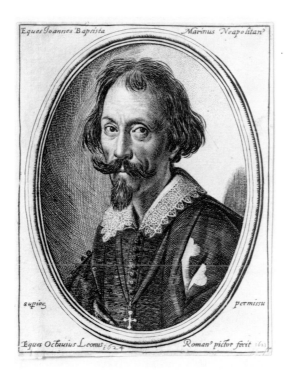

although Baglione maintains the prints were to be portraits of *Virtuosi*, the relationship of the portrait drawings to the series of prints is unclear. When Leoni began the drawings in about 1600, did he already intend to record the likenesses of the illustrious for prints, or did that idea come later? How many of the drawings would he have used as *modelli* for prints? We cannot know since the series was incomplete at his death.

An album of drawings, today in the Biblioteca Marucelliana in Florence, is of particular interest to us because it contains drawings that were *modelli* for nineteen of Leoni's etchings, or more than half of the total finished prints he executed.[44] Unfortunately, it has not been established who collected the drawings, or why, or precisely when, although the writing in the album and the binding both appear to be from the seventeenth century.[45] The drawings in the album themselves are undated, but dated replicas of some exist in the numbered series.[46] The unknown collector of the Florentine album mounted Leoni's drawings and grouped them in labeled categories according to the professions of the sitters: paint-

ers, sculptors, mathematicians (including Galileo), and poets. Artists comprise the largest number among them.[47] Visual evidence indicates that Leoni intended to divide his prints of *Virtuosi* into similar categories; this can be seen in the design of the works, specifically in their format and the frames surrounding the portraits. Artists are shown in polygonal frames (fig. 2), and the poets, as well as Galileo, in oval frames (fig. 3),[48] while dukes, popes, cardinals, and other church officials are depicted in a square, unframed format (fig. 4).[49]

Baglione states that the prints were made at Leoni's initiative, rather than as a commissioned work. Leoni's precise intentions for the printed portraits of *Virtuosi*, i.e. the extent of the series, its intended audience, and the means of distribution, must remain beyond our ken, but some observations can be made. All but one of the "finished" prints, i.e. those with frames or inscriptions, or both, are dated and were made between 1621 and 1628.[50] Leoni began with portraits of artists: the earliest are a self-portrait, and portraits of Salini and Baglione (Bartsch 6–8), all undated and unfinished; followed

in 1621 by the Cavaliere d'Arpino (Bartsch 23); Bernini (Bartsch 19) in 1622; and Guercino (Bartsch 18), Cristofano Roncalli (Bartsch 35), Marcello Provenzale (Bartsch 33), and Antonio Tempesta (Bartsch 38) in 1623. In addition to the poet Giambattista Marino (Bartsch 30), the two other plates produced in 1624, the first full year of the papacy of Urban VIII, depict the Cardinal-nephew Francesco Barberini and Galileo, whom the pope had strongly supported while still a cardinal, and whom he received warmly in the very year of 1624. In 1625, Leoni produced ten etchings, including the last artists' portraits he would execute—those of Vouet (Bartsch 39), Baglione (Bartsch 14), himself (Bartsch 9), and his late father (Bartsch 28). The rest were poets, prelates, and patrons.

By the time Leoni began his print series, he had amassed many drawings of famous artists active earlier in the century. Nevertheless, the record shows that he did not reach into this collection for *modelli* for the first etchings. Instead, each of the etched portraits (with the exception of Leoni's late father) depicts an artist who was active in the year the print was made.[51] Most, such as Cavaliere d'Arpino, Roncalli, and Leoni himself, were well established. Nevertheless, it is important to point out that two of Leoni's first four subjects—Bernini and Guercino—were brilliant young artists of recent fame and prominence.

Unlike Vasari and Palma, Leoni drew his subjects from the wide range of pursuits that characterize collections of *Uomini Illustri* or *Virtuosi* going back to Paolo Giovio. We have already seen, however, that rather than constructing an historic collection as Giovio had done, Leoni concentrated his attention on men of his own time and place. The portrait drawings depict figures from the first three decades of the seventeenth century, while the prints depict those active in the 1620s. Furthermore, the print series as it stood at Leoni's death strongly favors men who were patrons of the arts, if not artists themselves or poets who wrote about artists and works of art. Cardinal Maurice of Savoy and the two nephews of Urban VIII whose interest in the arts was already apparent, Cardinal Francesco Barberini and Don Antonio Barberini (later to be made cardinal), are included along with Urban.[52] Since the peak of Leoni's activity in the prints coincides with the first years of Urban's reign, the series is understandably weighted toward figures in the new papal court; in addition to the two cardinal nephews and the Savoy cardinal who was a moving force in Urban's election, Urban's favorite poet Francesco Bracciolini, and his own younger brother Cardinal Francesco Antonio Barberini, are also depicted. Nevertheless, Leoni did not shy away from including Cardinal Ludovico Ludovisi, a great patron from the previous reign who was then out of favor.[53]

Rather than isolating famous artists as Vasari and Palma had, Leoni included many artists among his *Virtuosi*. In so doing, he implicitly placed himself and his colleagues on a footing with the most important figures in contemporary intellectual life. This indicates something about the status that recently had been achieved by the art of painting and by painters themselves in Roman society. The nobility of the art of painting and its legitimate place with poetry and mathematics as one of the liberal arts had been expounded in treatises from the early sixteenth century on. Arguments formulated by Leon Battista Alberti with evidence from Pliny, and given broad circulation from about 1516 in Baldessare Castiglione's *Book of the Courtier*, had been repeated and elaborated in the middle of the sixteenth century by Benedetto Varchi, Paolo Pino, and Lodovico Dolce.[54] Painting was granted primacy over poetry, it was argued, because of its unique power to recreate nature as a visible reality.[55] The rationale most often cited, however, was historical esteem for the art of painting by persons of rank and intellectual achievement.[56] Pliny's tales of Alexander the Great's admiration for Apelles, and of the amateur artistic practice of Greek philosophers and Roman emperors, had established a precedent for the modern appreciation of Leonardo, Raphael, Michelangelo, and Titian by popes, kings, and emperors.[57] Even though Titian had been honored and knighted by Charles V, painters as a group in the mid-sixteenth century were not yet accorded the same status as the poets with whom they felt they favorably competed.

Cardinal Gabriele Paleotti expanded and codified the argument for painting in his post-tridentine treatise, published in 1582. The nobility of painting, he maintained, was both extrinsic by virtue of the honor in which it was held and intrinsic because of its inherent qualities: its own perfection and its ability to create enduring images of virtue that teach and inspire.[58] For Paleotti, painting reached its summit in a third, most noble aspect, the spiritual, through the depiction of Christian imagery.[59] Romano Alberti repeated Paleotti's three-part rationale for the nobility of painting in his own treatise three years later, but as a painter himself, he emphasized the intrinsic over the spiritual.[60] Alberti's *Della Nobiltà della Pittura*, published for the Accademia di S. Luca, also developed the notion that the practice of the art of painting itself ennobles the artist.[61]

Federico Zuccari established the Accademia di S. Luca in the late sixteenth century not as a craftsman's guild but as an institution that would foster and defend the intellectual foundations and the nobility of painting. By the time Ottavio Leoni was elected *principe* of the Accademia di S. Luca a generation later, the prestige of the artist had finally risen to the point that many, Leoni included, had been knighted. In fact, Leoni showed five of the nine artists in his "finished" series of prints with their emblems of knighthood, as he had shown Salini, Baglione, and himself in the early, undated plates (Bartsch 6–8).

Leoni's printed series of *Virtuosi* is analogous in some ways to a contemporary literary undertaking by his friend and patron, the most famous poet of the period, Giovanni Battista Marino. Like Leoni, Marino envisioned a grand scheme that was unrealized at his death in 1625, namely the publication of an illustrated edition of his *Galeria*.[62] The *Galeria*, first published in Venice in 1619 and reprinted many times during the century, was a tiny book of Marino's verses relating more or less directly to works of art, some of which he had collected by requesting them from a number of artists between 1600 and 1615.[63] Although the *Galeria* included poems on sculpture and medals as well as on paintings of fables, histories, and *capricci*, by far the largest group—nearly 400 verses in all— were on portraits of distinguished men and women.[64]

Their sheer numbers suggest that portraits were the *raison d'être* of the *Galeria*, as does Marino's first surviving reference to the planned book. In 1609 he wrote to Tommaso Stigliano that he had gathered "quasi un museo" of portraits of all the "uomini illustri ed eminenti de' nostri tempi" and that he intended to publish them, each with a verse of praise.[65] Apparently the scope of the *Galeria* did not expand to include other subjects until 1613, although these total fewer than half the number of portraits.[66]

Marino's great humanist forebear, Paolo Giovio, must have served as an example for this project. The very idea of the collection and of the *Galeria* is indebted to Giovio's *Musaeum* and to his published works. The categories Marino designated for his portraits also recall the broad spectrum of human endeavor represented in Giovio's museum, but are even more extensive, since they comprehend a group of tyrants, pirates, and villains.[67] Like Giovio, Marino celebrated both women and men, but unlike Giovio, who focused on modern history, Marino admitted figures from ancient and Biblical sources as well as his own contemporaries. Marino was an international figure, who had been attached to courts in Rome, Revenna, Turin, and Paris before returning to Rome and Naples just before his death, and his choice of artists for the *Galeria* carries a cosmopolitan flavor. He solicited works by painters from Rome, Venice, Bologna, Milan, and Genoa,[68] as well as by Poussin and Pourbus, whom he met during his years in Paris.[69]

The appearance of Marino's *Galeria*, published in 1619, and Leoni's printed series of *Virtuosi*, probably begun in about 1620, makes it tempting to link the two. Exactly when Marino and Leoni became acquainted is uncertain. If their friendship dated to 1603–1605, Marino's early Roman years, he might have asked Leoni to provide a likeness or two for the *Galeria*, but no evidence survives to document this. There is some overlap between the people celebrated in Marino's verses and in Leoni's drawn portraits, particularly among the artists, but this is

understandable since both chose the most noteworthy figures.[70] The two men certainly had met by 1623, when Leoni made the drawing of Marino that he etched the following year. In any case, some of Leoni's portrait drawings may well have been among those in Marino's "fascio de disegni a mano de diversi huomini Valenti" at his death in 1625.[71]

The publication of Marino's *Galeria* may have inspired Leoni's printed series of portraits, or encouraged him in a project long foreseen, or it may not have affected him at all. We need not search for an outer stimulus to explain Leoni's initiative, however. When he undertook his series of *Uomini Illustri*, the art of painting had taken its place among the liberal arts. Painters such as Leoni had been granted noble rank. We should not be surprised when the painter in such a society becomes a patron. By seeking to immortalize the great intellectual and artistic figures of his time in Rome, Ottavio Leoni made a statement about the artist's active role in the very determination of "cultural identity," as well as in the creation of cultural artifacts. He did so by participating in a venerable, international cultural phenomenon. As Marino the poet had done, Leoni the *peintre-graveur* perpetuated and developed a humanist tradition honoring *Uomini Illustri* that was the legacy of Paolo Giovio.[72]

APPENDIX 1

Annotated identifications in the album of portrait drawings by Ottavio Leoni, Florence, Biblioteca Marucelliana

PITTORI
I. Ottavio Leoni Romano
II. Anibale Carrazi Bolognese
III. Agostino Carrazi Bolognese
IV. Michel Angelo Merrsi da Caravaggio
V. Antonio Tempesta Fiorentino
VI. Gioseppe Cesare d'Arpino
VII. Gio. Francesco Barbiere da Cento
VIII. Filippo Liagno Napolitano
IX. Cristofano Ronchali da Pomaranci
X. Simon Vouet Francese
XI. Giovani Baglioni Romano
XII. Tomasso Mao Fiorentino
XIII. Domenico Ambrosino Romano
XIV. Girolamo Nani Romano

SCULTORI
I. Gio. Lorenzo Bernini Napolitano
II. Lodovico Leoni Padovano
III. Marcello Provenzali da Cento

MATEMATICI
I. Galileo Galilei Fiorentino
II. Pre' Cristofano Skeiner Todescho

POETI
I. Monsig.re Cianpoli Fiorentino
II. Gio. Batta Marino Napolitano
III. Gabriel Ciabrera Savonese
IV. Francesco Bracciolino Pistoiese
V. Pier Francesco Paoli da Pesaro
VI. Scipion Cicero Napolitano
VII. Tomasso Stigliano Pugliese
VIII. Ottavio Leoni Romano

APPENDIX 2
Identified printed portraits by Ottavio Leoni

Self-Portrait (oval format) [Bartsch 6]
Tomasso (Mao) Salini (oval format, with two head studies) [Bartsch 7]
Giovanni Baglione (oval format) [Bartsch 8]
Self-Portrait, 1625 [Bartsch 9]
Giovanni Baglione, 1625 [Bartsch 14]
Don Antonio Barberini, 1625 [Bartsch 15]
Cardinal Francesco Antonio Barberini, 1627 [Bartsch 16]
Cardinal Francesco Barberini, 1624 [Bartsch 17]
Giovanni Francesco Barbieri, called Guercino, 1623 [Bartsch 18]
Giovanni Lorenzo Bernini, 1622 [Bartsch 19]
Paolo Giordano II, Duke of Bracciano [Bartsch 20]
Paolo Giordano II, Duke of Bracciano [Bartsch 21]
Francesco Braccolini, 1626 [Bartsch 22]
Giuseppe Cesare, Cavaliere d'Arpino [Bartsch 23]
Gabriele Ciabrera, 1625 [Bartsch 24]
Giovanni Ciampoli, 1627 [Bartsch 25]
Duke Odoardo Colonna [Bartsch 26]
Galileo Galilei, 1624 [Bartsch 27]
Ludovico Leoni, 1625 [Bartsch 28]
Cardinal Ludovico Ludovisi, 1628 [Bartsch 29]
Giambattista Marino, 1624 [Bartsch 30]
Raffaelo Menicucci, 1625 [Bartsch 31]
Pier Francesco Pauli, 1625 [Bartsch 32]
Marcello Provenzale, 1627 [Bartsch 33]
Paolus Qualiatus Clodianus, 1623 [Bartsch 34]
Cristofano Roncalli, called Pomerancio, 1623 [Bartsch 35]
Cardinal Maurice of Savoy, 1627 [Bartsch 36]
Thomas Stilianus, 1625 [Bartsch 37]
Antonio Tempesta, 1623 [Bartsch 38]
Simon Vouet, 1625 [Bartsch 39]
Pope Urban VIII, 1625 [Bartsch 40]

NOTES

1. The paper delivered at the symposium sought to identify a portrait "type" in early seventeenth-century Rome, to establish its origins in local artistic culture rather than in official patronage, and to argue for its legitimate place in Roman "cultural identity." The informal, bust to half-length portraits in drawing, painting, and sculpture that belong to this "type," and were made by artists as diverse as Ottavio Leoni, Domenichino, Van Dyck, Bernini, and Vouet, will be the subject of a future study.

Egbert Haverkamp-Begemann and John Spike kindly read a late draft of the present text and made helpful suggestions, for which I thank them. Peter Lukehart's thoughts and advice at every stage have been of enormous benefit.

2. Paul Ortwin Rave, "Paolo Giovio und die Bildnisvitenbücher des Humanismus," *Jahrbuch der Berliner Museen* 1 (1959), 144. For the history of this idea before Giovio, see Wolfram Prinz, ed., *Die Sammlung der Selbstbildnisse in den Uffizien*, 3 vols. (Berlin, 1971), 1:17–20.

3. Rave 1959, 119.

4. Rave 1959, 120.

5. As expressed in a letter to Antonio Francesco Doni of 14 September 1548 in Giovanni Bottari, ed., *Raccolta di lettere* (Milan, 1822), 5:148; see Rave 1959, 142.

6. Peter Pena, who published posthumous editions of Giovio's eulogies, sent the artist Tobias Stimmer to Como to copy the images in Giovio's collection. In 1575 Pena brought out the first illustrated editions on the warriors, in 1577 that of the poets and philosophers (Rave 1959, 150).

7. Prinz 1971, 1:20.

8. Prinz 1971, 1:25.

9. Vasari and Borghini's project to depict the most famous Tuscan artists on the frieze of one wall of the Accademia del Disegno was only realized in the seventeenth century; see Prinz 1971, 1:25.

10. Prinz 1971, 1:27.

Giovanni Battista Paggi, writing in 1591 from Florence, supported his ideas on the fame and nobility of artists by citing collections of portraits of *Uomini Illustri* that contained artists, including "la galleria di S.A.S."; for the possibility that this refers to the Medici collection see Paggi's letter to his brother Girolamo, in Paola Barocchi, ed., *Scritti d'Arte del Cinquecento*, 3 vols. (Milan and Naples, 1971–1977), 1:197. Peter Lukehart kindly brought this to my attention.

11. Rave 1959, 147–153.

12. See Timothy A. Riggs, *Hieronymus Cock: Printmaker and Publisher* (New York and London, 1977), 192–194 and no. 269.

13. Riggs 1977, 192

14. Riggs 1977, 193.

15. Identified in Heinrich Schwarz, "Palma Giovane and his Family: Observations on Some Portrait Drawings," *Master Drawings* 3 (1965), 158–165.

16. The bound sketchbook of twenty-four parchment leaves came to the Institut Néerlandais from the collection of Frits Lugt, who first exhibited and published it in *Le Dessin Italien dans les Collections Hollandaises* [exh. cat., Institut Néerlandais] (Paris, 1962). James Byam Shaw, "A Pocket Sketchbook by Palma Giovane," *Arte Veneta* 32 (1978), 275–280, contains the first full description and analysis of the pocketbook, with many illustrations. All of the leaves are illustrated in the subsequent catalogue entry, in James Byam Shaw, *The Italian Drawings of the Frits Lugt Collection*, 3 vols. (Paris, 1983), 1:254–260, pls. 281–293. The portraits of artists had been previously noted in: Schwarz 1965, 159; Franca Zava Boccazzi, "Inserti ritrattistici in alcune tele di Palma il Giovane," *Pantheon* 23 (1965), 295–296; and David Rosand, "Palma il Giovane as Draughtsman: The Early Career and Related Observations," *Master Drawings* 8 (1970), 161 n. 62.

17. Byam Shaw 1978, 275–276, describes the materials and the contents of the book in detail.

18. Byam Shaw 1978, 277.

19. Byam Shaw 1978, 277.

20. Byam Shaw 1978, 277.

21. Based on a comparison of the self-portrait on p. 16 verso with the self-portrait in *The Burial of the Bodies of Sts. Tiburzio and Valeriano* in the church of the Toletini in Venice, which Boccazzi 1965, 294–295, dates to just after 1604; see, too, Byam Shaw 1978, 277.

22. Rosand 1970, 161 n. 62.

23. Rosand 1970, 161 n. 62.

24. Rosand 1970, 161 n. 62.

25. Byam Shaw 1978, 277, 280.

26. Another artist with a personal collection of artists' portraits was Giovanni Battista Paggi, who owned portraits of Michelangelo, Cambiaso, Correggio, and Giambologna, as well as other unidentified *Uomini Illustri*. On Paggi's collection, Venanzio Belloni, *Penne, pennelli e quadreria* (Genoa, 1973), 46–48. I am grateful to Peter Lukehart for this information.

27. Giovanni Baglione, *Le Vite de' pittori, scultori et architetti dal pontificato di Gregorio XIII. fino à tutto quello d'Urbano ottavo* (Rome, 1649), 1:322. "Volle far'egli molti ritratti de varij Principi, e persone virtuose d'ogni professione assai amorevoli, & affettionati; gl'intagliò in acqua forte, e ritoccò co'l bolino con tanta diligenza, & esquisitezza punteggiati, e somiglianti che più oltre non si può considerare."

28. Baglione 1649, 322: "e perche a tanta fatica avvezzo non era, diede in sì gran dolore di stomaco, che respirar non poteva, e da tanta grand'asma era accompagnato, che . . . ne gli anni 52. in circa di sua vita andossene all'altra."

29. Baglione 1649, 321–322, is the only contemporary source for Leoni's life. On the oeuvre, see T. H. Thomas, "Ottavio Leoni—A Forgotten Portraitist," *Print Collector's Quarterly* 6 (1916), 322–370, 371–373; Roberto Longhi, "Volti della Roma caravaggesca," *Paragone* no. 21 (September 1951), 35–39; Alfredo Petrucci, "Una galleria romana di ritratti," *Capitolium* 26 (1951), 112-118; Hanno-Walter Kruft, "Ein Album mit Porträtzeichnungen Ottavio Leonis," *Storia dell'Arte* 4 (1969), 447–458; and particularly John T. Spike, "Ottavio Leoni's Portraits *alla macchia*," in *Baroque Portraiture in Italy: Works from North American Collections* [exh. cat., John and Mable Ringling Museum of Art, and Wadsworth Atheneum] (Sarasota, 1984), 12–19. C. Roxanne Robbin is currently working on a dissertation on Leoni's place in Roman portraiture that will include a catalogue raisonné; both will be welcome additions to the literature.

30. Baglione 1649, 321.

31. The first dated print, depicting Cavalier d'Arpino (Bartsch 23), is from 1621. As Thomas 1916, 341–342, points out, the early plates (Bartsch 1–8) "are studies rather than plates . . . to be published, executed in the spirit of an artist who is amusing himself or searching out his way, and they have something of the personal and spontaneous quality of sketches."

32. Baglione 1649, 321–322. Although no painted portraits have been certainly identified, Roberto Longhi, in "Ultimi studi sul Caravaggio e la sua cerchia," *Proporzioni* 1 (1943), and "Il vero Maffeo Barberini del Caravaggio," *Paragone* no. 165 (1963), 89–91, linked Leoni's name to *Pope Paul V Borghese* (Rome, Palazzo Borghese). See also Spike 1984, 13.

33. Baglione 1649, 321.

34. *Abecedario de Pierre Jean Mariette et autres notes inédites de cette amateur sur les arts et les artistes*, 6 vols. (Paris, 1851/53–1859/60; reprinted Paris, 1966) 3:179–181.

35. Spike 1984, 17–19.

36. Spike 1984, 14.

37. Spike 1984, 14.

38. Both drawings are in the British Museum, London.

39. As was the portrait of Marcello Provenzale (Frankfurt, Städelsches Institut); see Kruft 1969, fig. 23. According to Spike 1984, 17–19, the portrait of Saraceni was on the New York art market in 1967 (photograph, Frick Art Reference Library, New York), while that of Borgianni is in the Albertina, Vienna.

40. Longhi 1951, 35–36, speculated that Leoni's election as *principe* might have inspired him to undertake a series of portraits of famous painters.

41. Spike 1984, 14, also observes from Mariette's list that Leoni "only inscribed the date 1614 on portraits of artists who were alive in that year." If the works gathered by Spike are representative of the rest, Leoni's production of portrait drawings increased noticeably in 1614 to a rate he sustained for the next twelve years.

42. On the portraits of Caravaggio, see Longhi 1951, 36.

43. Baglione 1649, 321. Thomas 1916, 326, takes issue with the notion that Leoni made many portraits from memory: "The precision of line and the convincing accuracy of the likeness do not suggest any such method of work."

44. The drawings were described and enumerated in Thomas 1916, 371–373. Kruft's monographic study of the album focused on the relationship of the portraits to the models. Comparing Leoni's drawings to other portraits of the same sitters, Kruft argued that apparent naturalism of the drawings belies the fact that Leoni idealized the appearance of his sitters, in keeping with the dictates of contemporary theorists such as Agucchi, Bellori, Lomazzo, and Armenini; see Kruft 1969, 454–456. Spike 1984, 15, joins Thomas 1916, 334, in identifying the album with the group Mariette called "the drawings of the portraits of the artists that [Leoni] engraved."

45. According to Thomas 1916, 371, they were mounted and bound in a seventeenth-century binding and annotated in a seventeenth-century hand. Spike 1984, 15, ventures that these drawings were *modelli* for the numbered and dated drawings Leoni kept, as well as for the prints.

46. Spike 1984, 15. The relationship of all the drawings in the Marucelliana album to their surviving numbered counterparts has yet to be studied, but in one such case—the 1620 portrait of Tomasso Salino in the Metropolitan Museum of Art—Spike believes that the undated drawing in the album is the original version from which the numbered drawing was copied. In this he differs from Kruft's assumption that those in the album were copied from works in the numbered series; see Kruft, 1969, nos. 24 and 26.

47. A full list of the portraits in the album is included as Appendix I; the printed portraits are listed in Appendix II.

48. Spike 1984, 120.
 Leoni did his first, unfinished, self-portrait in an oval frame (Bartsch 6), apparently before settling on his system; the second one (Bartsch 9) shows him in a polygonal frame. Interestingly, the collector of the Marucelliana volume, who had drawings for both of those prints, followed the frame categories, binding the earlier self-portrait with the poets (who also were in oval frames in the prints), and the later one with the artists.

49. Spike (personal communication) does not believe that this group constitutes a series.

50. The undated portrait of Paolo Giordano II, Duke of Bracciano (Bartsch 20), probably was executed in about 1620. Haskell, *Patrons and Painters* (New Haven and London, 1980), 96–97, assumed that Giordano commissioned this work as he did a head of himself in bronze by Bernini in 1623. That could explain the eccentrically shaped frame around this portrait, although Spike 1984, 120, suggested that it was the frame Leoni would have used for noble sitters had he lived to pursue the project. Leoni also etched Giordano's face in the square, frameless format (Bartsch 21) he used for other dignitaries, but he did not complete that print with an inscription.

51. As noted by Spike 1984, 14.

52. For the activities of Francesco and Antonio Barberini, see Haskell 1980, 43–46, 50–51, 53–56, etc.

53. On Ludovisi's patronage in these years and his relationship with Urban VIII, see Haskell 1980, 72–74.

54. *Lezzione di Benedetto Varchi, nella quale si disputa della maggioranza delle arti e qual sia più nobile, la scultura o la pittura* (Florence, 1546), reprinted in Paola Barocchi, ed., *Trattati d'Arte del Cinquecento*, 3 vols. (Bari, 1960–1962), 1:1–52; *Dialogo di Pittura di Messer Paolo Pino* (Venice, 1548), reprinted in Barocchi 1960–1962, 1:93–139; *Dialogo della pittura di M. Lodovico Dolce, intitolato L'Aretino, nel quale si ragiona della dignità di essa pittura e di tutte le parti necessarie che a perfetto pittore si acconvengono* (Venice, 1557), reprinted in Barocchi 1960–1962, 1:141–206.

55. See, for instance, Pino's remarks in Barocchi 1960–1962, 1:106: "Perché la pittura no è arte mecanica, ma arte liberale Questa è quella poesia che vi fa non solo credere ma vedere il cielo ornato del sole, della luna e delle stelle, la pioggia e neve, le nebie causate da'venti, l'acqua e la terra"

56. See Barocchi 1960–1962: for Varchi, 1:37; for Pino, 1:110; for Dolce, 1:157–158.

57. Dolce in Barocchi 1960–1962, 1:159, 161.

58. *Discorso intorno alle imagini sacre e profane* (Bologna 1582), in Barocchi 1960–1962, 2:153–158.

59. In Barocchi 1960–1962, 2:158–163.

60. Romano Alberti, *Trattato della Nobiltà della Pittura* (Rome, 1585), reprinted in Barocchi 1960–1962, 3:195–235. For the relationship of Alberti's text to Paleotti's see the critical commentary, 3:394–395.

61. Alberti in Barocchi 1960–1962, 3:206.

62. A. Borzelli's *La "Galeria" del Cavalier Marino* (Naples, 1923), is difficult to obtain, but there have been several recent studies. See Gerald Ackerman, "Gian Battista Marino's Contribution to Seicento Art Theory," *Art Bulletin* 43 (1961), 334–336; Marzio Pieri, ed., *La Galeria*, 2 vols. (Padua, 1979); and especially Giorgio Fulco, "Il Sogno di una 'Galeria': nuovi documenti sul Marino collezionista," *Antologia di Belle Arti* 3 (December 1979), 84–99. The recent edition of Marino's *Lettere*, ed. Marziano Guglielminetti (Turin, 1966), contains many references to the *Galeria*.

63. The extent and precise contents of Marino's collection are unknown. His estate inventory in Naples, published by Fulco 1979, 86–87, describes certain history paintings, but groups the portraits rather than listing them individually. The small number of paintings in this inventory (only thirteen painted portraits, for example, along with a "fascio de disegni"), which in no way matches the claims of Marino's earlier letters, may simply represent the natural attrition brought about by the itinerant life of a court poet.

64. There are seventy fables, thirty-seven histories, and seven *capricci*, plus thirty-six statues, ten reliefs, and twelve sculpted *capricci*. See Pieri 1979, 1:vii–xxiv.

65. Letter no. 53, in Guglielminetti 1966, 102; cited in Fulco 1979, 92, and Pieri 1979, 1:xxxviii.

66. It did not begin to realize the promise of containing "quasi tutte le favole antiche" announced in Marino's 1613 letter to Bernardo Castello; see Guglielminetti 1966, 143; Fulco 1979, 89, and Pieri 1979, 1:xxxix.

67. The other categories of portraits of men are: princes, captains, and heroes; philosophers and humanists; poets; orators and preachers; historians; mathematicians and astrologers; fathers of the church and theologians; jurists and physicians; artists; popes and cardinals; and one candidly designated "diversi Signori et Letterati amici dell'Autore." Women are grouped as follows: beautiful, chaste, and magnanimous; beautiful, immodest, and wicked; and bellicose and virtuous.

68. Fulco 1979, 94.

69. Fulco 1979, 95. Marino is best known to art historians as the man who brought Poussin to Rome.

70. Federico Barocci, Caravaggio, Annibale Carracci, and Cavalier d'Arpino figure among Marino's poems and Leoni's drawings. Cavalier d'Arpino and Cardinal Maurice of Savoy and Marino himself are found both in the poems and in Leoni's etchings.

71. Fulco 1979, 87.

72. It seems clear, as Thomas 1916, 366, suggested, that Van Dyck's ambitious printed portrait project known as the *Iconography*, begun after his return from Italy, is indebted to Leoni's *Virtuosi*. Van Dyck and Leoni may well have met during the young Fleming's several months in Rome in 1622–1623. Van Dyck's painted Roman portraits suggest that he knew about the works of Leoni and other portraitists working there. In any case, Van Dyck would have been aware of this enterprise by the most prominent portraitist of the time. A careful comparison of the two print series should await the conclusions of Joaneath Spicer's forthcoming study on the *Iconography*, announced in Spicer, "Unrecognized Studies for Van Dyck's *Iconography* in the Hermitage," *Master Drawings* 23–24 (1985–1986), 542 n. 2. Meanwhile, certain suggestions can be ventured from the material in existing studies: F. Wibiral, *L'Iconographie d'Antoine van Dyck* (Leipzig, 1877); Arthur Hind, *Van Dyck, His Original Etchings and His Iconography* (Boston and New York, 1915); Maurice Delacre, *Recherches sur le rôle du dessin dans l'Iconographie de Van Dyck* (Brussels, 1932); M. Mauquoy-Hendrickx, *L'Iconographie d'Antoine van Dyck*, 2 vols. (Brussels, 1956). Although many precedents for the *Iconography* existed, including Cock's series of artists' portraits already mentioned, the similarities between the *Iconography* and Leoni's *Virtuosi* indicate that the latter project influenced the scope and character of the former. Like Leoni, Van Dyck depicted military and political leaders and philosophers as well as artists, and seemingly produced them as sets in those categories. (Hind 1915, 17, quotes Wibiral's observation that in the edition published during Van Dyck's lifetime, all of the prints within a category bore the same watermark). Like Leoni in Rome, Van Dyck concentrated on figures of his own time and his home city, Antwerp. Like Leoni, Van Dyck, who had trained as a painter, became a printmaker in order to carry out a portrait series; like Leoni's portrait prints, his etched portraits were original creations rather than reproductions of other work. Van Dyck gave even more prominence to artists among his subjects: nearly fifty out of eighty. Most conclusively, Van Dyck, like Leoni, took it upon himself to create a body of prints that would celebrate and preserve the likenesses of his chosen *Uomini Illustri*.

ALICE T. FRIEDMAN
Wellesley College

Did England Have a Renaissance?
Classical and Anticlassical Themes in Elizabethan Culture

In his *Architecture in Britain, 1530–1830*, Sir John Summerson suggested that the arrival of "the Renaissance" in England could be understood to coincide with the appearance of a group of works by Italian craftsmen employed by Henry VIII during the 1530s. Yet in the footnotes to this text, Summerson adds the following caveat:

I must enter a warning here against the too free use of this word in connection with English architecture. The Renaissance was a movement originating in Italy in the fourteenth to the fifteenth century and having as its mainspring the recognition of the artistic values of classical antiquity. The Renaissance proper was over in Italy by 1520. In France and England during the sixteenth century the artistic products of the Renaissance and its sequel profoundly affected the arts, but the use and enjoyment of these products is not necessarily analogous to their use and enjoyment in Italy.[1]

This seems both contradictory and confusing: on the one hand Summerson is urging us to consider sixteenth-century English art, or at least some of it, as part of a broad-based European Renaissance movement, while on the other hand he is telling us that it also represents something peculiar and profoundly different. Yet to the historian of Elizabethan art and architecture, this not only rings true but also stands for an important revision of art historical values: Summerson does not suggest, as many have done, that Elizabethan architecture was a garbled version of a stylistic language misunderstood by provincial patrons and artists; on the contrary, by saying simply that the Renaissance and mannerist styles were used and enjoyed, to employ his terms, in the north in ways that differed from their use and enjoyment in Italian works bearing the same style labels, he raises the possibility of a much more positive interpretation, a reading within the terms of the culture itself.

Many art historians before and since Summerson have considered Tudor painting and architecture an embarrassment and an artistic gaffe; they would prefer to ignore its existence altogether and date the advent of the English Renaissance to the appearance of classicizing architectural designs by Inigo Jones in 1608.[2] In many ways one can hardly blame them: to the classically trained eye Tudor art, and particularly Elizabethan art, looks very peculiar indeed—flat and distorted, unsystematic, chaotic. It is above all hard to categorize, appearing undisciplined and unruly at worst and "mannerist" at best; but without the requisite classicizing phase, without a true Renaissance to precede it, who can say that English art of

For James S. Ackerman on his seventieth birthday

the sixteenth century really means what it seems to mean?[3] From the vantage point of the Italian Renaissance, English painting, sculpture, and architecture seem to ignore not only the techniques of naturalism but also the conceptual framework of classicizing humanist culture. English art appears to be without rules, without a sense of decorum.

I will argue, however, that the peculiarities of artistic style during the reign of Queen Elizabeth I were the result of a consciously chosen and sophisticated cultural language. This language was created at court in order to express the complex messages of Elizabethan political ideology, but it was gradually adopted by the nobility and upper gentry of England as the fashionable style of the age. The existence of such a distinctive and highly charged Elizabethan manner in painting and pageantry has been convincingly demonstrated by Sir Roy Strong and others, in particular through the analysis of iconic royal portraiture.[4] By having herself represented in a style that was both radically different from that identified with the previous generation and profoundly antinaturalistic, the queen could create a distinct identity for herself, for her reign, and for Protestant England. Through self-conscious medievalism and the manipulation of both classicizing and heraldic imagery, the queen's persona could be simultaneously situated in the traditional English past and in the fashionable humanist present.[5] Similar devices were employed in architecture, sculpture, and ornamental design, thus forming a recognizable Elizabethan manner.

In masques, pageants, and ceremonies such as the Accession Day Tilts (celebrated annually on 17 November), Elizabeth reinforced her power and that of the crown by employing complex visual and literary devices for the expression of her various political and ideological messages. Each of her personae could speak in a different voice, and all were to be heard simultaneously but with varying emphasis depending on the context and substance of the particular ideas to be communicated. The culture of the court—ceremonial, literary, visual—was focused on the communication of images and stories, narratives that could be ironic and paradoxical, using metaphor and sy-

necdoche to create a network of ideas and emotions concerning the queen and her realm. At the heart of this carefully orchestrated constellation lay a profound contradiction: the ruler was a woman. Recognizing that this was fundamentally unacceptable, she and her courtiers created a fictionalized ceremonial presence identified with various personifications of female power and virtue: she became Astraea, Diana, and England's *Eliza triumphans*, a goddess who combined the qualities of Venus, Juno, and Minerva and would be chosen by her subjects over all of them. In her analysis of Elizabethan myth-making, Frances Yates quotes Thomas Dekker's *Old Fortunatus* to suggest the multiplicity of royal names:

Are you then travelling to the temple of Eliza? Even to her temple are my feeble limbs travelling. Some call her Pandora: some Gloriana: some Cynthia: some Belphoebe: some Astraea: all by several names to express several loves: Yet all those names make but one celestial body, as all those loves meet to create but one soul. I am her own country and we adore her by the name Eliza.[6]

Clearly, the technique here was to pile up a series of symbols and images, building on the powerful effect of surprise, variety, and the diversity of cultural references employed. This was intended to reveal the author's (and by implication the reader's) broad education and mental agility.

A recently published discussion of the entertainment held at Harefield in 1602 suggests the diversity of images—contemporary, mythological, folkloric—that were woven together in the ceremonial events marking the queen's visit to her subjects' country houses during her summer progresses.[7] Seven items from the entertainment survive: (1) a dialogue between a bailiff and a dairymaid; (2) a dialogue between personifications of time and place; (3) a speech by Place in mourning robes made as the queen departed; (4) a complaint of five satyrs against the nymphs; (5) a poem which accompanied the presentation of a "robe of rainbows" (recalling the famous *Rainbow Portrait* at Hatfield House); (6) a song by a sailor; (7) a list of lottery prizes, the verses accompanying them, and the names of their recipients. Literary and visual images are

casually mixed together here without regard for the distinctions between separate cultural traditions (such as English and Roman) or, indeed, between various modes of discourse. Yet rather than suggest that such flexibility and disregard for the principles of order and decorum represent a failure to grasp these rules, it is possible to show that these, as other devices within Elizabethan court culture, were consciously employed to create a distinctive and richly evocative English court style. This additive process of mixing local and imported cultures was paralleled in princely courts throughout Europe.

By the second half of the sixteenth century, educated male courtiers in attendance on the queen and, significantly, the queen herself (but few other women of any rank) could be expected to know the fundamentals of Latin grammar and to have received some exposure to writings of Latin authors.[8] Thus they would have been aware of the conceptual framework of humanist culture, i.e., of the grammar and rules controlling relationships between words, parts of speech, and visual forms; the notion of coherence between the parts and the whole; and the concept of decorum or appropriateness. These values were clearly antithetical to the Elizabethan court culture as described above and, further, to the English Gothic inheritance which formed the visual environment in which courtly taste developed. The coexistence of these two modes of thinking, speaking, and writing suggests a self-conscious and intentional anticlassicism at court clearly identified with English tradition and formed in opposition to received humanist (and therefore Italianate and Catholic) culture. In this courtly culture, the power of the images would have been enhanced by the conflict between the expectations of a classically trained audience and the distorted or disrupted language (part classicizing, part Gothic revival, and part Gothic *survival*) through which messages, both literary and visual, were communicated.[9] This of course links the culture of Elizabeth's court with those of courts on the Continent: communication was predicated on an understanding of the rules of classicism and an ability to recognize when they were being broken; it de-

pended on the audience's ability to decode messages put forth simultaneously in a number of languages, both revealed and unspoken; and, finally, the appeal of this arcane system rested, in part, on its limited accessibility and self-conscious obscuring of meaning through the layering of diverse and disparate images.[10]

There is also evidence to show that the inner circle of Elizabethan courtiers was familiar with the literature of Renaissance architectural theory.[11] Those with a particular interest in building—Sir Thomas Smith, Lord Burghley, Sir Thomas Tresham, and Sir Francis Willoughby among others—owned copies of works by Du Cerceau, Delorme, Serlio, Palladio, and a wide range of authors as well as various editions of Vitruvius. Ignorance of the stylistic choices or insufficient understanding of theory or technique thus cannot be cited as underlying cause for the undisciplined and anticlassical appearance of Elizabethan buildings. Indeed, the surviving library catalogues and portfolios of drawings suggest that in both painting and architecture, a "correct" and consistent application of naturalistic or classicizing details—which would have helped to create unified, homogeneous and three-dimensional compositions—was intentionally suppressed in favor of a decorative and narrative style heavily influenced by Flemish, French, and German designs.

A comparison between a late miniature by Holbein, the *Portrait of a Gentleman* of 1540–1543 and Nicholas Hilliard's portrait of *George Clifford, 3rd Earl of Cumberland*, c. 1590, shows the extent to which the taste for emblematic works came to dominate at court (figs. 1, 2). In Holbein's work, we can readily appreciate the artist's ability to control techniques of light and shadow and to represent the third dimension convincingly, transferring skills from panel painting to the portrait miniature.[12] Though Hilliard acknowledged his debt to Holbein and was able to paint miniatures in a convincingly naturalistic manner, the court style associated with his oeuvre turned increasingly away from the Italianate manner which Holbein practiced so well. This shift in style not only suited the queen personally (Hilliard's flat, iconic portraits showed her as

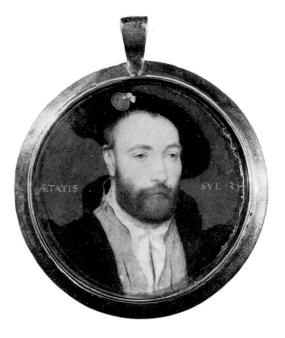

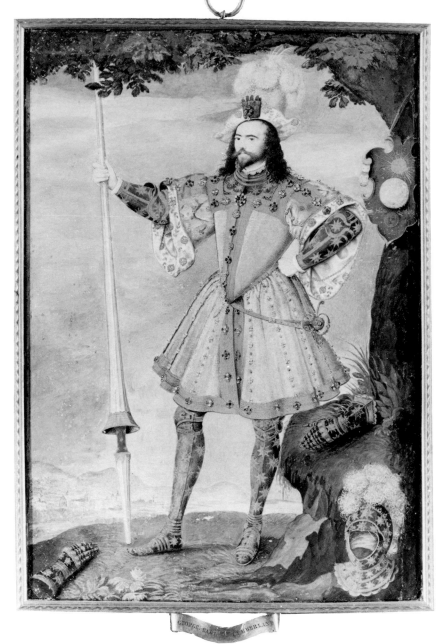

perpetually young) but also politically—and not simply in terms of the royal image. The new style was distinctively linked to the Elizabethan court, and Hilliard's highly detailed and iconographically complex portrait of Cumberland exemplifies it in both form and content. The work shows the earl wearing the ceremonial armor of the Accession Day Tilts and commemorates his assumption of the position of Champion of the Tilt in 1590.[13] In this portrait, as in those of the queen by Hilliard, the human form is subsidiary to the symbolic devices which dot the flattened surface of the work: Cumberland's tunic is decorated with armillary spheres (one of the queen's devices), olive branches, and caducei, while the queen's favor, her jeweled glove, is displayed like a badge on his hat. A heraldic shield, used in the pageant and bearing a Latin motto, hangs from a nearby tree. This transforms the work into an *impresa* in which text and visual imagery must be deciphered together to form one recondite message.

In the title page of Sir Philip Sidney's *The Countess of Pembroke's Arcadia* of 1593 (fig. 3), a design attributed to William Rogers but which, as Strong has pointed out,

reflects the manner of Hilliard, we recognize intellectual processes and aesthetic choices which parallel those underlying the high Elizabethan manner in painting.[14] For here too the design is composed of a series of overlapping and related images: at the top is the crest of the Sidney family, a por-

1. Hans Holbein, the Younger, *Portrait of a Gentleman*, 1540–1543, body color on thin card, 3.5 (1⅜) diam.
Yale Center for British Art, Paul Mellon Collection

2. Nicholas Hilliard, *George Clifford, 3rd Earl of Cumberland*, c. 1590, vellum affixed to a fruitwood panel, 25.8 x 17.6 (10⅛ x 6¹⁵⁄₁₆) National Maritime Museum, London

3. William Rogers (in the manner of Hilliard), title page to Sir Philip Sidney, *The Countess of Pembroke's Arcadia*, 1593, woodcut, 24.4 x 15.7 (9⅝ x 6³⁄₁₆) Houghton Library, Harvard University

4. Isaac Oliver, *The Lamentation over the Dead Christ*, 1586, pen and ink, wash, watercolor, and body color, 21 x 28 (8¼ x 11) Fitzwilliam Museum, Cambridge

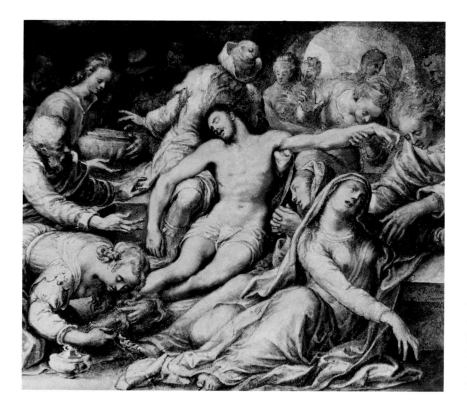

cupine passant, flanked by two animals, a bear and a lion, which are not part of the heraldic device but represent the animals slain by the heroes of the *Arcadia* itself; these two are represented in disguise as a shepherd and an Amazon; below, in an oval cartouche, is an *impresa* showing a pig and a marjoram bush wrapped with the motto "Non tibi spiro," I breathe out [sweet scents] but not for thee.[15] It is well known that the Elizabethans, like other sixteenth-century courtiers, were greatly enamoured of emblems, word games, devices, and conceits since these provided ready opportunities for the display of learning, secret or privileged information, and quickness of wit. Most interesting for our purposes here is how flexible the mannerist ornamental style could be and how well suited for the incorporation of many different visual and literary devices into one design. For the Elizabethans, whose intention was to establish a national style that brought together English heraldry, Arthurian legend, and classical culture, such flexibility was invaluable.

A further pair of examples clearly shows that this style of painting and drawing was consciously chosen. Two works by Isaac Oliver, *The Lamentation over the Dead Christ* of 1586 in the Fitzwilliam Museum and the miniature *Portrait of an Unknown Girl* of 1590 in the Victoria and Albert Museum reveal the range of his skill (figs. 4, 5). In the *Lamentation* he shows his ability to work in a Flemish manner, using elegant if somewhat awkward figures and three-dimensional space—devices conspicuously lacking in the portrait miniature. Moreover, the latter work is iconic, flattened, and wholly frontal, qualities that give the image an undeniable charm in its small format. That one artist could elect to work in such different styles depending on the context and content of his painting suggests a considerable visual sophistication for artist and audience alike.[16]

In architecture, it appears that a parallel withdrawal from the Italianate classicism of mid-century occurs during Elizabeth's reign. The first substantial evidence of a focused interest in Italy begins to appear in the years immediately following the death of Henry VIII in 1547. A circle of patrons

associated with the court during the Protectorate of the Duke of Somerset—a group which included Somerset himself and the Duke of Northumberland as well as a number of their younger followers, principally John Thynne, William Sharington, and William Cecil—diligently acquired foreign handbooks and employed foreign craftsmen; and they emulated building activities in Italy and France, notwithstanding the break with the Church of Rome which had occurred in the previous decade.[17] In his *First and Chief Groundes of Architecture*, published in 1563, the painter and architect John Shute describes how he had been sent to Italy ten years before by his patron, the Duke of Northumberland, for the express purpose of studying the works of ancient and modern masters of architecture.[18] What Shute may have seen and done on this visit is another matter, but it is fair to say that the very fact of this visit to Italy and the evidence of increasingly Italianate modes in the architectural projects of his patrons (at Dudley Castle, Lacock, and Somerset House, for example) represent a significant interest in the architecture of the Italian Renaissance. An important strain of French influence can also be found in examples dating from mid-century and well into the 1570s (at Burghley and Kirby, for example), but these experiments also gave way to a distinctive and original court style. Here again the medieval revival and the motifs of classicism were joined together as they had been in painting.

An extraordinary series of drawings dating from 1570 to 1600 suggests that while English architects of the period knew the latest styles in planning and design from the Continent (from workshop portfolios of copied drawings and from works by Serlio, Du Cerceau, Palladio, and others circulating among artists and patrons), they felt compelled to incorporate them into conservative projects. Such projects employed traditional English devices. A plan for an English country house in the shape of a Greek cross by Robert Smythson (fig. 6), one of a number of important drawings in the Smythson portfolio at the Royal Institute of British Architects in London, embodies the contradiction faced by architects working for the court.[19] The drawing dates

5. Issac Oliver, *Portrait of an Unknown Girl*, 1590, vellum affixed to a playing card, 5.4 x 4.3 (2⅛ x 1¹¹⁄₁₆) oval
Victoria and Albert Museum

6. Robert Smythson, *Plan for a House in the Shape of a Greek Cross* (II/16), c. 1580, 13.5 x 13.5 (5⁵⁄₁₆ x 5⁵⁄₁₆)
British Architectural Library, RIBA, London

7. Robert Smythson, *Plan for Wollaton Hall* (I/25 [1]), c. 1580, 33.3 x 35 (13⅛ x 13¾) British Architectural Library, RIBA, London

from c. 1580 and shows a variation on a centrally planned building with curved walls and semidomed spaces; this is a type unfamiliar in England but typical of designs published in Italian handbooks. Philibert Delorme had experimented with a similar form in the chapel at Anet in 1547–1552, but there too the project represented a departure from traditional norms.[20] Here Smythson adapted his model to the English context in two important ways: first, he has enclosed the cross-shaped building in a square and created a gatehouse at the entrance in a manner typical of castles and fortified manor houses; second, he has inserted a tripartite screen, a great hall and a screens passage (a short hallway separating the large main room from other parts of the house) into the arm of the cross at the top of the drawing. The latter device is the most significant, underlining the fact that the great hall was a crucial part of any Elizabethan country house design: it was a resonant survival from the medieval past and symbol-

ized both the owner's knightly status and his family's traditional power over the land.[21] In the revival of chivalry, this and other features of domestic architecture such as the gatehouse and the great hall took on an increased significance. Smythson's rather awkward design was thus the result of his attempt to conflate two very different planning traditions and two symbolic languages: that of medieval England and that spelled out in Italian Renaissance architectural theory.

In Smythson's project for Wollaton Hall, which also dates from the years around 1580, we can again recognize the juxtaposition of the two styles (fig. 7). Ignoring the constraints imposed by the site, which was on a steep hill, Smythson conceived of an ideal plan in which a large square would be subdivided into nine smaller ones; the house, with its four corner towers, would occupy the center of the designs, while courtyards and gardens would surround it. Service buildings such as the stable, brewhouse, bakehouse, and dairy were placed at the midpoints of each side of the large square; as in the *Greek Cross* plan, a gatehouse marked the center point of the entrance wall. Thus geometry ordered the project, reflecting the site plans shown in Italianate designs, notably those of Palladio. Inside, all was disorder and asymmetry, even in this paper architecture. The traditional castle type called for a carefully monitored approach via a series of checkpoints, turnings, and open spaces: the main gatehouse gave access to a courtyard surrounded by high walls; opposite, the entrance porch protecting the front door led past a porters' lodge and into a narrow hallway; inside, the screens passage and screen created a series of ninety-degree turnings which eventually opened onto the great hall. We can observe these features quite clearly at the core of the Wollaton design. They disrupted the orderly Palladianism of the plan but could not be omitted if the chivalric imagery and ceremonial traditions of the English countryside were to be maintained.

Inventories relating to Wollaton suggest that in the design of the house's upper floor, an area much less rigidly controlled by traditional planning and symbolism, Smythson was indeed able to incorporate a bilat-

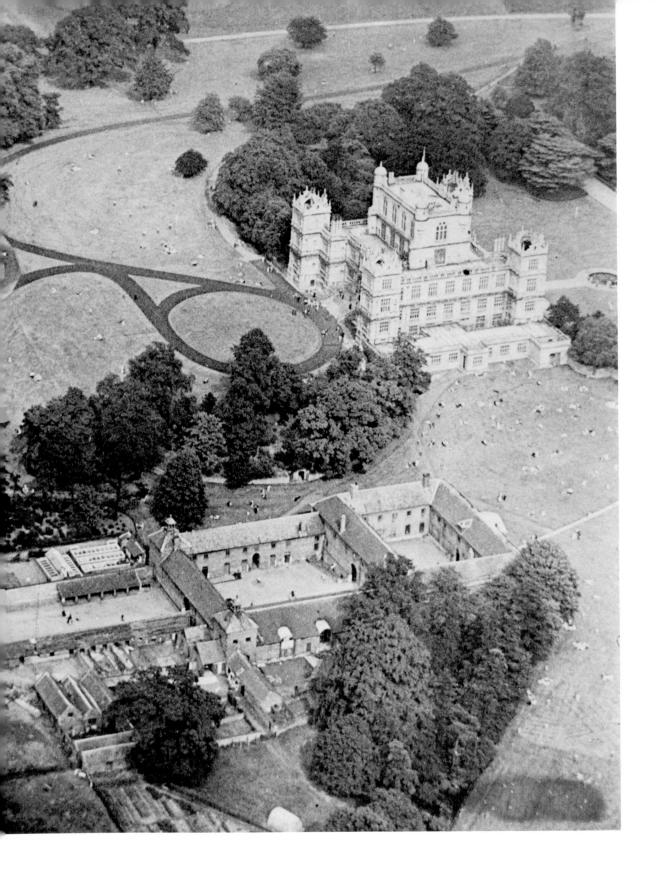

erally symmetrical plan.[22] But the exterior of the house, as built, reflected nothing of the architect's interest in Palladio or clas- sicism (fig. 8). With its high central tower, strapwork gables, and imposing site, the house resembled a fairy-tale castle; and it

8. Wollaton Hall, Notting-hamshire, 1580–1588
Photograph courtesy of Nottingham-shire County Library Services

9. Wollaton Hall, Nottinghamshire, *Virgil*
Author photograph

10. Hardwick Hall, Derbyshire, plan, 1590–1597

culture in the design of his house were indispensable; no courtier who built in the 1580s would be without them. Thus on the surface of the building, a grid of pilasters and niches divides the facades into bays, incongruously separating elongated rectangular windows which derive from Perpendicular Gothic. On each tower, classicizing busts, some with labels indicating the identity of the figures—Virgil, Aristotle, Plato, Cato—tell yet another story (fig. 9). Many of these are framed by complex strapwork devices, thus incorporating an additional language into the scheme; i.e., that of fashionable Mannerist ornament recently imported into England by Huguenot sculptors, designers, and jewelers newly arrived from the Low Countries and much patronized by the court.[23]

In his next work, at Hardwick Hall (1590–1597), Smythson once again attempted to adapt classicizing planning to the English context, but here he was able to effect a radical break with the past. In the plan of Hardwick, we immediately recognize the change: the great hall is no longer entered via the traditional circuitous route but directly, on axis with the front door (fig. 10). Placed longitudinally at the center of a roughly symmetrical plan, the great hall at Hardwick thus sacrifices references to medieval chivalric culture in favor of a solution that owes more to Palladio (fig. 11). The fact that the patron, Elizabeth Shrewsbury, "Bess of Hardwick," was a woman has a great deal to do with such a break with the past at Hardwick: neither her identity as a landowner nor the ceremonial rituals practiced by her household were as thoroughly dominated by tradition as they were for male courtiers; like the queen herself, she was an anomaly and could thus afford to participate in a planning experiment apparently initiated by her architect. The message may not have been consciously intended by either of them, but this significant shift in planning strategies remains.

Yet as at Wollaton, the requirements of the medievalizing court style were met on the exterior of the house (fig. 12). Flattened surfaces, a parapet of strapwork crenelation, distorted proportions, even the closed area of wall on the two stories above the

was meant to be experienced sequentially as a series of vistas, stopping points, and isolated images. This discursive and variable architectural experience was fundamentally at odds with the homogeneous and instantaneously perceived ideal of classicism. Even before the original outbuildings and gardens were replaced by picturesque plantings and a new stable block in the eighteenth century, the house appeared to be asymmetrical, its ornamental silhouette changing as the observer ascended the hill. Yet for the builder of Wollaton, Sir Francis Willoughby, references to classical

main doorway—all mark this building of the Elizabethan period. As we have seen in earlier examples, the whole consists of diverse parts: heraldic devices, classical columns, Perpendicular Gothic windows, the initials "ES" on each tower; these elements are drawn from various sources and depend on each other for cumulative effect. To be sure, the Palladian plan of the house contributed significantly to its appeal, but it was only one facet in a many-faceted composition. This is exactly the same strategy as that employed in the Harefield Entertainment, in the portraits of the Earl of Cumberland and of the queen herself, and elsewhere in Elizabethan court culture.

Perhaps the clearest example of stylistic choice in architecture occurs in a drawing of about 1622 by John Thorpe now in Sir John Soane's Museum (fig. 13). Though dated much later than the other works discussed here, Thorpe's project is paralleled by earlier drawings in his portfolio (which span the period 1596–1623), and shows the persistence of anticlassical themes in English art. Infrared photography reveals an underdrawing which copies Palladio's project for the Villa Pisani, but what appears on the page, in both plan and elevation, looks very little like the source.[24] Like Smythson, Thorpe mixed English and Italianate motifs in his projects: here, a glazed projecting bay creates a very Elizabethan lantern of light at the center of the composition but sits above a tripartite colonnade of distinctly Italianate details and proportions. Thus Thorpe not only ignores the Palladian elevation which accompanies the plan in the original but also adopts an anticlassical and partitive approach to his design, mixing languages, varying roof types and gable designs, and ultimately, assembling a collection of individual pieces rather than creating a unified, orderly whole.

A final group of examples raises two further points: first, Elizabethan architects seem to have been as familiar with classicizing elevations as they were with plans, despite the fact that they never combined them in an Italianate and stylistically consistent way; and second, when this knowledge was put to use in the design of architectural forms, these forms were treated as isolated objects in architectural settings (both interior and exterior) much as eighteenth-century landscape gardeners placed temples and pagodas in their designs as historicizing and evocative set-pieces.[25] In both periods, the consciousness of difference (historical and cultural) and novelty added meaning to the designs. In the 1570s, for example, Smythson worked for Sir Matthew Arundell at Old Wardour Castle in Wiltshire, renovating the late fourteenth-century castle by recutting windows and doors and adding impressive classical frames to the main entrance front and to the prin-

11. Andrea Palladio, *Design for the Villa Valmarana* From *I quattro libri dell'architettura* (Venice, 1570)

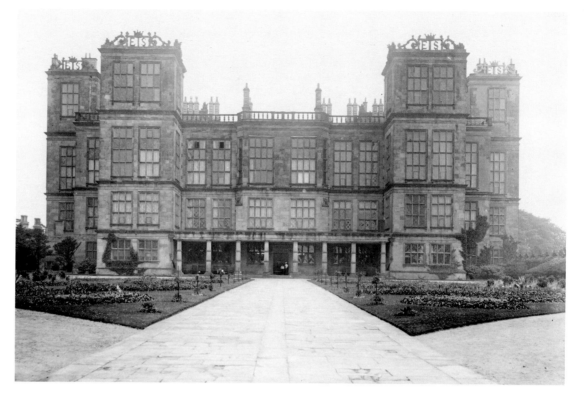

12. Hardwick Hall, Derbyshire
Photograph courtesy of National Monuments Record

13. John Thorpe, *Design for a House*, showing underdrawing of Palladio's Villa Pisani (infrared photo) (T 34)
By courtesy of the Trustees of Sir John Soane's Museum

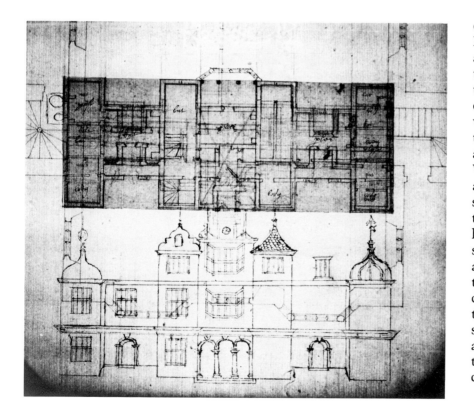

cipal doorway in the court (figs. 14, 15).[26] No attempt was made to fit all the detailing at the castle into a consistently modern, that is consistently Italianate, scheme. On the contrary, the authenticity of the medieval building seems to have added to its value, and Smythson was to incorporate details from it into his later works, notably at Wollaton where the patron, Sir Francis Willoughby, was Arundell's brother-in-law and, like him, a follower of the latest court styles. Among these details were the tall, traceried windows which marked the great hall on the upper floor of the castle. By sacrificing neither the evocative pointed arches of the original Gothic building nor the monumental solemnity of the Doric order, Smythson was able to feature both and to communicate a more complicated message about the oldness and newness of Elizabethan culture. The resulting image, like the court itself, drew its power from this conflation of meanings.

That this was not peculiar to Smythson

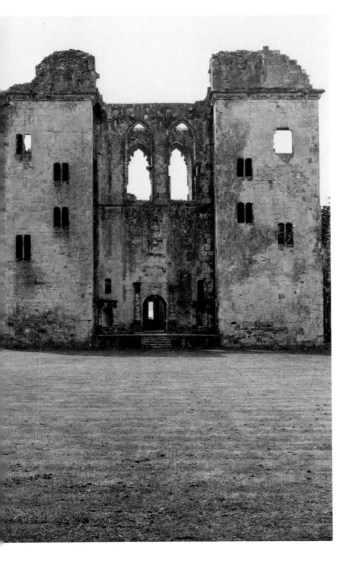

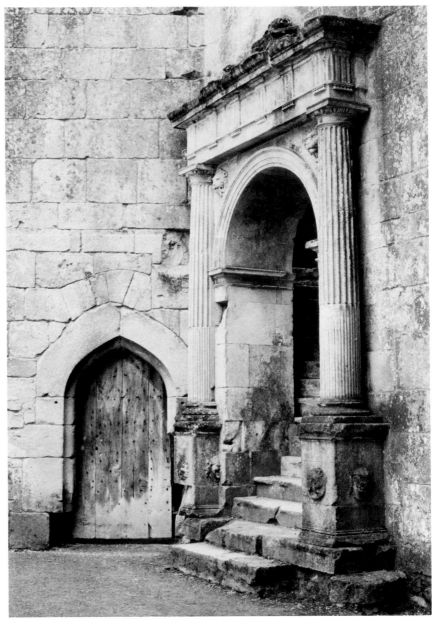

is made clear by a contemporary example at Kirby Hall in Northamptonshire, begun by Sir Humphrey Stafford and finished by Sir Christopher Hatton.[27] Here the courtyard is ringed with a colossal order of pilasters perhaps related to those at the chateau of Ecouen, while the elaborate entrance porch (fig. 16) certainly reflects the French frontispiece type found at Ecouen, Anet, and elsewhere.[28] It is the focus of the composition and gives the building its character, yet it was clearly meant to be read in the context of the courtyard, lodgings, and great hall. Ultimately, the *syntax* was English regardless of the detailing of individual elements in the composition. The porch at Kirby, like the door frames at Wardour, was fitted into an English scheme of checkpoints and stopping places. That these visual and symbolic foci were not only varied and evocative but meant to be discovered in a narrative sequence marks them as Elizabethan.

In this light, the design for a screen for

14. Old Wardour Castle, Wiltshire, late fourteenth century, entrance front
Author photograph

15. Old Wardour Castle, Wiltshire, door frames in the court
Author photograph

16. Kirby Hall, Northampton-
shire, 1570–1575, frontispiece
in the great court
Author photograph

nation of bays. The design can be related
to Palladio's Basilica at Vicenza and to im-
ages published by Serlio, but while similar
in appearance, these forms are clearly al-
tered by their context. By removing a detail
such as these five bays from their original
architectural (and cultural) setting and
transplanting them to the English great hall,
Smythson was able to benefit from the res-
onance and power of the forms without
yielding cultural ground. Placed in the con-
ventional position and retaining the tripar-
tite form, this Italianate and monumental
object in stone (or in a material painted to
look like stone) gains in force from the ele-
ment of surprise which would have been
experienced by the English viewer on dis-
covering that it has been substituted for the
familiar wooden screen. Such elements of
substitution, discovery, and surprise are, of
course, typical of the courtly style and its
popular derivatives.

Thus when we encounter a work such as
the tomb monument of Sir Christopher
Hatton, erected in Old St. Paul's about 1593,
we can recognize the disparate elements
which give the work its stylistic and cul-
tural identity (fig. 18). Once again heraldic
shields and animal supporters are juxta-
posed with classical personifications in fe-
male form; figures of Father Time and of
Transcience decorate the spandrels of an
arch flanked by ionic columns and pilas-
ters. An effigy wearing armor and placed in
a medievalizing pose with hands clasped in
prayer lies atop a Roman sarcophagus. No
attempt has been made to impose a uniform
scale on any of the details; indeed, the enor-
mous obelisks flanking the monument seem
only distantly related to it. Finally, a lengthy
inscription in Latin offers tribute to the de-
ceased, reinforcing verbally a message which
is in part communicated by the disparate
symbolic elements of the monument. Words
and figural sculpture take precedence over
abstract forms, but when these are used they
are meant to be treated associatively. At its
core, the experience of the work is more
literary and intellectual than it is visual.

This may ultimately be the key to the
underlying aims of Elizabethan art and ar-
chitecture. For reasons resulting from the
need for a distinctive and unassailable im-
age for the female ruler, Elizabethan culture

Worksop Manor by Smythson makes sense
(fig. 17). Worksop, built in the mid-1580s,
was the country house of the Earl of
Shrewsbury, Bess of Hardwick's estranged
husband.[29] Nowhere in his portfolio of
drawings does Smythson apply such an Ital-
ianate elevation to a building facade; to have
done so would have been to feature the new
style in too prominent a position. But a hall
screen, with its tripartite form and tradi-
tional English usage, was the ideal means
to explore a classicizing, rhythmic alter-

Within the figure:

A Platte
· at ·

For A Screene
· worsoPe ·

To bee Builte
manner

abounds with works of art and literature that were meant to be experienced through mediating intellectual distortions. Irony, double meaning, metaphor—these devices insured that anything could be both itself and its opposite simultaneously.

Ignorance of correct architectural classicism, or indeed of naturalism, played no part in the genesis of this style; the evidence suggests that these principles were consciously distorted rather than ignored. These facts help us to understand the art of the Stuart court in new light as well. On the one hand, it appears that the beautiful Palladian designs of Inigo Jones were prefigured in the works of English architects such as Smythson and Thorpe, but that Jones was encouraged by his own court patrons to shed the Anglo-Flemish manner of the previous reign and to explore the possibilities inherent in the "new" style. On the other hand, the tenacity of the Elizabethan manner and the survival of variations on it until nearly the end of the seventeenth century, testify to its success in speaking for English patrons in whose hearts and minds the conflict between nationalism, tradition, and humanist culture persisted. Whether one dates the advent of the "English Renaissance" to 1550, 1608, or, indeed, to the neo-Palladian movement of the early eighteenth century, and whether this

17. Robert Smythson, *Design for a Screen at Worksop Manor, Nottinghamshire* (I/ 26), c. 1585, 25.8 x 33.3 (10³/₁₆ x 13¹/₈) British Architectural Library, RIBA, London

18. Richard Stevens (?), *Tomb of Sir Christopher Hatton*, c. 1593

From W. Dugdale, *History of Old St. Paul's Cathedral in London* (London, 1658), 82. Houghton Library, Harvard University

movement is defined by a knowledge of the rules of classical art and architecture or a willingness to follow them, one thing is certain: the meaning of even the most rigorously copied models was fundamentally altered when they were transplanted to the English context and viewed through the eyes of an audience steeped in an entirely different culture with its own language, rules, and ways of seeing.

1. John Summerson, *Architecture in Britain, 1530–1830* (Baltimore, 1969), 6 n.5.

2. For Jones' earliest drawings, see John Summerson, *Inigo Jones* (London, 1966), 26–28.

3. The use here of the term "mannerist"—to suggest a broad-based, international style rooted in Italian painting, sculpture, and architecture, but ultimately flourishing in the ornamental and decorative motifs of the minor arts of northern Europe—follows the definition suggested by John Shearman in *Mannerism* (Harmondsworth, 1967), 15–30, and Manfredo Tafuri in *L'architettura del manierismo nel cinquecento europeo* (Rome, 1966).

4. See Roy Strong, *The English Renaissance Miniature* (London, 1983), and Jill Finsten, *Isaac Oliver: Art at the Courts of Elizabeth I and James I* (New York, 1978).

5. On the creation of Elizabethan court culture see F. Yates, *Astraea: The Imperial Theme in the Sixteenth Century* (London, 1975), and Roy Strong, *The Cult of Elizabeth* (London, 1977). Related themes are discussed in S. Greenblatt, ed., *The Forms of Power and the Power of Forms in the Renaissance* (Norman, Okla., 1982). For an analogous use of borrowed and local traditions, see M. Tafuri, *Jacopo Sansovino e l'architettura del '500 a Venezia* (Padua, 1969).

6. Yates 1975, 29.

7. Jean Wilson, "The Harefield Entertainment and the Cult of Elizabeth I," *The Antiquaries Journal* (1986, pt. 2), 315–329.

8. See J.H. Hexter, "The Education of the Aristocracy in Renaissance," in *Reappraisals in History*, 2d. ed. (Chicago, 1979), 45–70, and Lawrence Stone, "The Educational Revolution in England, 1560–1640," *Past and Present* 28 (1964), 40–80. For the differences between men's and women's educational experiences, see Alice T. Friedman, "The Influence of Humanism on the Education of Boys and Girls in Tudor England," *The History of Education Quarterly* 25, nos. 1 and 2 (Spring-Summer 1985), 57–70.

9. This notion was first described by Ernst Gombrich in "Zum Werke Giulio Romanos," *Jahrbuch der Kunsthistorischen Sammlungen in Wien* 8 (1934), 79; 9 (1935), 121.

10. For Renaissance pageants and courtly entertainments see Jean Jacquot, ed., *Les Fêtes de la Renaissance*, 3 vols. (Paris, 1959, 1960, 1975), and Roy Strong, *Art and Power: Renaissance Festivals, 1450–1650* (Woodbridge, 1984). For England, see Gordon Kipling, *The Triumph of Honor: Burgundian Origins of the Elizabethan Renaissance* (Leiden, 1977).

11. See Lucy Gent, *Picture and Poetry, 1560-1620: Relations Between Literature and the Visual Arts in the English Renaissance* (Leamington Spa, 1981). The appendix lists books and their owners from surviving published and unpublished library catalogues.

12. See Roy Strong, *Artists of the Tudor Court: The Portrait Miniature Rediscovered, 1520–1620* (London, 1983), 45–51.

13. Strong 1983, *Artists*, 134–135.

14. Strong 1983, *Artists*, 83–84.

15. The title page is discussed by Margery Corbett and Ronald Lightbown in *The Comely Frontispiece: The Emblematic Title-Page in England, 1550–1660* (London, 1979), 59–66.

16. It may be worth noting here that a related but much more far-reaching point about stylistic choices in English art of all periods is made by Nicholas Pevsner in *The Englishness of English Art* (Harmondsworth, 1964), chap. 3.

17. For Northumberland and his circle, see Summerson 1969, 43, 46–47, 55, and Maurice Howard, *The Early Tudor Country House: Architecture and Politics, 1490–1550* (London, 1987), 55–57, 185–187.

18. Shute's *First and Chiefe Groundes* has been published in a facsimile with an introduction by L. Weaver (London, 1912).

19. A catalogue of these drawings was published by Mark Girouard in *Architectural History* 5 (1962). See also Girouard's *Robert Smythson and the Elizabethan Country House* (London and New Haven, 1983).

20. See Anthony Blunt, *Art and Architecture in France, 1500–1700*, 2d ed. (Harmondsworth, 1970), 89–91.

21. For the medieval great hall and its use see Mark Girouard, *Life in the English Country House: A Social and Architectural History* (London and New Haven, 1978), 29–46.

22. Wollaton and its design are discussed at length in Alice T. Friedman, *House and Household in Elizabethan England: Wollaton Hall and the Willoughby Family* (University of Chicago Press, 1988). For English Palladianism before Jones, see John Summerson, "Piante palladiane nelle dimore del periodo elisabettiano," *Bolletino del centro internationale di storia dell'architettura* 11 (1969), 277–286.

23. Huguenot craftsmen are discussed in various essays by Mrs. K. A. Esdaile, including "The Part Played by Refugee Sculptors, 1600–1750," *Proceedings of the Huguenot Society* 18, no. 3 (1947–1952). See also Lionel Cust, "Foreign Artists of the Reformed Religion Working in London from about 1560 to 1660," *Proceedings of the Huguenot Society* 7 (1901–1904), 45–82.

24. Thorpe's *Notebook* was published by John Summerson, *The Book of Architecture of John Thorpe* (Walpole Society 40, 1966).

25. For the Elizabethan revival of Gothic, see Mark Girouard, "Elizabethan Architecture and the Gothic Tradition," *Architectural History* 6 (1963), 23–40.

26. See Girouard 1983, 78–81.

27. Summerson 1969, 47–48, and C.H. Chettle, *Kirby Hall, Northamptonshire* (London, 1947).

28. Blunt 1970, 136.

29. For Worksop, see Girouard 1983, 110–115.

WALTER S. MELION
The Johns Hopkins University

Karel van Mander's "Life of Goltzius":

Defining the Paradigm of Protean Virtuosity in Haarlem around 1600

Hendrick Goltzius occupies a privileged position in Karel van Mander's *Schilder-Boeck* or *Book on Picturing* of 1604, which charts the history of Netherlandish art in the fifteenth and sixteenth centuries. Presented as a series of artists' lives, the *Schilder-Boeck* frames a response to the argument of the 1568 edition of Giorgio Vasari's *Le Vite de' più Eccelenti Pittori, Scultori ed Architetti* (fig. 1).[1] Like Alessandro Lamo's *Discorso* of 1584, which praises the arts of Cremona, and Giovanni Armenini's *De' veri precetti* of 1587, which defends the principles of Lombard painting, Van Mander's *Schilder-Boeck* counters Vasari's claims for the cultural authority of Florentine painting, sculpture, and architecture, the arts of *disegno*, of which the supreme practitioner is Michelangelo.[2] Van Mander's "Life of Goltzius" eulogizes Goltzius as Michelangelo's Dutch counterpart and celebrates his mastery of painting, copper- and glass-engraving, the northern arts of *teyckenconst*. *Teyckenconst*, literally the "art of inscribing," is a critical category that translates and adjusts Vasari's *disegno*; and Goltzius, as the foremost exponent of *teyckenconst*, is seen as exemplifying standards of pictorial accomplishment that relate Michelangelo's art and high reputation to a cultural context.

Van Mander defines critical categories and supplies competing paradigms of pictorial excellence that are developed within a se-

ries of historical constructions. Book 1 of the *Schilder-Boeck*, a long pedagogical poem addressed to Dutch students of the visual arts, introduces the terminology employed in the following three books with specific reference to works by selected masters. Books 2, 3, and 4 chart ancient, Italian, and northern art respectively with chronological artists' biographies. Book 3, "Lives of the Italian Masters," is in fact a carefully abbreviated Dutch translation of the second edition of Vasari's *Vite*, which retains much of Vasari's essential structure and nomenclature.[3]

Van Mander uses the *Vite* as a tool, rather than a canon, in his own appraisal of the north. By yoking a self-contained edition of Vasari's *Vite* to his own northern "Lives," he builds a powerful system of cross-reference into the *Schilder-Boeck*. This juxtaposition of historical schemes consolidates the several competing responses to the 1550 edition of the *Vite*, formulated by Flemish cultural historians in the circle of Abraham Ortelius in Antwerp.[4] The reader, moving from one set of biographies to the next, discovers pronounced differences in the instances of prowess offered to clarify the aims of the Netherlanders and the Italians. Their respective concerns recall differently the preoccupations of ancient masters, while their works revise different aspects of the ancient pictorial accomplishments discussed in Book 2, "Lives of the

Greek and Roman Masters," just as their preferred paint media—tempera applied to walls in Italy and oils applied to panels in the Netherlands—differ from the ancients' encaustic spread in configurations of two or four colors. Van Mander's critical apparatus consists largely of such contrasts; by familiarizing the reader with the history of ancient *schilders* (picturers) and Vasari's discourse on art, he fashions informed beholders better able to distinguish the achievements of northern masters. Through the mechanism of cultural differentiation, he identifies Netherlandish and Italian art as regional projects, subdivided among Dutch, Flemish, Roman-Florentine, and Venetian communities, which retain unique characteristics yet also engage in extramural exchanges of theory and workshop practice.[5]

I want to concentrate here on Van Mander's account of Goltzius' virtuosic practice of the arts of *teyckenconst*, as it differs from the canonical Italian usage defined in Book 3 of the *Schilder-Boeck*. I shall complement this discussion by considering Goltzius' powers of invention. Just as in Vasari the history of *disegno* runs parallel to the history of *invenzione*, so, too, in the "Life of Goltzius" *inventie* parallels *teyckenconst*. I shall focus in particular on Van Mander's use of a metaphor that summarizes both categories of pictorial accomplishment and explains the prowess of Goltzius' hand—the assertion that he is a latter-day Proteus. The *Schilder-Boeck* distinguishes categories of abiding visual interest to Dutch art throughout the seventeenth century. By focusing on the "Life of Goltzius," I aim to explore the operation of Van Mander's discourse, as well as to demonstrate its pertinence to Goltzius' art.

Van Mander establishes Goltzius' title to surpassing *teyckenconst* and *inventie* by developing a metaphor—coined earlier by the humanist Schoneus in a dedication quatrain—that praises Goltzius' skill as a reproductive engraver: "All these things I have related, prove Goltzius to be a rare Proteus or Vertumnus of art, capable of refashioning himself in the form of all the species of rendering."[6] The passage refers specifically to the print series and demonstration plates that spread Goltzius' reputation as the lead-

1. Karel van Mander, title page to *Het Schilder-Boeck*, 1604, Haarlem; designed by Van Mander, engraved by Jacob Matham, published by Paschier van Wesbusch

ing reproductive engraver of his day: the *Meesterstukjes*, six episodes from the early life of the Virgin, four in the manner of sixteenth-century Italian painters and two in the manner of engravings by Dürer and Lucas van Leyden, published in 1594 with the Schoneus dedication to Duke Wilhelm V of Bavaria (figs. 2-7); the *Passion* series in the manner of Lucas, published in 1598 with a dedication to Cardinal Federico Borromeo (fig. 8); and the small, finely worked *Pietà* in the manner of Dürer, inscribed with Goltzius' initials in imitation of Dürer's monogram (fig. 9).[7] In these prints Goltzius does not copy prior works but, rather, aims to transcribe and employ the signature rendering of masters he revered.[8] He exercises his Protean hand by reproducing the characteristic pictorial means of his models. Series such as the *Meesterstukjes* and the *Passion*, for both of which he won gold chains, are double representations that fashion their subjects by refashioning representational means. In the "Life of Goltzius" the Protean metaphor extends beyond his prints to all his efforts at *schilderconst*—the Dutch

2. Hendrick Goltzius, *The Annunciation*, from the *Meesterstukjes*, 1594, engraving
Baltimore Museum of Art, Garrett Collection BMA 1946.112.12045

pounds the types of change for which Proteus functioned as an ancient metaphor: the transition of water into air and air into other elements, compounds, and the things of nature; the realization of thoughts as things made by man; the pantomime's ability to figure convincing likenesses of persons and things; the power of persuasive oratory to alter the listener's convictions; and finally, the skilled exercise of social tact, which enables the adept, chameleon-like, to assimilate himself to any given circumstances or policies. Proteus, then, signifies a constellation of changes—of materials, of appearances, of social profile—that can characterize broadly the artist's trade—his manipulation of media, his production of persuasive likenesses, his subordination of self in the interests of accurate depiction and in deference to a client's requirements. Goltzius' career, as Van Mander discusses it in the *Schilder-Boeck*, corresponds especially closely to the Protean metaphor: his attempts to transform traditional materials by mixing them in unprecedented ways, his ambition to cast compound likenesses that render the things of nature and the means of art, and, as we shall see, his efforts to subordinate himself as an artificer to his absorption in the object of representation.[10] In the context of the *Schilder-Boeck* he achieves standards of virtuosity that counterpoise the Protean pursuit of *teyckenconst* and *inventie* with the very different paradigms of *teyckenconst* and *inventie* articulated in the Italian "Lives."

The Italian "Lives" chronicles the restoration of painting after its demise in the centuries preceding the birth of Cimabue. In Van Mander's account, as in that of Vasari on which it is based, Giotto inaugurates the cycle of renewal by anchoring his painting to the prior practice of *teyckenconst*, the vehicle that promoted "the improved modern art of painting."[11] Giotto's *teyckenconst* is an executory skill, expressive of a mode of active conception. It signifies, first of all, drawing after life with a stylus but also the retention of visual impressions for the purpose of drawing from memory. Giotto regulates the objects of his attention and improves his *teyckenconst* by concentrating on figures, whose mobile gestures and

art of picturing. His drawing, painting, and glass-engraving become symptoms, too, of his Protean *teyckenconst* and *inventie*, terms whose meanings emerge from Van Mander's characterization of the master as the Netherlandish Proteus.

Van Mander explains the Protean metaphor in Book 5 of the *Schilder-Boeck*, the "Wtlegginge" or "Commentary on Ovid's Metamorphoses."[9] Proteus and Vertumnus are identified as Greek and Roman versions of the same deity, whose names signify "change" and "alteration." Van Mander ex-

postures embody the *affetti* (passions). He internalizes a fund of figural attitudes, which he proceeds to extend and adjust independently of nature: ". . . his gift and ingenuity are in postures and gestures and the movements of the passions, which he figures artfully, constantly innovating, so that with justice he may be called Nature's pupil."[12]

Michelangelo, the "universal light of *teyckenconst*," perfects the pictorial means that were generated by Giotto in a historically preliminary way and enhanced by his successors in the fourteenth and fifteenth centuries.[13] *Teyckenconst* presumes Michelangelo's mastery of line and ensures his consummate achievements in the sister-arts of painting, sculpture, and architecture. He is first and foremost a draftsman, whose earliest proofs of virtuosity are drawings indistinguishable from the prints they counterfeit, and whose mature *Last Judgment* fresco assimilates painting to the paradigm of drawing with hatched lines. Van Mander writes: ". . . it is hatched and very cleanly so in the shadows, and this is evident not only in the lower zones, which can be viewed from close by, but also above in the highest. . . ."[14]

In the *Last Judgment* Michelangelo paints a finished drawing and reaffirms the exclusionary definition of *teyckenconst* offered in the "Life of Giotto." He attends solely to the nude human figure, reasserting the achievement of the Sistine Ceiling: he beautifies the body by perfecting its proportions, mobilizes it by rotating the torso and limbs, varies its age and expressive physiognomy, diversifies incomparably the range of attitudes that externalize the *affetti*, and confers on configurations of nudes the powerful illusion of sculptural relief.[15] Michelangelo refines definitively the primary resource of Roman-Florentine art, *teyckenconst* understood as the artist's power to conceive and execute the body in movement. However, he accomplishes this feat by jettisoning categories of pictorial interest integral to Giotto's art and nourished by the armature of his *teyckenconst*: the facile disposition of figures as *contrapposti*, ornamentation of stories by attention to circumstantial details and setting, and compositional variation guided by ideals of decorum and narrative coherence.[16] Nor does

he pursue coloring delightful to the eye. Instead Michelangelo varies, transforms, and elaborates the canon of normative posture: ". . . in which with a high manner, he has truly attended to the nude, that is, to its beauty, perfect proportion, and formation of its limbs, in every attitude, surpassing all others in this ambition, and leaving joyful coloring by the wayside, along with many other ornaments, that other painters use to pleasant advantage, and ignoring, too, graceful invention in the composition of his history."[17]

Michelangelo is a lover of difficulty who

3. Hendrick Goltzius, *The Visitation*, from the *Meesterstukjes*, 1593, engraving Baltimore Museum of Art, Garrett Collection BMA 1946.112.12046

4. Hendrick Goltzius, *The Adoration of the Shepherds*, from the *Meesterstukjes*, 1594, engraving
Baltimore Museum of Art, Garrett Collection BMA 1946.112.12047

searches enthusiastically for complex attitudes, as arduous to perform as they are to depict.[18] The frescoes in the Capella Paolina are the most extreme expression of his total disregard for landscape, which engages the viewer incidentally at the expense of figures: ". . . one must search in vain for any incidental ornament, for the view into the distance, the landscape is not inviting: one sees neither trees nor buildings nor other such things, just as if having achieved the highest thing, he had been unwilling to regard the lower or smaller."[19]

Van Mander is clearly ambivalent about the selective emphasis of Michelangelo's art, which finally repudiates drawing after life as a legitimate enterprise. He transcribes the famous definition of reconstructive sight in which Michelangelo, questioned about his ability to reconstitute even colossi as graceful *figure serpentinate*, replies that the artist's eyes are like a pair of compasses. They measure human proportions actively, rather than simply receiving visual information, and they recreate figures they deem deficient in some respect. The artist's eyes judge rather than transcribe appearances, and *teyckenconst* designates the judicious works that result from this critical faculty, as well as the skill with which it is embodied in pictures.[20]

Teyckenconst certifies Michelangelo's power to reform figures by revisualizing them in his mind's eye, and denotes the vigor with which he originates figures lacking precedent in either nature or art. The eyes, functioning like compasses, inscribe nature with the "O" delineated previously by Giotto's arm and hand; Michelangelo's simile indicates that it is impossible for him to see figures without reconceptualizing them as perfect prototypes for his *teyckenconst*.[21] Michelangelo represents the conclusion of the Italian school that measured progress by contributions to *teyckenconst's* perfection: ". . . he has made figures 9, 10, and 12 heads high, and known how to fashion them gracefully, although no models for such figures could be found, and so he said that the compass must be in the eye rather than the hand: for the hand works, but the eye judges. . . ."[22]

Van Mander's "Life of Goltzius" provides the northern alternative to Michelangelo's definition of *teyckenconst*. Goltzius is identified as Michelangelo's Dutch counterpart and the supreme exponent of *teyckenconst* in the Netherlands.[23] Goltzius' work is seen to adjust and occasionally invert key features of Italian usage. For example, Goltzius resists the presumption that *teyckenconst* heightens the artist's authorial ego, exercising his aptitude for new resources of posture and gesture and liberating his pictorial means from the paradigms of notable predecessors. Michelangelo had encouraged the artist to contrive unprecedented figures ("fashioned out of one's

self"—"uyt zijn selven wat te maecken") and had warned against the imitation of pictorial manner, which impeded the growth of *teyckenconst*.[24] In a powerful demonstration of his virtuosity as a draftsman, Michelangelo had divested himself of all traces of manner by recording his remembered impressions of untutored graffitti. His ability to strip manner altogether from his art counterpoints his fertile invention of novel figures, the basis of his *teyckenconst* and the means that engender his own unique manner.[25]

By contrast Goltzius, the circumstances of whose life Van Mander uses to characterize the northern practice of *teyckenconst*, designs a repertory of disguises that obscure his social and professional identity.[26] Far from articulating an autographic self through the pursuit of "drawing out of himself," he travels and makes pictures incognito and abdicates his authorial identity to models, which he seeks to imitate by "nearly forgetting himself" ("zijn selven schier verghetende").[27] Van Mander describes his response to antiquities seen during a visit to Rome in 1590–1591 as an impulse to forget himself in the interests of recording accurate likenesses. The young Italians who observe Goltzius at work expect to find evidence of the German manner superimposed on his descriptive records, but are amazed instead to discover the supreme examples of *teyckenconst* that result from his efforts to draw anonymously after life:

> . . . for several months he kept himself secret and unknown, disguising himself in the costume of a German provincial, and calling himself Hendrick van Bracht, nearly forgetting himself, for the sight of so many fine and artful works liberated and removed his very mind and soul from his body, and he daily renewed his desire to see new things, giving himself over to copying constantly and diligently the best and rarest antiquities, no differently from any lowly apprentice. The youths who go to Rome in large numbers to draw, seeing him so costumed, looked occasionally over his shoulder at his sheets, curious to know what sort of rendering this German might have, expecting more to be amused than astonished.[28]

Van Mander here links the forgotten self to both the assumption of an alias and the

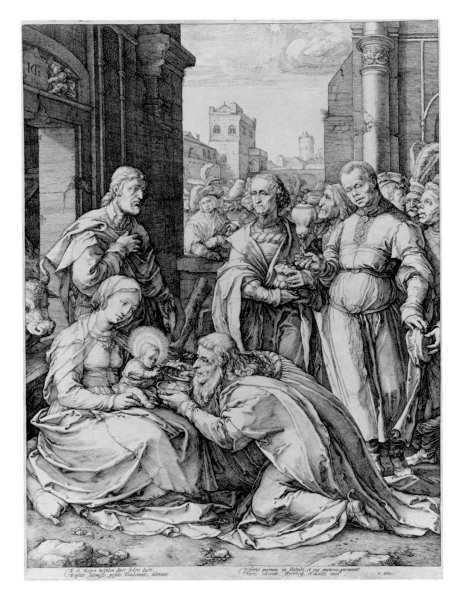

5. Hendrick Goltzius, *The Adoration of the Magi*, from the *Meesterstukjes*, 1594, engraving
Baltimore Museum of Art, Garrett Collection BMA 1946.112.12049

absorption in objects of observation. Goltzius loses himself by looking intently, and his drawings register that loss as a symptom of visual concentration and faithful reportage. His trip to Rome coincides with the outbreak of plague throughout Italy, yet he continues to draw after life, apparently oblivious to the corpses that strew the public places where he sits to record effigies. Although frail himself, Goltzius holds a commitment to *teyckenconst* that neutralizes all signs of self-regard, just as his drawings of sculpture disavow the interference of the draftsman.[29]

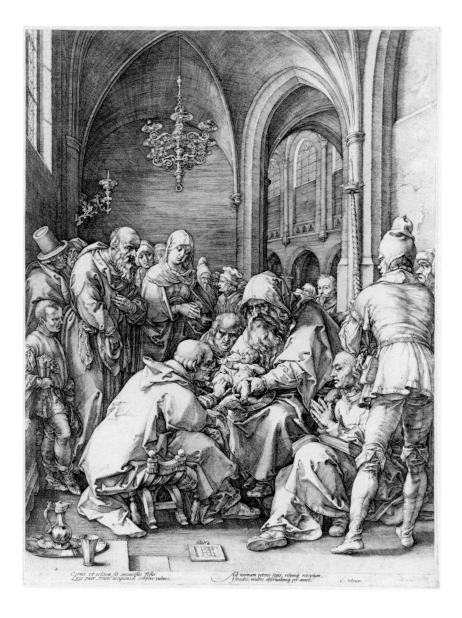

6. Hendrick Goltzius, *The Circumcision*, from the *Meesterstukjes*, 1594, engraving
Baltimore Museum of Art, Garrett Collection BMA 1946.112.12048

an early age he aimed not simply to transcribe the beautiful and diversified things of nature: but applied himself wonderfully well, too, to portraying the varied renderings of the best masters, such as Heemskerck, Frans Floris, Blocklandt, Federigo Zuccaro, and finally Sprangher, whose spirited manner he followed closely. . . ."[31]

Van Mander's observation frames a powerful syllogism that associates nature and rendering as objects of imitation: the diverse things of nature ("verscheyden ghedaenten der Natueren") are to the varied renderings of the best masters ("verscheyden handelinghen der beste Meesters"), as transcribe ("nae te volghen") is to portray ("nae te bootsen").

If at times Goltzius draws the diversity of nature, he aims at others to mimic the diversity of linear means, which is fundamental to his appreciation of pictorial manner. For Goltzius, as for his biographer, manner results from the draftsman's manipulation of line; in his drawings after drawings and prints, Goltzius subsumes his execution to the rendering he discovers in the model.[32] He does this because the most distinguished evidence of *teyckenconst* is facility at appropriating the rendering of masters, whose manipulation of the stylus must be claimed as his own. This standard of excellence carries two important consequences for the northern definition of *teyckenconst*, one technical, the other historiographical.

First, Goltzius' program of *teyckenconst* binds drawing and engraving as modes of representation. Van Mander states boldly in the "Life of Goltzius" that engraving supplies the paradigms of his surpassing *teyckenconst*: "Concerning his works, his prints above all testify to his mastery of *teyckenconst*."[33] Van Mander cites in particular two plates from the *Meesterstukjes*: *The Adoration of the Magi* in the manner of Lucas and *The Circumcision* in the manner of Dürer (figs. 5 and 6). In a telling anecdote he explains how Goltzius, eager to test the success of these reproductions of *handelinghen*, removed his monogram and artificially aged a number of impressions. He then sent the prints to markets in Rome, Venice, and Amsterdam, where collectors and engravers soon accepted them as gen-

Goltzius refines *teyckenconst* by subjecting both nature and art to drawing after life (*nae t' leven*) and from the memory of things seen (*uyt den geest*).[30] Unlike Michelangelo he neither confines himself to figures nor promotes a personal manner by alienating his works from the appearance of pictorial prototypes. On the contrary, his conception of virtuosity depends on his experience with reproductive engraving and extends the engraver's sensitivity to rendering, the different inflections of which must be translated into prints. Van Mander: "And I have this to say of him, that from

uine specimens of work by Dürer and Lucas. Van Mander adds ironically that these prints were published in masquerade ("vermont en in mascarade"), thus inviting the reader to draw parallels between Goltzius' counterfeits and his journey incognito to Venice and Rome. Goltzius' detractors, who praised these prints above his other works, claimed inadvertently that he had surpassed himself and ratified, as well, his ability to reactivate *handelinghen*.[34]

By referring to prints as distillations of Goltzius' *teyckenconst*, Van Mander identifies engraving as a mode of finished drawing and ascribes to drawing the reproductive function of prints. The claim that Goltzius draws with the burin asserts his virtuosic dexterity, for the burin is wielded very differently from the stylus and in fact reverses the motion of the delineator's hand. If Goltzius' prints display the draftsman's facility, his drawings imitate the engraver's linear means.

Van Mander's account of Goltzius' virtuosic drawings concentrates almost exclusively on works in pen on parchment and prepared canvas, which share the consummate rendering of prints ("rendered with smooth long hatched lines in a fashion both praiseworthy and unimpeachable"—"handelinghe met gladde langhe artseringhe, gansch loflijck en onberisplijck"[35]). Van Mander especially reveres these drawings because they are double representations that depict a subject by depicting the burin's strokes. Like prints they may be regarded, and sold, as self-sufficient specimens of the artist's *teyckenconst*: their supports, size, and rendering confirm that they are finished rather than preparatory works. I emphasize this point to distinguish Goltzius' understanding of public images from Michelangelo's, for this distinction allows us to discriminate further between their respective notions of *teyckenconst*. Michelangelo's drawing spurs the conception of *uomini nudi*, the means to perfection of the three privileged sister-arts, painting, sculpture, and architecture, and their allied media.[36] The *Last Judgment* fresco, although it retains evidence of Michelangelo's affinity for drawing, translates lines to the medium of paint in order to achieve the high distinction and public address of a mural

image. Painting, sculpture, and architecture complete what drawing proposes. Goltzius' public images on the contrary are prints after drawings and drawings executed like prints, media that translate each other as part of their representational function. His drawings and prints are evidence of *teyckenconst*, pursued as an end of art, rather than implemented provisionally as the means to more fully realized images.[37]

The second consequence of Goltzius' reproductive standard of virtuosity concerns rendering (*handelingh*). He perfects *teyckenconst* by turning it into the representa-

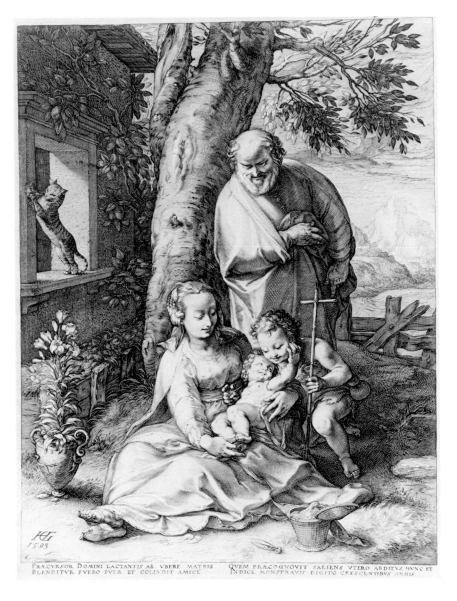

7. Hendrick Goltzius, *The Holy Family with St. John the Baptist*, from the *Meesterstukjes*, 1593, engraving Baltimore Museum of Art, Garrett Collection BMA 1946.112.12050

tion of rendering; the notion that rendering is Goltzius' object of representation informs Van Mander's claim that he is a latter-day Proteus because of his ability to retrieve the rendering of other masters. Goltzius forges lines into a tractable medium that can describe all other media and mimic the *handelinghen* of all other masters. He is great because of his range as a copyist—simply put, there is nothing he cannot reproduce—and because his drawings, whether of people, the things of nature, or the representational means of fellow artists, are so like their originals.[38]

Because he recovers the rendering of older northern masters, Goltzius can picture the past of northern art. He can do more than this, however. By distinguishing between the finished representation (*schilderij*) and representational means (*handelinghen*), he effaces the boundary between the past and present of Dutch and Flemish art. In series such as the *Meesterstukjes* he employs the rendering of Dürer and Lucas in subjects of his own devising, and thereby effectively produces new works that may be legitimately perceived as copies of old ones. In new pictures that represent old means, he renews and describes, but does not revise and transform the visual past.

Goltzius' *teyckenconst* is a critical category that encapsulates Van Mander's rejection of Vasari's progressive scheme for the history of the visual arts. Goltzius' *teyckenconst*, far from declaring the obsolescence of old pictorial devices, embraces and authorizes them as objects of representation. Goltzius gives closure to the northern history of *teyckenconst* by reactivating all prior *handelinghen*. His drawings and prints present the argument that the history of Netherlandish art need not be rated incrementally; every artist (or at least those ratified by inclusion in the *Schilder-Boeck*) has contributed a mode of visualization, which claims neither more nor less regard from the contemporary master.[39]

The "Life of Goltzius" suggests further that Goltzius' shift from engraving to painting around 1600 continues the program of the *Meesterstukjes*: the assimilation and discrimination of canonical forms of Italian and northern *handelinghen*.[40] Oils allow him

to master the rendering of the great Italians: Raphael's smoothly executed transitions of tone and hue, features essential to his graceful compositions; Correggio's gentle handling of pigments that seem to yield softly to the touches of the brush and thereby enhance the illusion of pliable flesh; Titian's thickly worked lights that advance before fluidly brushed shadows, which seem to merge in turn with the canvas ground; and Veronese's assimilation of brushwork to the coruscating weave of light-reflective textiles.[41] By proposing the kinship of the *Meesterstukjes* to Goltzius' painting, Van Mander secures his brushwork to the pursuit of *teyckenconst*.

I want to turn now to invention (*invenzione, inventie*), a critical category allied to *teyckenconst* by both Vasari and Van Mander, and assimilated to the Protean metaphor in the "Life of Goltzius." The "Lives" of Raphael, the Brothers Van Eyck, and Goltzius provide the most decisive accounts of *inventie*. As in the case of *teyckenconst*, the Italian "Lives," specifically the "Life of Raphael," functions as a foil to the "Life of Goltzius."[42]

Raphael's *inventie* is the ability to compose *istorie* that fulfill the requirements of grace, variety, and narrative tact; his decision to master invention results from the realization that he can make no further contributions to the history of *teyckenconst*, which was perfected by Michelangelo. Van Mander quotes Vasari's famous passage to this effect from the 1568 edition of the *Vite*:

. . . Raphael, having seen the great study made of the nude by Michelangelo, and recognizing that he could not surpass him, realized that the painter's excellence does not reside exclusively in the production of nudes, and discovered a wide open field in which he might transcend Michelangelo: that is, invention and the composition of histories, which he sought neither to elaborate confusingly with too much, nor to leave poor and miserable with too little. He sought, too, to enrich his work circumstantially with subsidiary details that might please the beholder . . . In sum, I say that Raphael was graceful in all things. . . .[43]

The citation retains Vasari's radical reformulation of *invenzione*, formerly the poet's or painter's resourceful discovery of a sub-

ject worth painting or versifying, but here a mode of representation as well. Raphael's *inventie* embraces the *by-een-voeginge* of the history—pictorial organization realized through the implementation of Michelangelo's *teyckenconst*, the *uomini nudi* perfected by Michelangelo as the means of Italian art, and complemented by an expanded repertory of subsidiary details such as costume and setting.[44] Raphael anchors *inventie* to ideal principles of narrative construction. The *ekphrases* of paintings in the "Life of Raphael" identify the two foremost principles as the distribution of *figure serpentinate*, whose attitudes activate stories clearly yet gracefully, and the orchestration of *figure come fratelli*, whose spatial symmetries integrate while varying the pictorial field. Van Mander cites the *Mass of Bolsena* as an especially clear instance of the *istoria* varied through recourse to configurations of *figure serpentinate*: "All the folk hearing Mass, kneeling and standing, men and women, are astonishing for the singularity and diversity of their fine attitudes: among them a woman seated on the ground, her neck embraced by a child, who turns herself gracefully."[45]

Raphael's invention oscillates between the poles of clarity and elaboration—the discovery of essential *bewegingen* (mobile attitudes) on the one hand and the addition of supplementary *bywercken* (accessories) on the other, the universal application of generalized standards of *gracelijckheyt* (grace) and *schoonheyt* (beauty) compounded with the introduction of varied *omstandicheden* (circumstances); by negotiating these poles Raphael turns the *istoria* into an optimal instrument of instruction and delight, neither too ornate nor too austere but, rather, based on natural action (*natuerlijcke actie*). Van Mander asserts that he attaches figures to narrative functions and the legible externalization of the *affetti*, and enriches painted stories by attending to the relevant circumstantial details suggested by canonical texts.[46]

In the "Life of Raphael" the figure of Attila from the Stanza d'Eliodoro exemplifies the aim of narrative coherence; his pose, an extreme form of the *figura serpentinata*, registers accurately the sudden fear that reverses his aggressive momentum forward.[47]

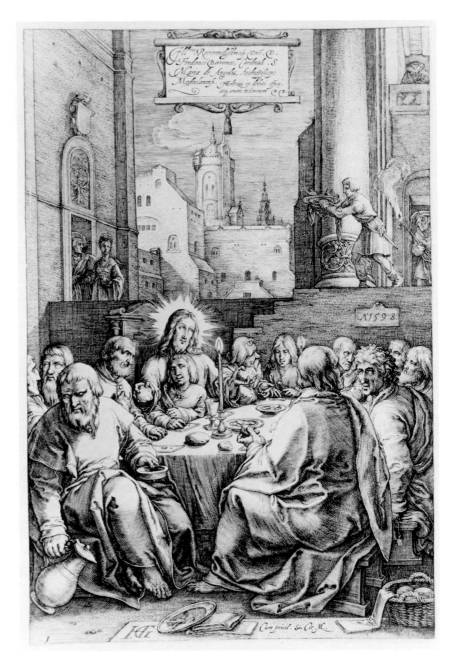

St. Peter in Prison accomplishes the parallel aim of consequent elaboration of the *istoria*; Raphael has shown the dreadful prison indicated by the Bible, and differentiated the natural and divine lights that penetrate the dark night. These details intensify the fresco's subject—the commission of a miracle: ". . . attending to the text, he sought to introduce all the circumstances . . . the

8. Hendrick Goltzius, *The Last Supper*, from *The Passion*, 1598, engraving
Courtesy of the Warburg Institute

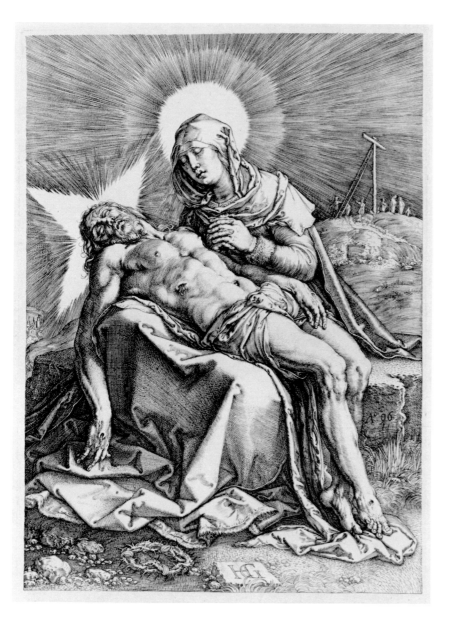

9. Hendrick Goltzius, *Pietà*,
1596, engraving
Baltimore Museum of Art: gift of
Alfred R. and Henry G. Riggs, in
memory of General Lawrason Riggs
BMA 1943.32.282

by a body that executes an about-face. Raphael's reputation as an *ordineerder*, a "composer of pictures," depends on the skill with which he enriches *istorie* by mobilizing *contrapposti* that even when circumstantial, remain narratively engaged.

More specifically, Raphael's fame as an *ordineerder* consists of this ability to commit incidentals to the aims of persuasive and engaging narration and, conversely, to expand the narrative field pertinently so that it encompasses accessory circumstances. *Ordineren*, so defined, is directly relevant to Raphael's authoritative *inventie*—the project of *by-een-voeginge der Historien* (literally the gathering of histories, but here the aggregation of historical figures and particulars) that provides his answer to Michelangelo's finished *teyckenconst*.[49] Raphael's *inventie* relies for its critical validity on the assumption that he implicates figures and accessories in the central event of the *istoria*; having expanded the scope of *bewegingen* (actions), *bywercken* (ornaments), and *omstandicheden* (circumstantial accessories) that inform his paintings, he yet subordinates these elements to the dictates of *ordineren*—the formulation of stories in affective, attractive, and integrated ways. *Inventie* denotes the facility with which he extends the artist's representational range, while continuing to fulfill the Albertian requirements of pictorial composition.[50]

In the northern "Lives," *inventie* has two applications, neither of which attaches the term to the orchestration of the *istoria* (*historie*). The "Life of Goltzius" illustrates one sort of usage, that defines *inventie* as any nonreproductive category of pictorial interest devised by the artist. Van Mander refers to the *Meesterstukjes*: "For recalling what species of rendering he had seen abroad, he with a single hand broadcast varied renderings in pictures of his own invention...."[51] I have asserted that the *Meesterstukjes* have the status of double representations, for besides depicting a subject, they cast rendering itself as an object of representation. If the successful appropriation of *handelinghen* declares Goltzius' *teyckenconst*, *inventie* designates all the respects in which he diverges from his models. In *The Circumcision*, for example,

angel casts a great flickering light onto the armor of the guards . . . and where this light does not fall, the moon casts her glow. These lights were well differentiated, and also the darkness of night. . . ."[48]

Both the *Repulse of Attila* and *St. Peter in Prison* feature *contrapposti*—the play of piercing light and impenetrable gloom, or the change of attack into retreat signaled

the tokens of *inventie* include the choice of a subject not previously engraved by Dürer, the grouping of figures that recalls rather than duplicates any of Dürer's plates, the setting of the scene in St. Bavo's, the inclusion of anachronisms such as the Flemish chandelier and the artist's self-portrait, and finally, the use of engraving for a print that resembles Dürer's woodcuts from the *Life of the Virgin* in format, scale, and subject. (Of course these features conspire to support the deceptive claims of Goltzius' *teyckenconst;* when first published *The Circumcision* was sold as a newly-found plate by Dürer, one that differed from the familiar prototypes precisely because it was genuine.)

Inventie has a second and more specific scope in the northern "Lives." It is one of the first Dutch inflections of Vasarian usage to be introduced and is featured prominently in Book 4 in the opening "Life of the Brothers Van Eyck." In this context *inventie* is the technical invention of oil-based pigments and the allied discovery of executory skills that respond to the new material and ultimately control it. Oils generate new modes of rendering, and Jan van Eyck's *inventie* promotes the use of oils. *Inventie*, then, initiates *handelingh* and provides both the material basis and concomitant dexterity that define painting in the Netherlands. Van Mander emphasizes in the very first line of the northern "Lives" that painting, so understood, is a "loflijcke deugtsaem oeffeningh"—virtuosic practice of high craft. Jan van Eyck's *inventie* posits painting, one branch of *schilderconst*, as a northern *oeffeningh*, or exercise of identifiable skills, the history of which can now diverge from Italian theory and practice:

It is clear that painting as it was first practised in the Netherlands with glue- and egg-based pigments originated in Italy . . . But in the way of all alert and diligent souls, Jan strove ever further for perfection, and discovered after many researches that pigments let themselves be tempered well with oils . . . And what most astonished and pleased Jan, was that pigments could be better manipulated and worked with oils, than with damp egg or animal glue, and needed no longer to be applied as if drawn with hatched strokes. Jan was justifiably pleased with this discovery: for here was born a new race and form of

work that astonished many . . . so that even from the land of the Cyclops and the ever-burning Etna, men came to see this outstanding discovery . . . Our art had need of this noble invention to draw closer and more like to the forms of nature.[52]

Implicit in the "Life of Goltzius" is the artist's attempt to compete with Jan's *inventie*. Goltzius feigns the technical invention of new media by mixing familiar materials in unprecedented ways. The mixture of media purports to be the basis for a genuinely new *handelingh*: "It then occurred to Goltzius to draw with the pen on canvas primed or prepared with oil color . . . So he proceeded and drew on a suitably large primed canvas a nude woman accompanied by a laughing satyr, both pleasingly ornamented and heightened, their flesh tinted in some places, and the whole varnished. . . ."[53]

Van Mander has no name for Goltzius' innovative procedure, which still defies description. He catalogues instead the layering of lines, strokes, daubs, and washes that results in a palimpsest of indecipherable means and unprecedented renderings. The response of emperor Rudolf II to Goltzius' virtuosic works in mixed media confirms their function as demonstrations of *inventie*. Astounded by the *handelingh* of Goltzius' *Female Nude with a Laughing Satyr*, the emperor consults with a court painter, who is likewise unable to solve the puzzle set by the artist's manipulation of means. Their astonishment echoes the earlier reaction of Jan van Eyck's contemporaries to his oil-based panels: "This work came into the hands of the Emperor, who wondered at the rendering and how it had been done, calling upon those active in the arts, who were also astonished: for it appears to the eyes both curious and lifelike."[54] The centerpiece of the anecdote is lost, but similar works survive and can help to illustrate the nature of the critical category *inventie*. The *Bacchus, Ceres, and Venus* of 1604 (fig. 10) transforms an earlier virtuosic representation of the epitome of Terence, the large *pen-werck* (literally, "work of the pen") of 1593 (fig. 11). In the *pen-werck*, pen and ink render the characteristic stroke of Goltzius' burin on a sheet of parchment; in turn his burin-work assim-

10. Hendrick Goltzius,
Bacchus, Ceres, and Venus,
1604, drawing in pen and ink
on prepared canvas
The Hermitage, Leningrad

ilates the calligrapher's cursive stroke. Thus the depiction of the proverbial triumvirate of gods conflates three *handelinghen*—the rendering of the draftsman's pen, the engraver's burin, and the calligrapher's quill— that together display the artist's proverbial mastery of *teyckenconst*. The version of 1604 effaces all signs of identifiable *handelingh*;

it declares Goltzius' *inventie*, rather than expounding his *teyckenconst*. On a monumental piece of linen canvas, primed as if for metalpoint, Goltzius has drawn elaborate networks of cursive lines with an arsenal of quills, graded by size and point; the nudes have been overpainted with transparent washes of diluted, rose-tinted oils

11. Hendrick Goltzius, *Bacchus, Ceres, and Venus*, 1593, drawing in pen and ink on parchment
By permission of the Trustees of the British Museum

and highlights added in white. The finished picture is neither a painting, drawing, nor print but rather, a new genus of representation and species of rendering. Such technically unprecedented works established Goltzius' reputation as an innovator who could vie even with the putative discoverer of oil-based pigments. The Protean Goltzius recalls Jan van Eyck in his inauguration of material and representational means, just as he had previously retrieved the *handelinghen* of earlier northern masters. As Van Mander makes clear, however, Goltzius did not actually invent new materials. He defamiliarizes traditional executory means and turns technical invention itself into an object of representation, feigning to disclose what he has not actually discovered. Van Mander frames Goltzius' *inventie*, like his *teyckenconst*, as a mode of appropriation, for he shows how the artist demonstrates *inventie* by representing ostensibly new pictorial means, translating into representational terms the kind of *inventie* that Jan exemplifies.[55]

The radical way in which Goltzius amalgamates technical resources becomes all the more apparent if we consider the regulations of his trade organization, the Haarlem Guild of St. Luke. The *Guild Letter* of 1590, which remained binding throughout the seventeenth century, stipulates in the first article the sorts of crafts governed by the new ordinances.[56] The article differentiates guildsmen by painstaking reference to the varieties of executory motions they make using specific tools and selected materials. *Tinnewerckers* are segregated from *blickwerckers*, who shape a lesser tin with a smaller lead component; *coper slaeghers*, who hammer copper, are distinguished from *geel ghieters*, who forge rather than beat copper and brass, just as *beeldsnyders*, who cut effigies, are separated from *beeldehouders*, who carve their statues with chisels and mallets. The *Guild Letter* documents a diversified terminology that accentuates the boundaries between professions and their *handelinghen*. The *Bacchus, Ceres, and Venus* of 1604 eludes the jurisdiction of the guild's terminology, by seeming to transgress the accepted domains guarded by artisans and defined by various tools, materials, skills, and modes of rendering.

Van Mander informs us that Goltzius was sedulously private in his working methods; like Jan van Eyck he concealed all but the visible fruits of his *inventie*. Like Jan again, whose interest in alchemy and the transmutation of substances inspired the distillation of oils, Goltzius sustained an interest in natural philosophy. In their respective biographies the commitment to alchemy and natural philosophy signifies the preoccupations that motivate masterful demonstrations of *inventie*.[57] Van Mander credits Goltzius with the renewal of *inventie*, the Netherlandish aptitude for technical invention that initiated northern art in 1400 and liberated the history of *schilderconst* from the history of Italian art. His claim to *inventie*, the representation of new media through unprecedented rendering, compounded with his mastery of *teyckenconst*, the repetition of the characteristic rendering of prior masters, extends the Protean metaphor, which rules his career as it is presented in Karel van Mander's northern "Lives."

NOTES

1. Karel van Mander, *Het Schilder-Boeck* (Haarlem, 1604). Van Mander discusses Goltzius' life and work extensively in "T'leven van Henricus Goltzius, uytnemende Schilder, Plaetsnijder, en Glaesschrijver, van Mulbracht," in Book 3, *Het Leven der Doorluchtighe Nederlandtsche, en Hooghduytsche Schilders*, folios 281v–287r; he also devotes three stanzas to Goltzius' virtuosic draftsmanship in the chapter on kinds and degrees of reflected light, "Van de Reflecty, Reverberaty, teghen-glans oft weerschijn. Het sevende Capittel," stanzas 47–49, in Book 1, *Den Grondt der Edel vry Schilder-const*, 33r.

2. Vasari published the 1550 and 1568 editions of the *Vite* under the auspices of the *Accademia Fiorentina*, incorporated by Duke Cosimo in 1542 with the aim of extending the jurisdiction of Tuscan as the vernacular component of the *studia humanitatis*. By 1568 Vasari spoke, too, as a representative of the *Accademia del Disegno*, incorporated in 1563. Van Mander was well aware of Duke Cosimo's involvement in the project of the *Vite*, as is evident from his remarks in the preface to Book 4, "Voorreden op t'Leven der Nederlandtsche en hooghduytsche vermaerde Schilders," 198r–198v. For a discussion of the founding program of the *Accademia del Disegno*, see Charles Dempsey, "Some Observations on the Education of Artists in Florence and Bologna During the Later Sixteenth Century," *The Art Bulletin* 62 (1980), 552–569; and, by the same author, on responses of the Carracci to Vasari, "The Carracci *Postille* to Vasari's *Lives*," *The Art Bulletin* 68 (1986), 72–76.

3. Books 1–4 are foliated consecutively and comprise an integrated subsection of the *Schilder-Boeck*. The titles of Books 2 and 3 are *Het Leven der oude Antijcke doorluchtighe Schilders* and *Het Leven der Moderne, oft dees-tijtsche doorluchtighe Italiaensche Schilders*. For the physical composition of the *Schilder-Boeck*, see Werner Waterschoot, "Karel van Mander's Schilder-Boeck (1604): A Description of the Book and Its Setting," *Quaerendo* 13 (1983), 260–286. For a detailed inventory of the elements that Van Mander deleted from his version of Vasari's text of 1568, see Hessel Miedema, *Karel van Manders Leven der Moderne, oft Dees-Tijtsche Doorluchtighe Italiaensche Schilders en hun bron* (Alphen aan den Rijn, 1984), 1–21.

4. Vasari problematized for the Flemish community of humanist proponents of the vernacular, the nature of their literate involvement with images. The letters exchanged by Ortelius and his friends attest to the brisk trade in copies of the *Vite*. See, for example, the letter of 1580 from Georg Braun to Ortelius, and the letter of 1587 from Domenicus Lampsonius to Ortelius, in Joannes H. Hessels, ed., *Abrahami Ortelii et Virorum Eruditorum ad eundem et ad Jacobum Colium Ortelianum Epistulae* (Cambridge, 1887), 230–232, 353–355. On Lampsonius, see Jean Puraye, *Dominique Lampson Humaniste 1532–1599* (Liege, 1950).

5. Unlike Vasari who claims the superiority of the Florentine theory and practice of the arts of *disegno*, and only grudgingly assimilates the Venetians into the history of art, Van Mander acknowledges the excellence of several schools of ancient and Italian art. He identifies three regional Greek schools—the Ionian, Sicyonian, and Attic—which correspond to the modern Netherlandish, Italian, and Venetian schools. See "Van Eupompus, Schilder van Sycionien," *Schilder-Boeck*, 70r–70v. On Van Mander's Italian "Lives," see Helen Noë, *Carel van Mander en Italië* (The Hague, 1954).

6. Van Mander, "T'leven van Henricus Goltzius," 285r: "Al dees verhaelde dinghen t'samen bewijsen, Goltzium eenen seldsamen *Proteus* oft *Vertumnus* te wesen in de Const, met hem in alle ghestalten van handelinghen te connen herscheppen."

Schoneus' dedication, which appears on *The Annunciation* of 1594, reads:

Ut mediis Proteus se transformabat in undis,
Formose cupido Pomone captus amore:
Sic varia Princeps Tibi nunc se Goltzius arte,
Commutat, sculptor mirabilis, atque repertor.

For *The Annunciation*, the opening plate of the *Meesterstukjes*, see note 7.

7. The *Meesterstukjes* consist of six plates: *The Annunciation*, 465 x 350 mm; *The Visitation*, 461 x 351 mm; *The Adoration of the Shepherds*, 461 x 350 mm; *The Circumcision*, 465 x 351 mm; *The Adoration of the Magi*, 460 x 350 mm; and *The Holy Family with St. John the Baptist*, 460 x 350 mm. The title *Meesterstukjes* seems to have originated with Bartsch, who designated the series *Les chefs-d'oeuvre* in his catalogue of prints by Goltzius, published as Volume 3 of *Le Peintre Graveur* (Vienna, 1803–1821). *The Passion* consists of twelve plates averaging 196 x 130 mm. The *Pietà* is dated 1596, 175 x 126 mm.

8. Hence Van Mander's use of the term *herscheppen*, a derivative of *scheppen*, that emphasizes Goltzius' reconstitutive powers.

9. Van Mander, *Wtlegginge, en sin-ghevende verclaringe op den Metamorphosis Publij Ovidij Nasonnis*, 115v.

10. On the transformation of traditional materials see the account of the Emperor Rudolf's fascination with the unprecedented execution of the *Nymph and Laughing Satyr*, in "T'leven van Henricus Goltzius," 285r, as well as the description of the *Bacchus, Ceres, and Venus* of 1593, a large drawing on parchment, as a *Dedalis stuck*, in "Van de Reflecty," 33r. On Goltzius' program of self-instruction through the representation of both nature and representational means, "T'leven van Henricus Goltzius," 284r. On his self-effacing concentration on the transcription of antiquities in Rome, regardless of the encroaching plague, "T'leven van Henricus Goltzius," 283r.

11. Van Mander, "Het leven van Giotto," 96r: ". . . baerde en bracht voort de beter Moderne Schilder-const, en oock t'recht gebruyck van Conterfeyten nae t'leven, t'welck binnen twee hondert Jaren te vooren niet op de beste wijse en hadde gheschiet."

12. Van Mander, "Het leven van Giotto," 96r: ". . . zijnen gheest en vernuft heeft hy in uytbeeldinghen, gesten, bewegingen der affecten, in zijn figueren seer constlijck laten blijcken, altijts yet nieuws bedenckende, dat hy der Natueren leerkindt met recht mocht heeten."

13. The "Life of Michelangelo" opens with the assertion that he is heir to the light first shed by Giotto; see Van Mander, "Het leven van Michel Agnolo Buonarruotti," 163v.

14. Van Mander, "Het leven van Michel Agnolo Buonarruotti," 170v: "Acht Jaren pijnichde hem Michel Agnolo dit werck te voldoen, het welck van verre en van by hem wel wil laten sien, sonder eenighen welstant te verliesen, en is geweest gheretocqueert, en met artseringen in de diepselen seer net voldaen, niet alleen onder, daer men by can, maer boven in't opperste . . ." On Michelangelo's ability to transcribe the rendering of prints, 164r.

15. Van Mander, "Het leven van Michel Agnolo Buonarruotti," 168r. These achievements, embodied by the *ignudi*, confirm the elevation of *teyckenconst* to the highest degree of perfection.

16. For Giotto's ability to wield antitheses, see the description of one of the servants of Job, from the series of six frescoes exemplifying his patience, in Van Mander, "Het leven van Giotto," 96r–96v. For Giotto's attention to detail, see the celebrated description of the *Navicella*, 96v. For his compliance with the requirements of decorum, the subsidiary figures who bring Job bad tidings in the Pisan frescoes, 96r.

17. Van Mander, "Het leven van Michel Agnolo Buonarruotti," 170r: ". . . in welck hy eyghentlijck met een groote maniere heeft ghelet op de naeckten, te weten, op de schoonheydt, volcomen proportie, en ghestaltenissen der Menschen lichamen, op alderley actituden, hier in allen anderen overtreffende, latende aen d'een syde de vrolijcke coloreringhe, en ander duysent aerdicheden, die ander Schilders tot vermaecklijcken welstandt ghebruycken, en oock eenighe gracelijcke inventie in't ordineren synder historie."

18. Van Mander, "Het leven van Michel Agnolo Buonarruotti," 171r–171v: "Om nu eyndlijck zijn leven in't corte te betrecken, en t'overloopen, is te weten, dat hy altijt seer ghenegen was tot alle moeyten, die de Conste belangen: bevindende, dat hy door alle swaricheden daer mede gheraeckte."

19. Van Mander, "Het leven van Michel Agnolo Buonarruotti," 170v: ". . . doch eenich omstandich bywerck moet men hier niet lustich zijn te zien, want het achter uyt, oft landtschap is niet cierlijck: men sieter boomen, noch ghebouw, oft dierghelijcke dinghen, ghelijck of hy alleen t'hooghste treffende op het leeghe oft gheringhe niet en heeft willen achten."

20. Van Mander, "Het leven van Michel Agnolo Buonarruotti," 171v. On the *figura serpentinata*, see David Summers, "*Maniera* and Movement: the *Figura Serpentinata*," *The Art Quarterly* 35 (1972), 269–301.

21. For the anecdote of the "O" of Giotto, Van Mander, "Het leven van Giotto," 96v. Giotto's ability to render a perfect circle freehand testifies to his control of the draftsman's representational means: lines that vary continuously in breadth by swelling and tapering seamlessly. These gracefully varied lines form the basis of Giotto's improved figures, themselves graceful and varied.

22. Van Mander, "Het leven van Michel Agnolo Buonarruotti," 171v: "Men heeft ghesien dat hy beelden heeft ghemaeckt, langh 9. 10. en 12. hoofden, als hy daer by wist eenige gratie te weghe te brenghen, alhoewel sulcx in't leven niet te vinden waer, soo seyde hy, dat den Passer most wesen in d'ooghe, en niet in de handt: want de handt arbeydt, en de ooghe oordeelt. . . ."

23. The analogy of Goltzius to Michelangelo occurs in "T'leven van Henricus Goltzius," 285v. The account of Goltzius' aptitude for *teyckenconst* consists of two parts, the first devoted to his engraving, the second to his drawing with pen and ink

24. Van Mander, "Het leven van Michel Agnolo Buonarruotti," 172v. Michelangelo disapproves of the slavish appropriation of pictorial manner, arguing that only those capable of discharging new things, fashioned from themselves, will gain from the translation of paradigms.

25. Van Mander, "Het leven van Michel Agnolo Buonarruotti," 172r. Michelangelo demonstrates his powerful memory and the art that conceals art, by imitating line for line an untutored *graffito* he had once seen scrawled on a wall. The ability to generate new things from the self counterpoints the ability to distance oneself from habitual excellences of manner.

26. The "Life of Goltzius" consists of two halves, roughly equal in length, which describe respectively his life and work. This bilateral organization distinguishes it from the other Netherlandish biographies. Among the anecdotes of his self-effacing prowess, is the story of his trip to Italy, during which he exchanged personas with his servant. By disguising himself, Goltzius aimed to disclose unprejudiced responses to his prints. Van Mander, "T'leven van Henricus Goltzius," 282v–283r.

27. Van Mander, "T'leven van Henricus Goltzius," 283r. In Rome Goltzius takes the pseudonym Hendrick van Bracht, a veiled reference to his family's origins in the town of Muhlbracht. Van Mander presents Goltzius' loss of self positively, as a liberation from the constraints of the body, which had so handicapped Goltzius with illness in Haarlem. In Italy Goltzius is repeatedly disembodied by the act of visual attentiveness, required by the exercise of drawing *nae t' leven*—after life. The term refers to work done while one is actually looking at the object of sight.

28. Van Mander, "T'leven van Henricus Goltzius," 283r:

> . . . hy hem oock etlijcke Maenden hiel stil en onbekendt, wat boerigh op zijn Hoogh-duytsch vercleedt, liet hem noemen Hendrick van

Bracht, zijn selven schier verghetende, om dat zijnen gheest en ghedacht door het sien der uytnemende constighe wercken waren als den lichaem ontschaeckt en benomen, daeghlijckx de begheerde nieuwicheydt zijnen lust vernieuwende, begaf hem als eenighe slechte leer-jongers, stadigh en vlijtigh te conterfeyten de beste en besonderste Antijcken. De Jongers, die veel te Room gaen teyckenen, hem in sulck ghestalt siende, saghen t'somtijt over op zijn Papier, belust om weten wat desen Todesco doch voor handlinghe mocht hebben, meenende veel eer yet belachlijckx als verwonderlijckx te sien.
On Goltzius' drawing after Roman antiquities, see Hessel Miedema, "Het voorbeeldt niet te by te hebben: Over Hendrick Goltzius' tekeningen naar de antieken," in *Miscellanea I. Q. van Regteren Altena*, eds. Hessel Miedema, Pieter J. J. van Thiel, and R. W. Scheller (Amsterdam, 1969), 74–78. Goltzius implements a procedure that binds his visual experience of the model from points of view near and far.

29. On Goltzius' obliviousness to the dire circumstances in Rome, Van Mander, "T'leven van Henricus Goltzius," 283r. On his recurrent illnesses, which Van Mander believes were induced by the many impediments to his pursuit of the visual arts, 282v. The conviction of imminent death precipitates Goltzius' Italian journey, 282v.

30. The terms for drawing after life and from the memory of things seen (respectively *nae t' leven* and *uyt den geest*) define the relationship of visual perception to representation, by measuring to what extent sight has been brought to bear on the production of an image. On *nae t' leven*, see Hessel Miedema, *Karel van Mander, Den grondt der edel vry schilder-const*, 2 vols. (Utrecht, 1973), 2:303–304, 435–436, 437–438; Svetlana Alpers, *The Art of Describing* (Chicago, 1983), 40–41. On *uyt den geest*, see the opposing view in Miedema 1973, 2:437–438, which equates the term with Michelangelo's *uyt zijn selven wat te maken*, and takes it for a reconstructive faculty. Alpers 1983, 40–41, 242, attaches *uyt den geest* to *nae t' leven* and defines it as a mnemonic faculty complementary to work done after life. Examples of Goltzius' work *nae t' leven* include his drawings after nature and the sheets after selected Netherlandish and Italian masters, "T'leven van Henricus Goltzius," 284r. The visual memory of prime examples of Italian *colorito* spurs his attempts at painting *uyt den geest*, several years after his return to Haarlem, 285v.

31. Van Mander, "T'leven van Henricus Goltzius," 284r: "En dit heb ick van hem te segghen, dat hy van jonghs aen niet alleen en heeft de schoonheydt oft verscheyden ghedaenten der Natueren ghesocht nae te volghen: maer heeft oock seer wonderlijc hem gewent verscheyden handelinghen der beste Meesters nae te bootsen, alsnu Heemskercken, Frans Floris, Blocklandts, dan Fredericks, en eyndlinge des Sprangers, welcx gheestighe maniere hy seer eyghentlijck volghde. . . ." By adding the prefix "nae" to the verbs "volghen" (to follow) and "bootsen" (to figure, fashion, or portray), Van Mander em-

phasizes that his theme is Goltzius' commitment to imitation. "Naevolghen" is literally "to follow after," which I have translated as "transcribe," while "naebootsen" is "to fashion after," which I have translated simply as "portray," though the more precise sense would be "to capture the likeness of" the renderings of Heemskerck, Floris, Blocklandt, et al. On Goltzius' study of these and other masters, Emil K. J. Reznicek, *Hendrick Goltzius Zeichnungen*, 2 vols. (Utrecht, 1961). Goltzius had received specialized training in reproductive engraving with Dirck Volckertsz Coornhert in the mid-1570s. The complex negotiations conducted in 1585–1586 between the Jesuit order in Rome, their Antwerp factor Christophe Plantin, and Goltzius, exemplify his international reputation as a reproductive engraver. See Nicolaas de Roever, "Een Drietal Brieven van Hendrick Goltzius," *Oud-Holland* 6 (1888), 149–153; Otto Hirschmann, *Hendrick Goltzius als Maler 1600–1617* (The Hague, 1916), 5–9; Maj-Brit Wadell, *Evangelicae Historiae Imagines: Entstehungsgeschichte und Vorlagen* (Goeteborg, 1981), 9–17.

32. Hence the implementation of the Protean metaphor, which avows that Goltzius can translate himself into the rendering—*ghestalten van handelinghen*—of his chosen models. The assertion follows from the success of his prints in the manner of Lucas and Dürer, which activate their linear means and consummate in turn his earlier project of self-instruction through the appropriation of the varied representational means—*verscheyden handelinghen*—of modern masters, such as Heemskerck, Floris, Blocklandt, Federico Zuccaro, and Sprangher, all celebrated draftsmen. This translational criterion of pictorial accomplishment derives from the standards of reproductive engraving, which become the overall measure of Goltzius' excellence in *teyckenconst*.

33. Van Mander, "T'leven van Henricus Goltzius," 284r: "Aengaende zijn wercken, al vooren zijn Printen die ghetuyghen over al ghenoech zijnen verstandighen gheest in de Teycken-const."

34. Van Mander, "T'leven van Henricus Goltzius," 284v.

35. Van Mander, "T'leven van Henricus Goltzius," 285v: ". . . handelinghe, met gladde langhe artseringhe, gantsch loflijck en onberisplijck" The passage describes the execution of a lost parchment drawing of *The Metamorphosis of Peristera*, executed for the Amsterdam painter Franciscus Badens, but it can be applied equally well to Goltzius' demonstration engravings of the 1580s and 1590s, such as the various prints after Sprangher, dated between 1585 and 1589. These plates feature long, graduated hatches, which virtuosically extend the flourished strokes perfected by the engraver Cornelis Cort, expanding the length and breadth of the burin's flexed course. Van Mander cites three drawings executed on parchment and rendered like prints: *Bacchus, Ceres, and Venus*, 1593, 631 x 495 mm., pen and several shades of brown ink on parchment, London, British Museum; *Faunus With a Young Faun*, c.

1600, 624 x 464 mm., pen and several shades of brown ink on parchment, Vienna, Albertina; *Pietà*, 1598, 818 x 598 mm., pen and various shades of brown ink on parchment, Vienna, Albertina. On these drawings, see Reznicek 1961, 1:101–105, 251–253, 278, 286–288. On the critical response to such drawings at the turn of the seventeenth century, Julius Held, "The Early Appreciation of Drawings," in *Studies in Western Art, Acts of the Twentieth International Congress of the History of Art*, ed. Ida E. Rubin (Princeton, 1963), 82–85. See, too, Oscar Doering, *Des Augsburger Patriciers Philipp Hainhofer Beziehungen zum Herzog Philip II von Pommern-Stettin* (Vienna, 1894), 32, for testimony that the Dutch coveted such drawings above paintings, as the highest examples of Goltzius' finished execution and sureness of hand.

36. Van Mander, "Het leven van Michel Agnolo Buonarruotti," 164v: ". . . om den Naecomers open te wijsen den wegh der drie Consten, Schilderen, Beeldthouwen, en Bouwen, daer hy in gheexcelleert heeft"

For the equation of Michelangelo's exemplary *teyckenconst* with the mastery of *naeckte Beelden*, Van Mander's translation of Vasari's *uomini nudi*, see the remarks on the Sistine Ceiling, 168r. On *disegno* generally and Vasari's "Life of Michelangelo" in particular, Svetlana Alpers, "*Ekphrasis* and Aesthetic Attitudes in Vasari's *Lives*," *Journal of the Warburg and Courtauld Institutes* 23 (1960), 190–215; Ernst Gombrich, "Norm and Form: The Stylistic Categories of Art History and Their Origins in Renaissance Ideals," in *Norm and Form: Studies in the Art of the Renaissance* (London, 1966), 81–98; David Rosand, "The Crisis of the Venetian Renaissance Tradition," *L'Arte* 3 (1970), 5–34; Michael Baxandall, *Giotto and the Orators* (Oxford, 1971), 11, 19, 49; Michael Baxandall, *Painting and Experience in Fifteenth Century Italy* (Oxford, 1972), 139–141; Wolfgang Kemp, "*Disegno*: Beiträge zur Geschichte des Begriffs zwischen 1547 und 1607," *Marburger Jahrbuch für Kunstwissenschaft* 19 (1974), 219–240; David Summers, *Michelangelo and the Language of Art* (Princeton, 1981), 250–261; Miedema 1984, 69–71.

37. Goltzius should be contrasted in this regard to Raphael, as he is presented in "Het leven van Raphael Sanzio van Urbijn, Schilder, en Bouwmeester," "*Het leven van Raphael Sanzio van Urbijn, Schilder, en Bouwmeester*," 117r–121v.

38. For an alternative reading of Goltzius' career, contemporary with the *Schilder-Boeck*, see Nicholas Hilliard, "A Treatise concerning the Arte of Limning," in *The First Annual Volume of the Walpole Society*, ed. Philip Norman (Oxford, 1912), 19–20. Written between 1598 and 1602, the treatise extols Goltzius as the greatest engraver of the age. Hilliard's proof of this conviction rests mainly, though not exclusively, on Goltzius' plates in the manner of Dürer and Lucas. His estimation of Goltzius presumes that he, like Michelangelo, chooses occasionally to subordinate personal manner to prototypes, because his own hand is so self-informed and self-assured. Van Mander, by contrast, takes him for Pro-

teus, who seduces the eye by concealing all traces of himself.

39. Van Mander chronicles one strain of Netherlandish art, which is decisively progressive and applies the historiographical scheme of the Italian "Lives." Gossaert, Scorel, Heemskerck, and Floris perfect by stages the Netherlandish mastery of the nude.

40. Adam Bartsch, *Le Peintre Graveur*, 3:15–16, identified Parmigianino as the source of *The Visitation*, and adduced Raphael for *The Annunciation*, Jacopo Bassano the Elder for *The Adoration of the Shepherds*, and Federico Barocci for *The Holy Family with St. John the Baptist*. Otto Hirschmann, *Verzeichnis des graphischen Werks von Hendrick Goltzius* (Leipzig, 1921), 6–12, emended Bartsch's attribution of *The Annunciation*, suggesting a master in the circle of Barocci. The definitive study of the *Meesterstukjes* has yet to be written. On Goltzius' dedicatee, Duke Wilhelm V of Bavaria, see Jacob Stockbauer, *Die Kunstbestrebungen am Bayerischen Hofe unter Herzog Albert V. und seinem Nachfolger Wilhelm V.* (Vienna, 1874).

41. Van Mander, "T'leven van Henricus Goltzius," 286v. It is surely significant that Goltzius memorizes the canon of Roman, Lombard, and Venetian masters codified by the Carracci reform, rather than reaffirming the canon promoted by Vasari's *Vite*. He reveres the *pastosità* of Correggio, the *chiaroscuro* of Titian, and the *colorito* of Veronese, as well as the grace of Raphael. Van Mander names Bologna as one of the cities visited by Goltzius en route to Florence and Rome. Diane DeGrazia discusses Goltzius' impact on Agostino in *Prints and Related Drawings by the Carracci Family: A Catalogue Raisonné* (Washington, 1979), 43–44, 342–343. Agostino's *Sine Cerere et Baccho friget Venus*, thought previously to have been copied by Goltzius, proves in fact to have been transcribed by Agostino. On Agostino and Goltzius, see, too, Diane DeGrazia, *Le stampe dei Carracci con i disegni, le incisioni, le copie, e i dipinti connessi: Catalogo critico* (Bologna, 1984). On the Carracci reform, Charles Dempsey, "The Carracci Reform of Painting," in *The Age of Correggio and the Carracci, Emilian Painting of the Sixteenth and Seventeenth Centuries* [exh. cat., National Gallery of Art, Metropolitan Museum of Art, Pinacoteca Nazionale, Bologna] (Washington, 1986), 237–254. On the articulation of a Lombard canon, Elizabeth Cropper, "Tuscan History and Emilian Style," in *Emilian Painting of the Sixteenth and Seventeenth Centuries: A Symposium* (Washington, 1987), 49–62.

42. On *invenzione*, Alpers 1960, 190–215; Gerhard Langemeyer and Reinhart Schleier, *Bilder nach Bildern* [exh. cat., Westfälisches Landesmuseum für Kunst und Kulturgeschichte] (Münster, 1976), 74–94; Martin Kemp, "From *Mimesis* to *Fantasia*: The Quattrocento Vocabulary of Creation, Inspiration and Genius in the Visual Arts," *Viator* 8 (1977), 347–398; Hessel Miedema, *Kunst, Kunstenaar en Kunstwerk bij Karel van Mander* (Alphen aan den Rijn, 1981), 139–141; Miedema 1984, 67–69. I owe a debt of thanks to Dr. Sharon Fermor, who at the Warburg Institute in 1980 introduced me to her

work-in-progress on invention and Vasari's theorization of movement.

43. Van Mander, "Het leven van Raphael Sanzio van Urbijn, Schilder, en Bouwmeester," 121r:

> En also Raphael, siende Angels groote studie in de naeckten, en dat hy daer niet in t'achterhalen was: En Raphael dan wetende, dat d'excellentie der Schilderije niet en bestaet alleen in naeckten te maken, soo vondt hy een wijdt open veldt, om hem in veel dinghen voorby te loopen: als in d'Inventie, en by-een-voeginge der Historien, de selve niet met te veel te confunderen oft confuys te maken, noch met te weynich al te miserabel oft arm. Oock beneerstighde hy hem, zijn werck met alle omstandicheden te verrijcken, en met veel bywercken, die den aensiender vermaken gheven . . . Eyndlijck (om cort te maken) segh ick dit: dat Raphael in alles gracelijck was. . . .

44. Van Mander, "Het leven van Raphael Sanzio van Urbijn," 121v:

> Oock beneerstighde hy hem . . . bysonder met schoon gracelijcke tronien, van Vrouwen, Kinderen, Jongelingen, en Ouderlingen, de selve ghevende alle bewegingen, nae dat sy werckende behoeven: oock fraey hulselen, tuyeringhen, cleederen, en chieraten, schier niet wetende oock wat schoonheyt gheven: de vluchten der Peerden, en wreetheyt der Soldaten, Landtschappen, verscheyden weders, prospectiven, en derghelijcke vele.

On inventie as by-een-voeginge, see also the definition of invention in "Van het teyckenen, oft Teycken-const," Grondt, 9v. Ordineren is Van Mander's term for pictorial construction.

45. Van Mander, "Het leven van Raphael Sanzio van Urbijn," 119r: "Al t'Mis hoorende volck knielende en staende, Mannen en Vrouwen, maken verbaest, om dese seldtsaemheyt, verscheyden fraey actien: Onder ander een Vrouw, onder in de grondt sittende, met een kindt op den hals, keert haer seer gracelijck om: een ander, vertellende wat den Priester gheschiet is."

On the device figure come fratelli, David Summers, "Figure come Fratelli: A Transformation of Symmetry in Renaissance Painting," The Art Quarterly n.s.1 (1977), 59–88.

46. Van Mander deploys all these terms on 121r, where he explains the competition of Raphael and Michelangelo, who excel in different categories of schilderconst, namely teyckenconst and inventie. On the narrative appropriateness of Raphael's figures, whatever their gender and age, 121r. On the painter's ability to steer a middle course between elaboration and clear narration, see note 45. On Raphael's powers of amplification, see Ernst Gombrich, "Raphael's Stanza della Segnatura and the Nature of Its Symbolism," in Symbolic Images: Studies in the Art of the Renaissance (London, 1972), 85–101.

47. Van Mander, "Het leven van Raphael Sanzio van Urbijn," 119v.

48. Van Mander, "Het leven van Raphael Sanzio van Urbijn," 119r–119v: ". . . en op den text der Schrift achtende, socht daer neffens in alle omstandicheden yet fraeys by te brenghen . . . daer den Engel met een groote claerheyt de wapenen der Wachters doet vlickeren . . . en waer dese geen claerheyt can gheven, daer geeft de Maen haer schijnsel. Dese Lichten waren al onderscheydelijck wel uytghebeeldt, oock de duysterheyt der nacht . . ."

49. Van Mander enunciates the principles of ordineren in chapter 5 of the Grondt, "Van der Ordinanty ende Inventy der Historien," 15r–22v. On the invention of a periodic schema of pictorial composition, see Baxandall 1971, 121–139.

50. On Raphael's decision to differentiate himself from Michelangelo by concentrating on bewegingen, bywercken, and omstandigheden, see Van Mander, "Het leven van Raphael Sanzio van Urbijn," 121r.

51. Van Mander, "T'leven van Henricus Goltzius," 284v: ". . . want bedenckende wat hy over al voor handelinghen hadde ghesien, heeft met een eenighe handt verscheyden handelinghen van zijn inventie ghetoont. . . ." Van Mander's remark turns on the play of hand and handelinghen, which implies the engraver's ability to translate his hand into the signature hands of other masters. On the reproductive brief of the Meesterstukjes, see Leonie von Wilckens and Peter Strieder, eds., Vorbild Dürer [exh. cat., Germanisches Nationalmuseum, Nürnberg] (Nuremberg, 1978), 16, 109; David Acton, "The Northern Masters in Goltzius's Meisterstiche," Bulletin of the Museums of Art and Archaeology of the University of Michigan 4 (1981), 40–53.

52. Van Mander, "Het leven van Ian en Hubrecht van Eyck, ghebroeders, en Schilders van Maeseyck," 199r–199v:

> Het is openbaer, dat in ons Nederlant de Schilder-const moet uyt Italien gecomen zijn, te weten, met Lijm en Ey-verwe te wercken . . . En also sulcke werckende wacker gheesten, verder en verder soeckende, nae volcomenheyt trachten, bevont hy met veel ondersoeckens, dat de verwe gemengelt met sulcke Olyen haer seer wel liet temperen . . . En t'gene dat hem noch meer verwonderde en behaeghde, was dat hy bevondt, dat haer de verwe beter aldus met de Oly liet verdrijven en verwercken, dan met de vochticheyt van Ey oft lijm, en niet en hoefde so ghetrocken te zijn gedaen. Van deser vondt was Ioannes hooghlijck verblijdt, gelijck hy met groote oorsaeck wel mocht: want hier is gheboren een nieuw gheslacht, en gedaente van wercken, tot groot verwonderen van velen . . . datmen van by den Ciclopen en den eeuwich brandenden bergh Etna is gecomen, om sulcken uytnemenden vondt te sien . . . Dese edel inventie behoefde noch onse Const, om de Natuere in gedaenten nader comen, oft ghelijcker te worden.

On the sixteenth-century tradition that ascribes the invention of oil-based pigments to Jan, see Erwin Panofsky, Early Netherlandish Painting, 2 vols. (Cambridge, 1953), 1:151–153; Johannes Taubert,

"Beobachtungen zum schöpferischen Arbeitsprozess bei einigen altniederländischen Malern," *Nederlands Kunsthistorisch Jaarboek* 12 (1976), 41–71; J. R. J. van Asperen de Boer, Molly Faries, and Jan Piet Filedt Kok, "Schildertechniek en atelierpraktijk in de zestiende-eeuwse Kunst voor de beeldenstorm," in *Kunst voor de beeldenstorm* [exh. cat., Rijksmuseum] (Amsterdam, 1986), 86–91.

53. Van Mander, "T'leven van Henricus Goltzius," 285r: "Hier nae quam Goltzio in den sin, op gheprimuerde oft van Oly-verwe bereyde doecken metter Pen te teyckenen . . . Des gingh hy toe, en teyckende met de Pen op eenen paslijcken grooten gheprimuerden doeck een naeckt Vrouwen beeldt, met eenen lacchenden Satyr daer by, seer aerdigh en versierigh ghedaen, en heeft daer oock op gehooght, en een weynigh de naeckten t'som plaetsen met verwe aengheroert, en daer op vernist. . . ." Van Mander cites three drawings executed with the pen on prepared canvas: the *Woman With a Laughing Satyr*, which entered the collections of Rudolf II, *The Metamorphosis of Peristera*, praised for its *gladde langhe artseringhe* and done for the painter Franciscus Badens, and a third unfinished work, which Van Mander has not been allowed to see, but which he reports will feature large nudes and will surpass all the preceding *pen-wercken*. Reznicek, *Die Zeichnungen von Hendrick Goltzius*, 1:284–286, has identified this latter drawing as the *Bacchus, Ceres, and Venus*, 1604, 228 x 170 mm, pen and several shades of brown ink on prepared canvas, Leningrad, Hermitage. The *pen-wercken* mimic the *handelingh* of Goltzius' engravings, which mimic in turn the *handelingh* recommended to draftsmen in Van Mander, "Van het teyckenen," 10r, stanza 20.

54. Van Mander, "T'leven van Henricus Goltzius," 285r: "Na der handt creegh hem den Keyser, die over desen handel hem heel verwonderde, hoe dit gedaen was, roepende daer over eenige van der Const, die oock verwondert waren: want het heel seldsaem en wercklijck te sien is." Rudolf II collected other works by Goltzius, among them a silver plate engraved in 1595, acquired by the Duke of Braunschweig-Wolfenbuettel and presented by him as a gift to the emperor. For the inventory of the imperial collections, see Rotraud Bauer, "Die Kunstkammer Kaiser Rudolf II. in Prag: Ein Inventar aus den Jahren 1607–1611," *Jahrbuch der Kunsthistorischen Sammlungen in Wien* n.s. 36 (1976), 1–185; Eliska Fucikova, "The Collection of Rudolf II at Prague: Cabinet of Curiosities or Scientific Museum?" in *The Origins of Museums: The Cabinet of Curiosities in Sixteenth- and Seventeenth-Century Europe*, eds. Oliver Impey and Arthur MacGregor (Oxford, 1985), 47–53. Philip II, too, commissioned a drawing on parchment from Goltzius—the *Pietà* of 1598, for which see note 35.

55. In the *Bacchus, Ceres, and Venus* of 1604, Goltzius stands with Cupid at an altar fueled by the gifts of Bacchus and Ceres, tendrils of vine and ears of grain. His contribution is a pair of compasses which he holds before the flames. They allude to the *topos*, which ascribes to the virtuosic draftsman the ability to draw freehand a perfect circle. The kind of line inscribed by a compass, of course, resembles the swelling and tapering arcs perfected in Goltzius' engravings and translated by the pen in drawings such as the *Bacchus, Ceres, and Venus*. In effect Goltzius attests his love of the pen, which is the offering made at the altar of Venus. On the *topos* of the compass and the hand, and the relationship of drawing to calligraphy, see Ben P. J. Broos, "The 'O' of Rembrandt," *Simiolus* 4 (Autumn 1971), 150–184.

56. For the text of the *Guild Letter*, dated 22 February 1590, see Hessel Miedema, *De archiefbescheiden van het St. Lukasgilde te Haarlem* (Alphen aan den Rijn, 1980), 57–61. On the Haarlem Guild of St. Luke in the sixteenth century, see Hessel Miedema, "De St. Lucasgilden van Haarlem en Delft in de zestiende eeuw," *Oud-Holland* 99 (1985), 77–109.

57. On Jan van Eyck's alchemical experiments, Van Mander, "Het leven van Ian en Hubrecht van Eyck," 199v. On Goltzius as *natuerlijck Philosooph*, "T'leven van Henricus Goltzius," 286v. Documents of 1605 reveal Goltzius' involvement with the alchemist Leonard Engelbrecht, whose efforts to produce gold he supported; see Abraham Bredius, "Bijdragen tot de levensgeschiedenis van Hendrick Goltzius," *Oud-Holland* 32 (1914), 137–146. In his unfinished autobiography Constantijn Huyghens decries Goltzius' preoccupation with alchemy; see *De jeugd van Constantijn Huygens*, trans. and ed. Albertus H. Kan (Rotterdam, 1971), 72.

HILARY BALLON
Columbia University

Constructions of the Bourbon State:

Classical Architecture in Seventeenth-Century France

During the reign of Louis XIV (1643–1715), classical architecture became French. France, of course, did not displace Rome as the historical seat of antiquity. Indeed the preeminence of ancient Rome was never more respected than in Louis XIV's France. The crown actively promoted the study of antiquity by sponsoring Roman sojourns for young architects under the aegis of the French Academy in Rome, founded in 1666. It also published books on ancient architecture such as Claude Perrault's translation of Vitruvius (1673) and Antoine Desgodetz' *Les édifices antiques de Rome* (1682), and assembled a collection of antique casts for study in Paris. All these programs were part of a cultural project to establish France as the modern site of classical design, the heir and arbiter of the Greco-Roman tradition. How is it that France assumed this role during Louis XIV's reign and succeeded in attaching a French national identity to classical architecture? That is the question I would like to address.

The creation of a French classical architecture can be described in stylistic terms by tracing the assimilation of antique elements into a vernacular manner or by defining the Frenchness of French buildings. My concern, however, is not with matters of style but with the broader cultural project of the Bourbon crown through which style itself obtained meaning. I do not dispute that distinctive features of a national

manner can be identified in such areas as stereotomy and planning, as Pérouse de Montclos has argued in his recent book, *Architecture à la Française* (1982). But these characteristics do not account for the ideological specificity attached to classicism during Louis XIV's reign. Under the direction of Jean-Baptiste Colbert, the crown aspired to harness the authority of classicism in projecting the glory of France, and it was in the negotiations between the universal aspirations of classical culture and the exclusive claims of a national art that French classical architecture was produced. My strategy in this essay is to lift seventeenth-century French classicism from a history of style and inscribe it in the cultural politics of Louis XIV's rule, in order to understand how the conflicting values of classicism and national identity were at least temporarily resolved.

During Colbert's administration (1661–1683), the cultural program of Louis XIV was devoted to two aims: first, establishing French cultural supremacy in Europe; and second, producing a national, that is to say royalist, art to promote the glory of the crown. Insofar as classicism was regarded as a universal heritage, it provided an obvious vehicle through which France could project its claims for supremacy on a European scale. Yet the Greco-Roman tradition, which excluded France's Gothic past, did not satisfy the demand for a national

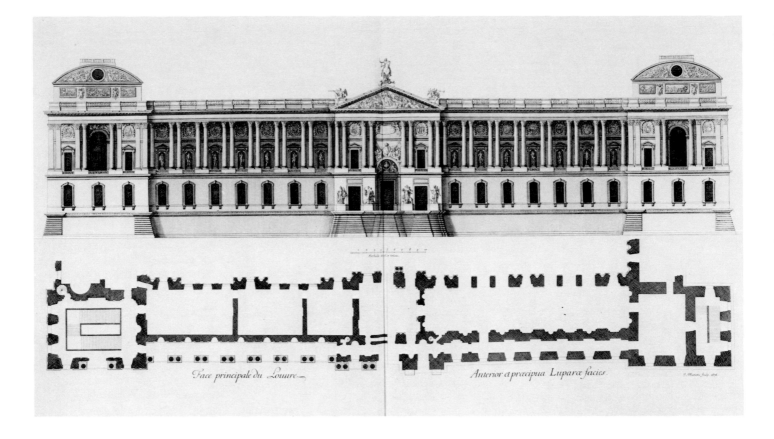

Face principale du Louure — *Anterior et præcipua Luparæ facies*

art. To transform the classical heritage into something construed as French, new forms were needed, and French architects did not hesitate to invoke national difference to justify their alteration of the classical canon. As early as the 1560s, Philibert Delorme defended his departure from Roman models in national terms, naming his design of a banded column the French order, although its Gallic character was by no means self-evident. A century later, Claude Perrault took a similar tack with the Louvre Colonnade, arguing that its innovative features—the paired columns and wide intercolumniations—were sanctioned by France's Gothic legacy (fig. 1): "The taste of our century, or at least of our nation, is different from that of the ancients, and perhaps in that it retains a bit of the Gothic because we love air, light and openness. This made us invent a sixth manner of arranging columns which is to couple them and join them in pairs, and also to put the space of two intercolumniations in one."[1]

The appeal to national identity did not, however, win for these inventions an undisputed place within the classical tradition. The "Gothic" qualities of the colonnade were denounced by François Blondel for failing to comply with the taste of the Ancients.[2] Charles Le Brun likewise condemned the designs for a French order solicited by Colbert in 1671 because they strayed too far from classical standards, his own designs excepted, of course. "It had been customary to grant a certain respect to antique monuments," he lamented, and now "the nations neighboring France will laugh at our new venture."[3] It was critical that the modern inventions be regarded as legitimate expansions of the classical tradition, not as violations of it, and to achieve this assimilation required more than finely calibrated designs; it required adjustments in the theoretical underpinnings of the discipline to render such innovations permissible. The creation of an architecture that was both French and classical thus inter-

1. Colonnade of the Louvre, engraved by Jean Marot, 1676
From Cabinet du Roi, vol. 4

sected a debate in architectural theory concerning the authority of antique models and standards of beauty. The Bourbon imperative for a royalist culture exerted pressure on the classical tradition, precipitating the Quarrel of the Ancients and Moderns and placing Louis XIV's France at the intellectual center of debate over the meaning of classicism in the modern world.

The following speculative remarks are an attempt to describe the triangular relationship between the architect's claim for inventive freedom, his respect for the classical tradition, and royal support for the creation of a national culture during Colbert's administration. After discussing proportion in the treatises of Roland Fréart de Chambray and Claude Perrault—texts which illuminate the crisis emerging in French architectural theory concerning aesthetic standards—I will turn to the Royal Academy of Architecture, through which the crown regulated architectural practice. By examining the complicitous relation between French architectural theory and royalist policies, we can begin to see the particular historical configuration that permitted the seventeenth-century construction of a French classical architecture.

THE DEBATE OVER PROPORTION

The architectural orders and the proportional relations that govern them came under new scrutiny in French treatises of the second half of the seventeenth century, a scrutiny that registered collapsing faith in the Renaissance theory of proportions. One of the first contributions to this reappraisal of the orders was Fréart de Chambray's *Parallele de l'Architecture antique et de la moderne*, published in 1650. Comparing the orders of Vitruvius with those of ancient Roman buildings and Renaissance architects, Chambray demonstrated that no concordance existed among the proportional systems of the ancients and moderns. The accompanying engravings by Charles Errard illustrated these differences by rendering all the orders at a common scale. As we shall see, Chambray's faith in the authority of the ancients was unwavering, but paradoxically, his comparative analysis raised

doubts about the divine and absolute nature of that authority by proving its utter failure to regulate Renaissance proportions.

Central to Renaissance theory was the belief that architectural proportions embodied a harmonic natural order, a belief articulated by Philibert Delorme in his treatise, *Le Premier Tome de l'Architecture* (1567), which was reprinted in 1648, two years before the publication of the *Parallele*. Delorme described proportion as the manifestation of a cosmic order mirrored in the human form, and he planned a second volume, on divine proportion, where he intended to explain how "the proportions of all types of building plans and elevations . . . can be determined from the measures of the entire human body, conforming to the measures and proportions which are found in the Holy Bible."[4] Since proportion in Renaissance theory was anchored to an absolute foundation in nature, it was not considered a fundamentally free element of design to be left to the judgment of the architect, however much his judgment might be necessary for fine-tuning. Renaissance proportions varied from one another and from antique prototypes as a result of that fine-tuning, but these variations were not considered problematic before Chambray. That he regarded deviations in proportional schemes as a problem requiring adjudication indicated a new mentality that Chambray himself did not acknowledge; but he nonetheless confirmed it in his defensive response, urging the return of modern architecture to an inaccessible point of origin in Greek antiquity.

Roland Fréart de Chambray was a central figure in the formation of the French classical doctrine, both as an agent of the crown and as an author. From 1638 to 1643, Chambray, his brother Paul Fréart de Chantelou, and their cousin François Sublet de Noyers, the Superintendent of Royal Buildings under Louis XIII, conceived a program of state-sponsored classicism that centered on the establishment of a royal academy of painting and the appointment of Nicolas Poussin as painter to the king. Sublet succeeded in bringing Poussin to Paris in 1640, but after two unhappy years at Louis XIII's court, Poussin returned to Rome, and Sublet's fall from power in 1643 brought his cultural

enterprise to an end.[5] Thereafter Chambray turned to the printed page. In 1650 he published a translation of Palladio's *Four Books on Architecture* as well as the *Parallele*, followed in 1651 by a translation of Leonardo's *Trattato della Pittura*, a work he dedicated to Poussin, and in 1663 a translation of Euclid's treatise on perspective. Chambray's most important work appeared in 1662, *Idée de la perfection de la peinture*, a treatise on painting which Jacques Thuillier has described as the "decisive book for the classical doctrine."[6]

In the *Parallele*, Chambray advocated a return to the ancient Greek sources, launching a radical attack on all subsequent architectural innovations. He declared the superiority of the three Greek orders, Doric, Ionic, and Corinthian, which "not only contain all that is beautiful but all that is necessary in Architecture."[7] The Latin orders, Tuscan and composite, he dismissed as inferior Roman inventions which should never be combined with the Greek orders and if possible should be eschewed altogether. However shocking the proposition, he wrote, "those to whom I speak will understand as soon as they have cast aside a certain blind respect for even the worst errors which antiquity and custom commonly instill in most minds. . . ."[8] Although this language echoes the frustrated complaint of a Modern, Chambray was a strident Ancient, urging the strictest respect for antiquity. The critical examination he proposed was intended to restore architecture to its original Greek forms, to purge it of all deviations. "It is not my idea to encourage novelty; on the contrary I would like, if it were possible, to return to the source of the orders and from there derive in their purity the images and ideas of these incomparable Masters . . ."[9] (fig. 2). With the reservation "if it were possible," Chambray conceded that his aspiration was utopian. It was not possible to return to the origins of the orders, a point illustrated by Perrault's comparison of the source of the Corinthian capital, a leaf-covered basket, with Vitruvius' interpretation of it (fig. 3). The closest one could come to untainted sources were the already altered examples of Vitruvius and of ancient Rome, which Chambray recommended as authoritative

models. "I value nothing unless it conforms to some famous ancient example or to the precepts of Vitruvius, the father of Architects, so that art may be restored, if it is possible, to its true principles, and in this way re-established in its original purity from which the licentious compositions of our workmen have so perverted it."[10]

2. Callimachus drawing the original Corinthian capital, engraved by Charles Errard
From Roland Fréart de Chambray, *Parallele de l'architecture antique et de la moderne*, 1650

Planche XXIII.

Fig. I.

Fig. II.

3. The Corinthian capital of Vitruvius compared with original model. By illustrating Vitruvius' departure from the prototype, Perrault implicitly critiques Chambray's ideal of untainted Greek sources
From Claude Perrault, *Les dix livres d'architecture de Vitruve,* 1673

Following this principle, Chambray faulted the Renaissance authors for diverging from ancient prototypes. He unhappily found that the moderns, while full of praise for antiquity, often disregarded its standards. On the Doric order of the Theater of Marcellus he wrote, "I am astonished that of all our modern architects, most of whom

have seen and spoken of this example as the most excellent Doric model that we have from antiquity, not one has followed or perhaps even well observed the original. . . ."[11] With regard to the Corinthian orders of Palladio and Scamozzi, the Frenchman wrote: "Of all the Corinthian models which I have proposed for the rule of the order, having selected them for this purpose from the most excellent antique examples, there is not one with the proportions which these two masters observe. . . ."[12]

Chambray was unable to find any Renaissance scheme that satisfied his standard of absolute fidelity to ancient prototypes. What he did find were rather loose interpretations of antique orders, and his standard provided him with no guidance in making judgments about these imperfect copies. Comparing the Ionic orders of Serlio and Vignola, Chambray wrote: "The inequality of these two profiles is so great that it is almost impossible to approve of them both, and nevertheless there is no good reason to condemn one any more than the other, each one having its own sufficiently regular principle, together with its authorities and examples"[13] (fig. 4). Chambray stumbled on a similar problem in judging the Doric orders of Serlio and Vignola since neither was more faithful to his chosen antique model. After much hesitation, Chambray favored Serlio's order only because an excuse could be invented for his departures from Vitruvius without supposing an intentional violation of the ancient source. Chambray thus suggested that Serlio was misled by an inaccurate copy of Vitruvius.[14]

Despite its "conservative" defense of the ancients, Chambray's treatise had subversive implications. By treating the divergent proportions of the various orders as a problem requiring regulation, the *Parallele* raised doubts about the control that nature was supposed to exert on the orders. To rescue classical architecture from this state of disorder, from the chaos of licentious innovation that Chambray found in the modern world, he urged a return to Greek models "in all their purity"; but the sources were irretrievable, and his solution impossible. Chambray's defense of the ancients should not be understood as a prescriptive program, because the treatise fails to articulate

any consistent standard that architects could implement. Rather, his ideal of an original Greek architecture of chastened splendor was the projection of a myth, a myth that would mask or appear to resolve a cultural conflict concerning the foundation of the orders.

In its subversive aspects Chambray's treatise can be linked with Claude Perrault's forthright assault on the Renaissance theory of proportion, despite the fact that these men maintained opposing views on the value of modern inventions. Perrault boldly defended (and designed) the very sort of novelties that Chambray condemned, and when Perrault denounced "the prejudice and false supposition that it is impermissible to depart from the practices of the ancients," he certainly had Chambray in mind. "If this law had prevailed," Perrault claimed, "architecture would never have reached the point to which it was brought by the inventions of the ancients which were new in their time."[15] Divided as they were on the issues of modern invention and progress in art, Chambray and Perrault nevertheless shared the same goal of restabilizing the orders in the modern world.

Perrault overturned the Renaissance theory of proportion by arguing that proportions were determined not by absolute standards of beauty but by changeable social conventions. Perrault's position—which he developed in the notes to his first edition of Vitruvius, in the amplified notes to the second edition of 1684, and in the *Ordonnance des cinq especes de colonnes selon la methode des anciens* (1683)—has been discussed at length elsewhere so I shall offer only a few summary remarks.[16] Striking at the fundamental Renaissance belief in the correspondence of architecture and music, Perrault contended that architectural proportions were not structured by immutable relations in nature as musical harmonies were. This difference explained why proportions had been altered over time without dissatisfying the eye, whereas manipulation of musical harmonies caused aesthetic offense. Proportions were a variable or "arbitrary" aspect of beauty determined, like fashion, by socially defined tastes, and he contended, such was the power of conventions that they endowed partic-

4. Ionic orders of Serlio and Vignola compared, engraved by Charles Errard
From Chambray 1650

ular standards with an illusion of their natural necessity. Through custom and habit, conventional standards of beauty obtained "an authority equal to that of certain political laws."[17]

Having revealed the conventional basis of proportion, Perrault emphasized the re-

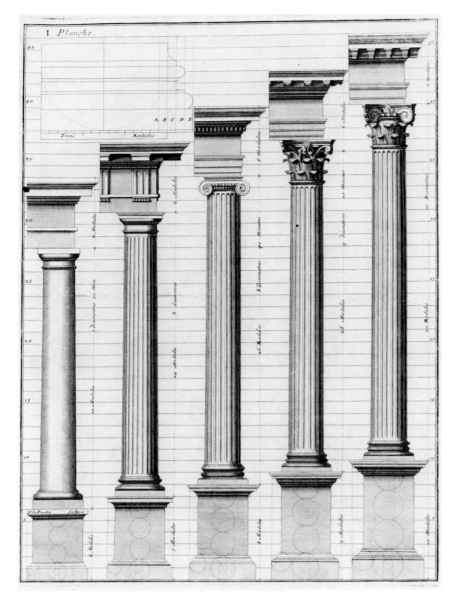

5. Perrault's proportional rule
From Claude Perrault, *Ordonnance des cinq espèces de colonnes,* 1683

sponsibility of "human institutions" to define aesthetic standards:

Because Beauty has no other foundation than the imagination, which works in such a way that things are pleasing if they accord with .the idea each one of us has of their perfection, rules are therefore essential to form and to correct this ideal. And it is certain that if nature refuses rules to some particulars as she has to language, to the characters of the alphabet, to clothes, and to all that depends on chance, on the will and on habit, then human institutions must supply them, and for that a

certain authority is necessary which acts in place of positive reason.[18]

Critical of "all those treatises that compared proportional systems from the past, without proposing a new conclusive one," including Chambray's text, Perrault devised his own proportional rule which he recommended for its simplicity.[19] Perrault rejected the traditional module of half a column diameter because when subdivided to determine the proportions of the smaller parts of the order it produced unwieldy fractions. He used instead a module of a third of a column diameter with which he generated proportional values that clearly expressed the relation of each part to the entire order in easily remembered whole numbers (fig. 5). Dimensions were then assigned by calculating the mean measurements of selected orders from the ancient and modern world.[20] Although an empirical study of French buildings may one day prove otherwise, the literary evidence indicates that Perrault's proportional rule was rejected largely because it made no allowance for the optical adjustments that the Royal Academy of Architecture insisted were necessary. Its failure did not, however, invalidate the broader claims of Perrault's theory. On the contrary, its failure bore out his argument that proportional relations, based as they were on convention, acquired authority only through the power of a political institution or social body to enforce them. This was precisely the role assumed by the Royal Academy in dismissing Perrault's rule.

Perrault's "instrumentalization of proportion," as Alberto Pérez-Gomez calls it, and the theory of arbitrary beauty have been much discussed in relation to the birth of modernism, but here I want to consider their relation to the cultural program of Louis XIV and its architectural centerpiece, the Royal Academy of Architecture. The profusion of projects glorifying the crown, such as the triumphal arches bedecked with encomiastic sculpture, did not fundamentally distinguish Louis XIV's architectural program; these typological and representational devices were after all the traditional resources of propagandistic art, and these commissions, the typical activity of building patrons. The royal program was distin-

guished by the crown's role in regulating and authorizing the standards of classical architecture through the agency of the Royal Academy of Architecture, and it is this phenomenon that requires explanation. My claim is that Claude Perrault provided theoretical support for the extension of royal authority into the regulation of classical architecture. I mean neither to attribute this intention to Perrault nor to suggest that the theory of architecture was fully subsumed in the political sphere. Rather I am arguing that the emerging cracks in the theoretical foundations of classical architecture abetted the crown in positioning itself as the guardian and regulator of classical standards. In the domain of architectural theory, Perrault mapped out a space into which the Bourbon crown moved, a space constituted for the societal function of defining aesthetic conventions whose authority derived neither from nature nor God but from the king of France.

THE ROYAL ACADEMY OF ARCHITECTURE

The Royal Academy of Architecture was founded by Colbert in 1671. Its mission, like that of the Royal Academy of Painting and Sculpture which Colbert reorganized in 1663, was to generate a body of knowledge concerning the discipline. Toward this end the academy was required to offer classes for the education of young architects and to hold weekly meetings for discussion of architectural issues. The academicians addressed matters ranging from the practical to the theoretical. They evaluated the masonry of Parisian monuments and local quarries, assessed the designs that were voluntarily submitted for approval, and discussed the major treatises on architecture. Delorme, Palladio, Vitruvius, Serlio, and Scamozzi all were read during the institution's first decade. At the end of that period, in 1682, the academy spent several months reviewing its findings "in order to choose what will be of greatest use to the public" with the intention of preparing a publication describing the academy's position on the various topics that it treated.[21] In fact such a publication was not prepared, but

this project nonetheless illustrates the academy's self-conscious task of formulating a normative doctrine.

What then was the academy's relation to the crown? It is clear that the academy was entirely dependent on royal patronage. Whereas the Academy of Painting could nominate its associates, the crown reserved the sole right to appoint members to the Academy of Architecture; membership brought with it the title of royal architect, a royal stipend, and a ban against the relatively lucrative work of contracting construction. Despite its financial dependence, however, the academy did not function as the direct mouthpiece of the crown, simply enforcing artistic policies dictated from above. The opposition of Blondel, the director of the academy, to the colonnaded east front of the Louvre, the most important royal monument in Paris, is only the clearest example that the crown and the academy did not have identical points of view. Furthermore the academy largely deliberated on erudite and technical matters in which the crown could have had little interest. The relationship between the state and the academy was a mediated one whereby the academy's production of knowledge was authorized by the power of the absolutist state. The academy was a mechanism through which the discourse of architecture, technical and theoretical, was fostered and validated by the crown.

One of the vexing topics to which the academy returned on several occasions during its first decade was Perrault's theory of arbitrary beauty. At its very first sessions, the academy debated whether beauty in architecture was absolute and whether proportion was determined by a positive (i.e., natural, absolute) or arbitrary rule, issues raised by Perrault's still-unpublished theories. The majority agreed that there was a positive beauty in architecture, but the minority of dissenting voices was sufficiently strong on 28 January 1672 that the discussion was tabled until Vitruvius was consulted and Colbert was in attendance.[22] Upon the reception of Perrault's translation of Vitruvius two-and-a-half years later (11 June 1674), the treatise was examined for one year, until 25 June 1675, and after an eight-month hiatus, discussion resumed for an-

other seven months (3 February to 26 August 1676). In the course of these extended deliberations, the issue of arbitrary beauty was not again raised. Wolfgang Herrmann attributed this surprising silence to the extreme irritation that the subject caused the academicians, an explanation I would qualify.[23] The academy's irritation resulted not from unanimous opposition to Perrault, as is frequently argued, but from a serious difference of opinion that prevented the academy from making a conclusive statement in 1672. However, by the time the issue of arbitrary beauty was raised again nine years later, François Blondel had succeeded in shaping opinions in the academy, and a consensus against Perrault was reached. The minutes for 18 August 1681 contain the fullest disclosure of the academy's views on the subject. Some aspects of architecture were acknowledged to be arbitrary; nevertheless it was deemed "very likely that there is a certain arrangement, number, disposition, size and proportion of parts in architecture which produce the harmony that one calls beauty . . . and which is no less natural than the . . . harmonic union which pleases us in music," a direct rebuttal to Perrault's differentiation of proportion in architecture and music. To Perrault's point that only men of refined taste noticed changes in architectural proportions, offered as evidence of the conventional nature of proportions, the academy reasoned that neither in architecture nor in music was knowledge of proportions requisite to appreciate the beauty created. Closing the discussion on an uncompromising note, the academicians concluded that arbitrary elements can produce beauty only if joined to the absolute qualities of architecture: that is, "a certain arrangement, number and proportion."[24] These points were elaborated by Blondel in his academic lectures published as the *Cours d'Architecture* (1675–1683), a work which provides a powerful defense of proportion and geometry as absolute values of architecture in accommodating Renaissance theory to the world of the seventeenth century.

The academy's opposition to Perrault's theory of arbitrary beauty appears to contradict my claim that his ideas provided theoretical justification for the operation of the Royal Academy. Yet I would argue that we need to differentiate two levels in describing the academy, the operational and the discursive. On the operational level, Perrault's theory correctly described the behavior of the academy as a body defining and empowering aesthetic conventions. In terms of its discourse though, the academy firmly defended the absolute value of proportion, a claim itself made valid through the authority vested in the academy by the crown. That the academy was not conscious of functioning in accord with Perrault's theory, that it did not acknowledge its institutional and social function of defining conventions but perceived itself as articulating absolute truths—all this does not suffice to invalidate Perrault's theory; nor does it restore the orders to the lost state of divine embodiment. The academy was restabilizing the orders in the context of a secularization of classical values, a crisis it did not explicitly recognize but which nonetheless prompted the academy's reaffirmation of Renaissance values and enabled it to function for the crown as the authorizing force behind French classical architecture.

The academy's belief in absolute standards by no means entailed a strict defense of ancient precedent and censure of modern inventions. The academy was willing to criticize Vitruvius as Perrault had, disapproving for example the ancients' practice of "narrowing the upper part of doors for the reasons which are in the notes of Monsieur Perrault."[25] The academy was particularly attentive to national differences and frequently discounted ancient and Renaissance sources that did not apply to the French experience. The academicians observed with derision that a design in Serlio's seventh book on architecture "might perhaps have some utility in Italy, but could not be used in France because there is not even a reasonable place for the beds in the bedrooms"; and Scamozzi's designs were similarly dismissed because they did not accommodate French planning practices.[26] Consistent with its respect for French concerns, the academy did not oppose the invention of national types, and when Colbert invited designs for a French order in 1671, numerous academicians submit-

ted projects, including Antoine Desgodetz, Daniel Gittard, and Augustin-Charles D'Aviler as well as Charles Le Brun and Charles Errard, members of the Royal Academy of Painting.[27] Blondel found most of the schemes wanting, but he insisted on the merit of the enterprise:

I do not share the belief of those who will tolerate nothing in Architecture for which there is no example among ancient works; on the contrary, I know that there are many things in the buildings of the Ancients whose use I would never recommend. And I am persuaded that on the subject of the Composite Order, we have no less right to change the Roman ideas than the Romans had to alter those that they received from Greek architects; provided . . . that one is not led astray and one does not depart from certain general rules which have always guided their inventions.[28]

For Blondel and the academy, the authority of the ancients was to be preserved not by ruling all inventions illegitimate as Chambray had, an untenable position given their commitment to a French national architecture, but rather by insisting on the taste and style of the Ancients. It was on stylistic grounds that the academy criticized the designs for a French order, the Colonnade, and other projects, but however harsh its stylistic judgments were, the academy did not maintain a principaled opposition to innovation. In their interest in producing a national architecture, Perrault and the academy had no disagreement; but whereas Perrault engaged the problem of modern inventions by examining the ideological premises of the classical system, the academy engaged the problem in terms of style, leaving the premises intact.

It is important to emphasize the academy's fundamental support for national inventions, because the institution is traditionally cast as the seat of an unyielding fidelity to the Ancients, an historiographical viewpoint best illustrated by Hubert Gillot's *La Querelle des anciens et des modernes en France* (1914). Gillot portrayed the quarrel between Ancients and Moderns as an ongoing struggle between two opposing principles, "the principle of Antiquity which authoritarians and traditionalists invoke, all those who claim that the French genius must, at the pain of adulteration, narrowly attach itself to its Greco-Latin origins . . . and the principle of modernity defended in all periods by avant-garde minds. . . ."[29] To Gillot, the Ancients and academicians were one and the same, creatures of the crown promoting a rule-bound art rendered sterile by the contamination of the state, by the *étatisation* of art, while the Moderns were those who rebelled heroically against academic norms in the name of artistic freedom. In configuring the two positions, Gillot identified the interests of the state exclusively with the academy and the Ancients, but as we have seen, no less fierce a Modern than Claude Perrault was a staunch royalist. Gillot viewed the seventeenth-century quarrel through an early twentieth-century filter, assimilating the academy to the ninteenth-century salon and the Moderns to the progressive avant-garde. Yet both the Ancients and the Moderns in the seventeenth century were associated with the *étatisation* of art, both camps paid homage to the crown and promoted a national art within the classical tradition. To deny the academy's interest in modern French inventions is to ignore the pressures exerted on the classical tradition by the formation of a national culture. The academy was allied with neither party in the quarrel but rather was trying to reconcile both parties in demarcating a French position within the classical canon.

Given their shared commitment to a French classical architecture, it was not difficult for the academy to dissociate Perrault's theory of architecture, to which they strongly objected, from his translation of Vitruvius, which they greatly admired. The translation was regarded both as a masterpiece of classical scholarship and as a royal accomplishment in that it was sponsored by the crown and incorporated in the corpus of the academy. As the author of *L'Architecture harmonique* (1679), René Ouvrard, put it, Perrault had made Vitruvius speak French. The frontispiece of the translated treatise can be read as a condensed image of this common goal, the creation of a French classical architecture (fig. 6). On one level, Sebastien Mercier's engraving was an homage to Perrault, for it includes all the architectural projects on

6. Frontispiece, engraved by
Sebastien Mercier, for *Les dix
livres d'architecture de
Vitruve*
From Perrault 1673

which he worked: the French order, Triumphal Arch of the Porte St. Antoine, Colonnade of the Louvre, Observatory, and of course the translation of Vitruvius. Even the construction apparatus depicted in the midground may illustrate the machines Perrault invented to polish and lift stones. Beyond this biographical dimension, the frontispiece represents the state's identification with, and transformation of, classical architecture. Behind a section of entablature in the right foreground sits the personification of France, crowned and draped in fleurs-de-lis. She holds the royal staff of justice and leans on the *orbis mundi* marked with the royal emblem, signifying France's universal dominion. The globe is braced by the figure of abundance, a cornucopia in her lap and stalk of wheat in her hand. With an open palm, she gestures to the personified figures of the arts who collectively present the French Vitruvius. The volume is supported by Painting with her palette and brushes on the right, Architecture in the middle holding a compass and gazing at the treatise, and Sculpture on the left with a bust and French capital, its acanthus leaves springing from a ring of fleurs-de-lis. The kneeling figure of Measurement, a ruler on her lap, guides the reading of the treatise. The French Vitruvius, the offering of the arts, is paired with the French capital, the flower of the order; and as the entablature completes the order, so the French state brings glory to the arts.

The collaboration of the crown and Vitruvian classicism that the figures symbolize is given concrete form in the buildings rising in the distance, all royal commissions. The triumphal arch, designed by Perrault in 1668 for the Porte St. Antoine and never completed, was to be adorned with an elaborate sculptural program devoted to Louis XIV's military victories in Flanders and the Franche-Comté and crowned by an equestrian monument of the king thirty feet high. Behind it, another royal equestrian statue surmounts the pediment of the Louvre Colonnade, a building we have already seen that exemplified Perrault's idea of a French classical architecture. On the hilltop in the distance is the Observatory, the seat of the Royal Academy of Sciences, reminding us that the crown was also implicated in the formation of scientific norms. The buildings depicted in the frontispiece did not comply with academic standards, for both the triumphal arch and the colonnade were sharply criticized by the academy and Blondel. But despite the problem of style, Perrault's buildings represent the creation of a French classical architecture to which the academy was entirely devoted.

There is no topographical reality in Perrault's frontispiece. Paris is not seen, perhaps because Louis XIV had already removed the court to Versailles. But this abstracted urban landscape serves to emphasize that the buildings need only be situated in relation to the French state presiding in the foreground. Just as the crown was implicated in undermining the divine rule that had once governed the orders, so too the crown acted to reinstate the orders in a newly conceptualized system, a system in which the monarch, absolute and divine, justified the conventions of classical architecture through the operations of the Royal Academy. The Bourbon crown succeeded in constructing a French classical architecture by making *la raison d'état*, the reason of state, rule the orders.

NOTES

This is a substantially revised version of a paper delivered at the symposium "Cultural Differentiation and Cultural Identity in the Visual Arts," sponsored by the Center for Advanced Study in the Visual Arts, National Gallery of Art, and the Department of the History of Art, The Johns Hopkins University. I would like to thank the organizers for inviting me to participate in the symposium as well as members of the audience for the questions they posed, in particular Henry Millon and Orest Ranum, whose comments helped me to rethink and sharpen my argument. I would also like to acknowledge the stimulating discussion of Louis XIV's cultural politics in Bernard Magne, *Crise de la littérature française sous Louis XIV: Humanisme et nationalisme (Lille/Paris, 1976)*. All of the illustrations are published with the permission of the Avery Architectural and Fine Arts Library, Columbia University in the City of New York, for which I am grateful.

1. "Le goust de nostre siecle, ou du moins de nostre nation, est different de celuy des Anciens, et peut-estre qu'en cela il tient un peu du Gothique: car nous aimons l'air, le jour et les dégagemens. Cela nous a fait inventer une sixième maniere de disposer ces Colonnes, qui est de les joindre deux à deux, et de mettre aussi l'espace de deux entre-colonnemens en un. . . ." Claude Perrault, *Les dix livres d'architecture de Vitruve* (Paris, 1673), 76 n. 3.

2. "Je n'ay rien à dire sur cette amour que l'on attribue à nostre Nation pour le jour et les degagemens, puisqu'on avoüe en même temps qu'il tient encore du Gothique, et qu'il est en cela fort different du goust des Anciens. . . . Les Architectes Goths n'ont rempli leurs edifices de tant d'impertinences, que parce qu'ils ont cru qu'il leur étoit permis d'ajoûter aux inventions des Grecs et des Romains; Et ces cartouches ridicules, ces grotesques bigearres, et ces ornements extravagans . . . joints au grand mepris qu'ils ont pour les mesures legitimes des parties de l'Architecture, ne viennent que de ce qu'ils sont persuadez qu'ils ont autant de droit de produire des nouveautez et d'ajoûter aux pratiques des Anciens. . . ." François Blondel, *Cours d'architecture enseigné dans l'Académie Royale d'Architecture*, vol. 1 (Paris, 1675–1683), part III, 235.

3. Cited by Jean Marie Pérouse de Montclos, "Le sixième ordre d'architecture, ou la pratique des ordres suivant les nations," *Journal of the Society of Architectural Historians* 36/4 (1977), 231.

4. Philibert Delorme, *Le premier tome de l'architecture* (Paris, 1648), 150v.

5. On the cultural policies of Sublet de Noyers, see the dedication in Roland Fréart de Chambray, *Parallele de l'architecture antique et de la moderne. Avec un recueil des 10 principaux auteurs qui ont écrit des cinq Ordres; Scavoir Palladio et Scamozzi, Serlio et Vignola, D. Barbaro et Cataneo, L.B. Alberti et Viola, Bullant et De Lorme* (Paris, 1650); Claude Michaud, "François Sublet de Noyers Superintendant des bâtiments de France," *Revue Historique* 241 (1969), 327–364; Jacques Thuillier, "Académie et classicisme en France: les débuts de l'Académie royale de peinture et de sculpture (1648–1663)," in *Il mito del classicismo nel Seicento*, ed. Stefano Bottari (Messina, 1964), 181–209.

6. Thuillier 1964, 206.

7. Fréart 1650, 2.

8. Fréart 1650, 2.

9. Fréart 1650, 2.

10. Fréart 1650, 97.

11. Fréart 1650, 14.

12. Fréart 1650, 72.

13. Fréart 1650, 44.

14. Fréart 1650, 24.

15. Perrault, *Vitruvius*, 1684, 79 n. 16. This statement was not included in the first edition of Vitruvius.

16. On Perrault's theory of architecture, see Alberto Pérez-Gomez, *Architecture and the Crisis of Modern Science* (Cambridge, Mass., 1983); Wolfgang Herrmann, *The Theory of Claude Perrault* (London, 1973); Wolfgang Dieter Brönner, *Blondel-Perrault zur Architekturtheorie des 17. Jahrhunderts in Frankreich* (Bonn, 1972).

17. Perrault 1673, 102 n. 2.

18. "Car la Beauté n'ayant guere d'autre fondement que la fantaisie, qui fait que les choses plaisent selon qu'elles sont conformes à l'idée que chacun a de leur perfection, on a besoin de regles qui forment et qui rectifient cet Idée: et il est certain que ces regles sont tellement necessaires en toutes choses, que si la Nature les refuse à quelques-unes, ainsi qu'elle a fait au langage, aux charactares [sic] de l'écriture, aux habits et à tout ce qui dépend du hazard, de la volonté, et de l'accoutumance; il faut que l'institution des hommes en fournisse, et que pour cela on convienne d'une certaine autorité qui tienne lieu de raison positive." Perrault 1673, preface.

19. Claude Perrault, *Ordonnance des cinq especes de colonnes selon la methode des anciens* (Paris, 1683), xiv.

20. Perrault was unsystematic in calculating the mean, his base measurements were often inaccurate, and his selection of buildings inconsistent, but the fault seems to lie with sloppiness rather than an intentional deception to favor preselected dimensions.

21. *Procès-verbaux de l'Académie Royale d'Architecture 1671–1793*, 7 vols., ed. Henry Lemonnier (Paris, 1911), 2:1–2 (12 January 1682).

22. *Procès-verbaux* 1:1–6 (31 December 1671–28 January 1672).

23. Herrmann 1973, 34.

24. *Procès-verbaux* 1:321–322 (18 August 1681).

25. *Procès-verbaux* 1:114 (30 March 1676).

26. *Procès-verbaux* 1:275 (on Serlio, 26 February 1680); 1:315–316 (on Scamozzi, 16 June 1681).

27. See Pérouse de Montclos 1977.

28. "Je ne suis pas du sentiment de ceux qui ne veulent rien souffrir dans l'Architecture dont on n'ait quelque exemple dans les Ouvrages antiques: je sçay au contraire qu'il y a beaucoup de choses dans les bâtimens des Anciens, dont je ne voudrois jamais conseiller l'usage. Et je suis persuadé que sur le sujet de l'Ordre Composé, nous n'avons pas moins de droit de changer les pensées Romaines, que les Romains en ont eü d'alterer celles qu'ils avoient reçeues des Architectes Grecs; pourveu, comme j'ay dit, que l'on ne s'égare point, et que l'on ne sorte point de certaines regles generales dans lesquelles ils ont toûjours renfermé leurs inventions. . . ." Blondel 1675–1683, part 3:250.

29. Hubert Gillot, *La Querelle des anciens et des modernes en France* (Nancy, 1914). Reprint Geneva, 1968, avant-propos, also 203.

Notes on Contributors

Hilary Ballon holds degrees from Princeton University and the Massachusetts Institute of Technology. The author of *The Paris of Henry IV: Architecture and Urbanism*, she is a member of the faculty at Columbia University. Currently she is at work on a book on the architecture of Louis Le Vau.

Susan J. Barnes is senior curator at the Dallas Museum of Art. Her study, *The Rothko Chapel: An Act of Faith*, was published in 1989. Formerly she was an assistant dean of the Center for Advanced Study in the Visual Arts, National Gallery of Art, and chief curator of the North Carolina Museum of Art.

Alice T. Friedman co-directs the architecture program at Wellesley College, where she is associate professor. The author of *House and Household in Elizabethan England: Wollaton Hall and the Willoughby Family*, she has also written about English tomb sculpture, Tudor education, and the history of marriage. She is working on a study of Lady Anne Clifford as a patron of painting and architecture.

Evelyn B. Harrison, a classical archaeologist, has taught at Columbia and Princeton universities and the Institute of Fine Arts, New York University, where she is professor. She has written on archaic and classical Greek sculpture and is publishing the sculpture found in the excavations of the Athenian Agora by the American School of Classical Studies at Athens.

Walter S. Melion's research focuses on the theory and practice of northern art of the sixteenth and seventeenth centuries. Recently he completed a manuscript on Karel van Mander's *Schilder-Boeck*. He received his Ph.D. from the University of California, Berkeley. An assistant professor, he teaches at The Johns Hopkins University.

Esther Pasztory teaches pre-Columbian art at Columbia University. Among her books are *Aztec Art* and *The Mural Paintings of Tepantitla, Teotihuacán,* and she edited *Middle Classic Mesoamerica: 400–700 A.D.* Born in Budapest, she came to the United States during the revolution of 1956. She received her Ph.D. from Columbia University.

Martin J. Powers has written on the social history of early Chinese art and recently completed a manuscript entitled *Pictorial Art and Political Expression in Early Imperial China.* He teaches the history of Chinese art at the University of Michigan, Ann Abror.